Philip Morris is proud to be associated with the exhibition of "Edward Hopper: The Art and the Artist" at the Whitney Museum of American Art.

In the course of our corporate activity in support of the arts during the 1960s and 1970s, Philip Morris has established close and special ties with the Whitney Museum and has sponsored several major exhibitions dealing with the history of our country and our people.

In contemporary terms, if we want to know where we came from and who we are, we would do well, I believe, to turn to the lifework of Edward Hopper. His canvas has logged much of America in the first two-thirds of the twentieth century, and appears to offer a comprehensive visual depiction of our modern character and identity.

With frankness, precision, and sympathy, he seems to have recorded the everyday sense of life in the cities and towns and along the coasts of our nation. And because he did so with such stark directness, Hopper has become—perhaps more than any other—the major artist-biographer of this century.

The American life he examined is now presented in all its striking fullness at the Whitney Museum in the most extensive and complete exhibition of his work ever presented. Hopper's career interlaced with the history of the Whitney at several critical junctures, and the bequest of his work to the Museum, of course, makes the relationship permanent.

For Philip Morris, it is an honor to be able to contribute to the realization of this exhibition which expresses the association between an outstanding museum of American art and a great American artist—an association that, one hopes, will inspire others.

George Weissman
Chairman of the Board
Philip Morris Incorporated

EDWARD HOPPER

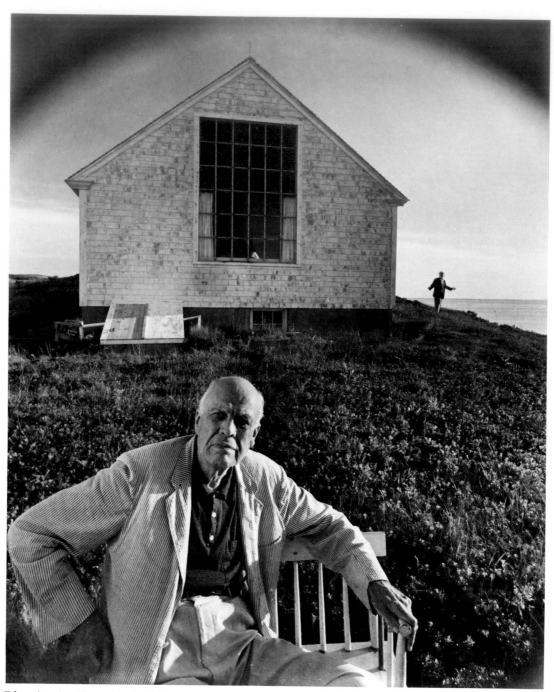

Edward and Jo Hopper in South Truro, Massachusetts, 1960. Photograph © Arnold Newman.

EDWARD HOPPER

THE ART AND THE ARTIST

GAIL LEVIN

W · W · NORTON & COMPANY · NEW YORK · LONDON

IN ASSOCIATION WITH THE

WHITNEY MUSEUM OF AMERICAN ART

This book, published by W. W. Norton & Company in association with the Whitney Museum of American Art, accompanies the exhibition "Edward Hopper: The Art and the Artist" at the Whitney Museum, sponsored by Philip Morris Incorporated and the National Endowment for the Arts. The publication was organized at the Whitney Museum by Doris Palca, *Head, Publications and Sales,* Sheila Schwartz, *Editor,* James Leggio, *Copy Editor,* Anita Duquette, *Rights and Reproductions,* Angela White, *Research Assistant,* and Anne Munroe, *Assistant.*

Dates of the exhibition

Whitney Museum of American Art, New York
September 16, 1980–January 25, 1981 (second floor)
September 23, 1980–January 18, 1981 (third floor)

Hayward Gallery, London; Arts Council of Great Britain
February 11–March 29, 1981

Stedelijk Museum, Amsterdam
April 22–June 17, 1981

Städtische Kunsthalle, Düsseldorf
July 10–September 6, 1981

The Art Institute of Chicago
October 3–November 29, 1981

San Francisco Museum of Modern Art
December 16, 1981–February 14, 1982

First published, 1980, in the United States by W. W. Norton & Company, Inc., New York.
Published simultaneously in Canada by Penguin Books Canada Ltd, 2801 John Street, Markham, Ontario L3R 1B4.

All rights reserved under International and Pan-American Copyright Conventions. *Printed and bound by Dai Nippon Printing Co., Ltd.,* Tokyo, Japan.

BOOK DESIGN BY ANTONINA KRASS
LAYOUT BY BEN GAMIT

Library of Congress Cataloging in Publication Data

Hopper, Edward, 1882–1967.
Edward Hopper: the art and the artist.
Bibliography: p. 72.
Includes index.
1. Hopper, Edward, 1882–1967—Exhibitions.
I. Levin, Gail, II. Whitney Museum
of American Art, New York.
ND237.H75A4 1980 759.13 79-27958
ISBN 0-393-01374-X
ISBN 0-393-00082-6 (pbk.)

6 7 8 9 0

CONTENTS

FOREWORD

The works by Edward Hopper now in the Permanent Collection of the Whitney Museum of American Art cover the full span of his creative life and represent the most extensive public collection of any single American artist. This resource, central to the history of the development of twentieth-century American art and particularly to American realism, was established as a result of the patronage and generosity of Gertrude Vanderbilt Whitney, founder of the Museum.

In January 1920 the first one-man exhibition of Edward Hopper's paintings was held at the Whitney Studio Club, organized in 1918 by Mrs. Whitney. During these years Hopper had found no support for his work and was earning his living through commercial art and illustration. Mrs. Whitney's help came at a time when American artists were receiving little recognition; her commitment to Hopper was carried on by the Whitney Museum of American Art from its founding in 1930 until the artist's death in 1967. When his wife, Jo, died a year later, she left to the Museum their entire artistic estate, the largest bequest of the work of an American artist ever made to a public institution. Hopper and the Whitney Museum became synonymous. While this is a source of great pride in 1980, as we celebrate the 50th Anniversary of the founding of the Museum, it must be said that the bequest contained few masterpieces, and we must still attempt to acquire examples of the artist's finest achievements.

The bequest of the Hopper estate presented what at first seemed to be an overwhelming administrative burden. The obligations it generated were impossible to fulfill without assistance. In 1976, six years after the bequest

had been assembled at the Museum, the Andrew W. Mellon Foundation provided a generous grant to support curatorial research that will culminate in a four-volume catalogue raisonné of Edward Hopper's paintings, drawings, prints, and illustrations, to be published by W. W. Norton & Company, in association with the Whitney Museum. Without the assistance of the Mellon Foundation, for which we are extremely grateful, the bequest would still be in storage, withdrawn from the public, and our knowledge of the artist obscured. Gail Levin, with the help of the grant, was appointed Associate Curator, Hopper Collection, in 1976, and has prepared two definitive exhibitions of Hopper's work. The first was "Edward Hopper: Prints and Illustrations" in the fall of 1979, part of the prelude to the anniversary year. "Edward Hopper: The Art and the Artist" is the second of these exhibitions, and presents Hopper's paintings and drawings as part of the 50th Anniversary celebration. Both exhibitions are supported by Philip Morris Incorporated and the National Endowment for the Arts. These two sponsors, the largest contributors to our exhibition programs, have each played a major role in the life of the Whitney Museum. It is a pleasure to acknowledge their part in this endeavor so closely identified with our history.

All research on Hopper builds upon the work of Lloyd Goodrich. His intimate knowledge of the artist derives from their forty-year association, which began when Hopper was a member of the Whitney Studio Club and Goodrich was an editor of *The Arts,* a magazine supported by Mrs. Whitney. Goodrich, now an Honorary Trustee of the Museum, became Curator in 1935 and was Director from 1958 to 1968. His and the Whitney Museum's continuous recognition of Hopper's work, particularly with the major retrospective exhibitions Goodrich organized in 1950 and 1964, strengthened the artist's ties to the Museum, resulting in the Hopper bequest. Goodrich's observations on the artist's life and work, published in books, meticulously recorded in papers and notes, and simply remembered, are a resource of primary importance. We are deeply indebted to him for his research and for his enthusiastic assistance with our present project.

Edward Hopper was an exceedingly private person who, through his own efforts and the watchful protectiveness of his wife, sought to determine how much of his life and what part of his art would enter history. Gail Levin has diligently and resourcefully worked to reveal the complicated nature of Hopper's personality and the sources and evolution of his work. Her study now becomes a major, integral part of both the history of the Museum and the scholarship of American art.

The question of what is American in American art has challenged scholars for a long time, and we are still seeking a cogent answer. For many, the light, space, solitude, and dignity of the work of Edward Hopper seem to epitomize the character of much of twentieth-century American art. We are gratified to be able to present a complete study of his work to the public and to secure his identification with the Whitney Museum. This would not have been possible without the assistance of many owners of his works who have graciously cooperated with all our efforts. The exhibition "Edward Hopper: The Art and the Artist" will travel to Chicago and San Francisco as well as London, Amsterdam, and Düsseldorf, where the work

of Edward Hopper will be presented in depth for the first time. A smaller version of the exhibition will travel to several museums in the United States and Europe in 1982. Introducing Hopper to new audiences reaffirms that the Whitney Museum is now, fifty years after its founding, internationally recognized as the most important museum devoted to American art.

Tom Armstrong
Director
Whitney Museum of American Art

PREFACE

This volume is intended as a general introduction to the paintings of Edward Hopper. It is a companion volume to *Edward Hopper as Illustrator* and *Edward Hopper: The Complete Prints* (both published last year). The present book will be followed by a catalogue raisonné of Edward Hopper's paintings, drawings, prints, and illustrations, to be published in four volumes. Because the catalogue raisonné will reproduce each work in chronological order by medium, I have welcomed the opportunity here to arrange the artist's work thematically. Since so many of the subjects that recur throughout Hopper's career were first explored in his boyhood work or, at the latest, in the work of his early maturity, much can be learned by examining his *oeuvre* in this manner.

The retrospective exhibition accompanying this publication celebrates both the 50th Anniversary of the Whitney Museum of American Art and the sixtieth anniversary of Hopper's first one-man show, held at the Whitney Studio Club, the Museum's predecessor. The decision by Hopper and his wife, Jo Nivison Hopper, to bequeath their artistic estate to the Whitney Museum is a measure of their appreciation for the early and sustained support his work received from this institution.

In the process of compiling the catalogue raisonné, I have attempted to collect all of the Hoppers' correspondence. Either original manuscripts or copies of the letters from the artist or his wife referred to in this volume are in the Hopper archives at the Whitney Museum of American Art. In addition, I have assembled for the archives copies of all known newspaper and magazine articles which refer to the artist, as well as typescripts of interviews that have come to my attention.

Until his marriage in 1924, the records Hopper kept of his work were incomplete. Jo Nivison, however, proved to be a devoted and exacting archivist; she deserves credit for the careful ledgers she kept on all of the works Hopper exhibited, sold, or gave away. But no records exist for those works, mostly drawings, that never left the artist's studio. An extensive selection of the study drawings, which reveal so well Hopper's creative process, is published here for the first time.

I am deeply grateful to Tom Armstrong, Director of the Whitney Museum of American Art, for entrusting me with so important a project as the catalogue raisonné of Edward Hopper, and for his encouragement, enthusiasm, and continuing support. I wish to thank the Andrew W. Mellon Foundation, which generously supported research for the catalogue raisonné. I also appreciate the important support for the exhibition that accompanies this publication from both Philip Morris Incorporated and the National Endowment for the Arts.

Lloyd Goodrich, whose writings on Hopper and extensive unpublished notes on interviews with the artist provide an important resource, has been a constant source of encouragement and inspiration. He first wrote about Hopper's work in an enthusiastic review for *The Arts* over fifty years ago. I am grateful for the generous loan of the ledger books Hopper bequeathed to him. His early and lasting enthusiasm for Hopper's work, in the spirit of Gertrude Vanderbilt Whitney's original commitment to Hopper, resulted in the Hopper bequest to the Whitney Museum.

Additionally, I have had valuable conversations with John Clancy, Barbara Novak, and Brian O'Doherty, who knew the Hoppers well and who generously shared their reminiscences with me. I also wish to thank all those who through their personal recollections have helped me to know Hopper better. For information on Nyack and the Hopper family, I appreciate the assistance of Arthayer R. Sanborn, Maureen Gray, and Alan Gussow.

I would like to thank all of the owners of works by Hopper who have shared them with me and, especially, those who have so generously loaned to the exhibition. Others who have helped me in many important ways include Daniel Abadie, Elizabeth Cornell Benton, Florence Blauvelt, Milton W. Brown, Milton Cederquist, Noreen Corrigan, Joan Dayan, Betsy Fahlman, Lawrence A. Fleischman, Sherry Goodman, Linda Hartigan, William I. Homer, April Kingsley, Robert L. Mowery, Bennard B. Perlman, Helen Farr Sloan, Leo Steinberg, Helen Tittle, Berta Ward, and Judith K. Zilczer.

At W. W. Norton & Company, James Mairs has provided invaluable support for this publication and supervised its realization. The sensitive eye of Antonina Krass, designer of this volume, has added immeasurably to its quality. I am very grateful for her skills, kindness, and understanding.

So ambitious a series of projects as this exhibition and publication and the forthcoming catalogue raisonné could not be attempted, much less accomplished, without the contributions of many people. I gratefully acknowledge the cooperation of the staff of the Archives of American Art, Washington, D. C., as well as the staffs of the many libraries I visited in the

course of my research. The dedicated help I have received from many members of the staff of the Whitney Museum has been important in the completion of this project. To all of them I wish to express my sincere appreciation, for I realize my good fortune in working with so many devoted, capable individuals on a day-to-day basis.

The Whitney staff members who merit individual acknowledgment include Doris Palca. She has coordinated publication arrangements for this volume, envisioning a beautifully illustrated book from the start. The successful reproduction of so many color plates which aspire to a close approximation of Hopper's palette is due in a large part to the tireless efforts of Anita Duquette, who searched relentlessly for both new means and sources of photography. Among the many photographers, Geoffrey Clements merits special thanks for accomplishing a colossal amount of work in such a short time. Nancy McGary, the Whitney's Registrar, and her staff deserve special recognition for making the complex arrangements necessary to bring these works to the Museum for the exhibition. John Martin and his staff of art preparators have also helped make this project a success. May FitzGerald, Librarian, deserves my thanks as well. I would also like to acknowledge Elizabeth Tweedy Streibert, formerly of the Museum's staff who did the preliminary cataloging work on the Hopper bequest.

Angela White, my assistant, has contributed significantly to both the publication and exhibition. Her good humor, dedication, and intelligence have facilitated my work and made it more fun. My secretary, Jane Freeman, has also greatly assisted me in this project through her ability, conscientiousness, and cheerful presence. James Leggio has copy edited this volume. For this, for his kindness and his help in other ways, I am most grateful.

Barbara Matilsky, while serving as a summer intern, contributed to this project, as did Amy Curtis and Jacqueline Appleton, volunteer interns. Noel Manfre, who energetically volunteered her time and superb organizational skills, deserves special thanks.

Above all, Sheila Schwartz has edited this book with sensitivity and wisdom, offering many invaluable suggestions. Her generosity and encouragement have made my task a much easier one. My debt to her is immense and my gratitude heartfelt.

For the contents and conclusions of this book, I am of course responsible. I hope that the 280 color reproductions of Hopper's paintings, accompanied by his drawings in an affordable volume, will inspire many to examine more closely his important contribution to the art of our century. In writing, I have realized that, owing to the vast amount of information gathered and the limitations of both time and length, this book could not be definitive. If my work prompts further study, I will feel that I have succeeded.

Gail Levin
November 29, 1979

EDWARD HOPPER

THE IDENTITY OF
THE ARTIST

"I don't know what my identity is. The critics give you an identity. And sometimes, even you give it a push." Edward Hopper's cynical view of the role of critics, as expressed here in a statement made late in life, not only affected the course his career took, but also shaped his self-image as an artist. With equal cynicism, he remarked of artists in general: "Ninety per cent of them are forgotten ten minutes after they're dead." [1] Hopper was wrong about the critical estimation of his own work. In the years since his death, critics have continually praised his art, calling him "the major twentieth-century American 'realist' and one of the giants of American painting." [2] In fact, critics have long admired the realist character of Hopper's work, and he himself accepted this praise. Less comprehensible to him was the considerable regard for his painting among proponents of abstract art, who early on acclaimed the aesthetic qualities of his composition, his forms, and his light. As one writer noted, Hopper won the respect of abstract artists: "even during the 1950s his reputation was secure, and artists sometimes coupled Jackson Pollock and Edward Hopper as twin poles of American individualism and artistic integrity." [3] Hopper, however, was dismayed by the shifting tide of critical attention toward Abstract Expressionism, an art he considered as untenable as that of the early European modernists he had first ignored in Paris in 1906. Instead of understanding the critics' simultaneous regard for both his art and Abstract Expressionism, he perceived the wide gap separating his carefully planned

Edward Hopper, c. 1908.

and executed compositions from the Abstract Expressionists' gestural styles, and probably concluded that their advent threatened the continued acceptance of his representational art.

Such sensitivity to critical responses, real or imagined, was always part of Hopper's personality. Until the end of his life, even after much success, he remained vulnerable to negative criticism of his work—in part because he was highly self-critical by nature and demanding of himself as an artist, but also because comments less than enthusiastic raised lingering feelings of self-doubt. These feelings first developed during the years he struggled for recognition. From 1908, when he began to participate in group exhibitions, his work was initially ignored and then received disparaging notices. His sensitivity to criticism during these formative years made him especially susceptible to cultural nationalism, which had been escalating among American artists and critics since the turn of the twentieth century. Hopper found that his deep preoccupation with French culture—acquired during three trips to Paris (1906–7, 1909, and 1910)—was incompatible with this new American nationalism. His work during the 1910s revealed clear signs of French influence, so he responded to the critics by producing pictures with acceptably American subject matter. By 1924 Hopper had shifted entirely to painting his surroundings, renouncing French themes. In so doing, he had to struggle to move beyond the overwhelming impression of French art and culture that had so captivated his imagination.[4]

Robert Henri, Hopper's favorite teacher at the New York School of Art from 1903 to 1906, had encouraged his students to go abroad, perhaps because he himself had gained so much during his several years of study and work in Paris. Hopper later paid tribute to his teacher when he wrote that Henri made the "influence of the French masters of the nineteenth century . . . of vital importance to American painting."[5] Yet Henri also promoted the development of a distinctly American art. As one of the organizers of The Eight, the group of painters who exhibited at the Macbeth Gallery in New York in February 1908, he challenged the conservative National Academy of Design, calling for a new art characterized by Americanism in subject matter—"the American idea."[6] Henri also took the time to revise a definitive article on The Eight (written by Mary Fanton Roberts for the *Craftsman* magazine and called "The Younger American Painters: Are They Creating a National Art?") which chastised artists who borrowed their style and themes exclusively from European painting, and praised The Eight for producing "a home-grown art, out of our own soil."[7]

Encouraged by the impact of The Eight's exhibition, fifteen of Henri's former students, Hopper included, organized their own independent show, held in the upper floor of the old Harmonie Club building on West Forty-second Street from March 9–31, 1908. This, the second exhibition challenging the artistic hegemony of the National Academy of Design, was hailed in the press as "one step nearer to a national art":

Here are skyscrapers, people, streets, manners and gestures of our time, of our country. Here is the particular air of New York. They say of New York that it is beautiful, not because one may find in it virtues which have been admired in

other cities, but because of its own peculiar beauties. . . . One must admire in them an egotistical and purely national pride. It has never before been shown in the work of American painters.[8]

Hopper, however, here showing his art for the first time, had chosen to include three oils, *The Louvre and Seine, The Bridge of the Arts, The Park at Saint Cloud,* and one drawing, *Une Demmiondaine* [*sic*], all produced in France (Pls. 101, 103, 106). He was thus the only artist in the exhibition who appeared to have overlooked his American surroundings. This distinction was not noted, however, in the few critical reviews the exhibition received, none of which discussed Hopper.

Hopper's work was first singled out by critics for discussion when he showed two oils, the monumental *Soir Bleu* and a much smaller canvas, *New York Corner,* in a group exhibition at the MacDowell Club of New York at 108 West Fifty-fifth Street from February 11–21, 1915 (Pls. 378, 233). The reviewer for the *New York Herald* praised *New York Corner*—"a perfect visualization of New York atmosphere"—but ignored the far larger and more impressive *Soir Bleu.*[9] Other reviewers were not so subtle: "Edward Hopper is not quite successful with his 'Soir Bleu,' a group of hardened Parisian absinthe drinkers, but he is entirely so with his 'New York Corner' "; and "in Edward Hopper's 'New York Corner' there is a completeness of expression that is scarcely discoverable in his ambitious fantasy, 'Soir Bleu.' "[10] Hopper's obviously French theme and style in *Soir Bleu* did not find favor in an atmosphere of burgeoning nationalism, yet his modest depiction of an American scene won him much sought-after praise.

The call for an American art was also prevalent among the artists and critics of the more avant-garde circle around Alfred Stieglitz. Although Hopper did not subscribe to their modernist taste, he would have been aware that they too were defensive about American art's excessive debt to European models, especially after the New York Armory Show of 1913, where European art stole the limelight. Even Marsden Hartley, an artist who had borrowed freely from European art, had, in the years just after the First World War, come to realize the need for a more native art.[11] Hartley expressed these feelings in his article "Red Man Ceremonials: An American Plea for American Esthetics," written in Santa Fe, New Mexico, during the summer of 1919:

> A national esthetic consciousness is a sadly needed element in American life. We are not nearly so original as we fool ourselves into thinking. . . . We have the excellent encouragement of redman esthetics to establish ourselves firmly with an esthetic consciousness of our own. . . .[12]

By 1927 Hopper himself was writing of the necessity of creating a "native art":

> Out of the horde of camp-followers, imitators and publicity-seekers who attach themselves to all movements in art as in science and politics, are emerging certain artists of originality and intelligence who are no longer con-

Edward Hopper, c. 1915.

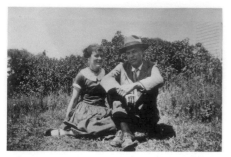

Edward and Jo Hopper, Cape Elizabeth, Maine, 1927.

tent to be citizens of the world of art, but believe that now or in the near future American art should be weaned from its French mother. These men in their work are giving concrete expression to their belief. The "tang of the soil" is becoming evident more and more in their painting. . . . We should not be quite certain of the crystallization of the art of America into something native and distinct, were it not that our drama, our literature and our architecture show very evident signs of doing just that thing.[13]

Hopper had suppressed his nostalgia for France four years earlier after making his last etching of a French theme, *Aux Fortifications* (Fig. 1). That summer of 1923 in Gloucester, Massachusetts, under the encouragement of his friend (and, later, his wife) Josephine Nivison, Hopper began to paint watercolors of his surroundings (Pls. 197–199). In November 1924 he exhibited these watercolors in a one-man show at the Frank K. M. Rehn Gallery in New York City. It was with this "American" exhibition that Hopper, at the age of forty-two, finally achieved his first financial success as a painter. Up to this point he had been supporting himself as a commercial illustrator, an occupation he thoroughly disliked.

When Hopper wrote in 1927 of the "tang of the soil," he had already developed his mature style and subject matter. His oil paintings too were concerned with his American surroundings—primarily city themes in winter and coastal New England views during the summer. The critical reception of *Sunday,* Hopper's 1926 painting of a lone man seated on a street curb, shown in a group exhibition called "America Today" at the Rehn Gallery

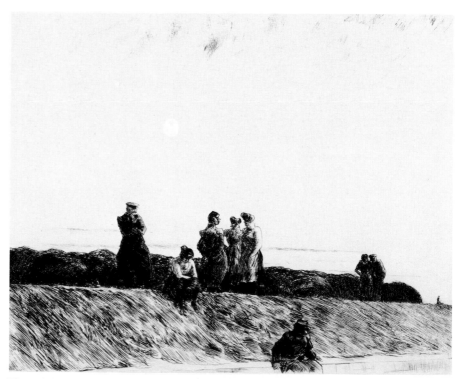

Fig. 1. Edward Hopper, *Aux Fortifications,* 1923. Etching, 12 × 15 inches. The Metropolitan Museum of Art, New York; Harris Brisbane Dick Fund, 1925.

that year, is indicative of the critics' ongoing preoccupation with nationalism, and demonstrates how well Hopper's art seemed to fit the intellectual currents of the 1920s (Pl. 160). For example, one reviewer noted:

> No question of the Americanness of this picture both as to treatment and to subject—a street, empty and silent; a worker, clean-shirted and helplessly idle . . . out of such commonplaceness has Hopper created beauty as well as injected humor and an astute characterization of place and type.[14]

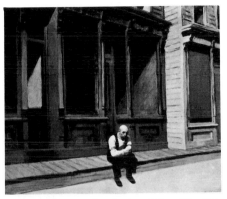

Edward Hopper, *Sunday*, 1926 (see Pl. 160).

In 1927 Lloyd Goodrich, who became Hopper's most ardent critical supporter, wrote: "It is hard to think of another painter who is getting more of the quality of America in his canvasses than Edward Hopper." [15]

By the 1930s, when cultural nationalism came into full flower and the Regionalists Thomas Hart Benton, Grant Wood, and John Steuart Curry were celebrated, Hopper's paintings had become more intensely personal and introspective. But they remained, at least superficially, representations of ordinary American scenes. Critics like Thomas Craven and Peyton Boswell, Sr., were calling for the development of an indigenous American art that would turn its back on French modernism and express "the spirit of the land." [16] Only Hopper's close friend and former classmate, the critic and painter Guy Pène du Bois, understood that the "extremely self-conscious movement . . . 'the American Scene'" had made Hopper, "one of the most unfashionable of men," into "one of the most fashionable of painters." Yet, as early as 1931, du Bois saw the limitations of this movement:

> It believes that only through a complete devotion to the American scene will an American art be created. It believes also that American artists are likely to lose their national purity in foreign lands. It would keep them provincial in thought, word and work.[17]

And du Bois noted prophetically:

> No painter's importance can rest so simply in that which he paints. . . . Some time, Hopper will be recognized as a painter with a very sound technical equipment and a superbly individual vision.[18]

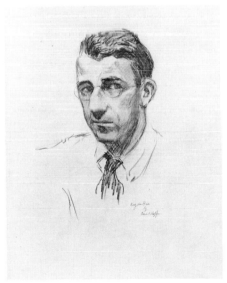

Edward Hopper, *Guy Pène du Bois*, 1919 (see Pl. 34).

Despite the wisdom of du Bois' remarks, critics continued to discuss Hopper's work in the context of American Scene painting. A reviewer incorrectly described his one-man exhibition held at the Museum of Modern Art in 1933 as "the work of a man who has always been stubbornly American, both in technique and subject matter," ignoring the five French caricatures included in the show.[19] Obviously, this critic did not know of Hopper's *Soir Bleu* (Pl. 378), exhibited nearly twenty years before, or even of his earlier paintings of Paris shown at the Whitney Studio Club in 1920.[20] Another critic attributed Hopper's rapid rise to fame to "the fact that he has come in on the rising tide of nationalism," recognizing the "requirements of what was meant by racial quality in American art," and

remarked that Hopper's work was "the antithesis of the type of work produced under domination of French standards." [21] By 1939 Hopper was praised as "probably the finest living painter of the American scene, [who] ranks just below Maurice Utrillo as a painter of streets and their houses." [22] This comment expresses the limitation Hopper saw in being typecast as an American Scene painter, for even some of the critics who promoted this aesthetic continued to regard American art as provincial, in the shadow of the School of Paris.

Perhaps because of Hopper's irritation with the parochial, yet ambivalent, critics who narrowly characterized his work as American Scene painting and overlooked his intellectual sophistication and emotional authenticity, in 1941 he chose to exhibit a selection of his 1907–14 paintings at the Rehn Gallery. This exhibition, which included eleven scenes of France, forced some critics to recognize that Hopper's art transcended the limited categorization American Scene painting:

> For at least a decade and a half, Hopper's style has seemed to epitomize the sort of plastic speech that, with augmenting assurance, is termed "American." Indeed, suddenly confronted with evidence, it may require some effort to adjust one's self to the fact that Paris has its place in the retrospective pattern of so American a painter's growth.[23]

Despite this momentary recognition of Hopper's French roots, the point was soon forgotten and the American Scene characterization persisted—as did Hopper's emphatic protestations:

> The thing that makes me so mad is the "American Scene" business. I never tried to do the American scene as Benton and Curry and the midwestern painters did. I think the American Scene painters caricatured America. I always wanted to do myself. The French painters didn't talk about the "French Scene," or the English painters about the "English Scene." [24]

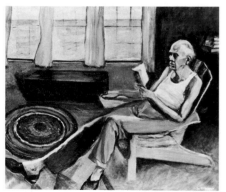

Josephine N. Hopper, *Edward Hopper Reading Robert Frost*, c. 1955. Oil on canvas, 25 × 30 inches. Private collection.

Hopper's intellectual sophistication made it all the more difficult for him to accept the provincialism of "the American Scene business." That he respected intellectual achievement is clear from his description of his father as "an incipient intellectual who never quite made it." [25] As a youth, Hopper read avidly from his father's library—"the English classics and a lot of French and Russian in translation." Later on he continued to immerse himself in poetry, fiction, philosophy; English literature, as well as the French and German writers. Over the years he indicated his fondness for writers as varied as Molière, Victor Hugo, Paul Verlaine, Arthur Rimbaud, Marcel Proust, Goethe, Emerson, Thomas Mann, Renan, Sherwood Anderson, Ernest Hemingway, John Dos Passos, E. B. White, Robert Frost, and Henrik Ibsen. He also had studied the art of the European old masters during his years as a student and on his travels abroad. Throughout his life Hopper maintained an interest in both European and American cultures. But he saw no need for nationalistic ambitions, believing instead that an artist responds naturally to his own heritage: "The American quality is *in* a painter—he doesn't have to strive for it." [26]

Beyond his aversion to misguided nationalism, painting was too private an experience for Hopper to allow it to be described in terms of political, social, or other extra-aesthetic critical concerns. Hopper saw his art primarily as a reflection of his own psyche: "So much of every art is an expression of the subconscious, that it seems to me most of all of the important qualities are put there unconsciously, and little of importance by the conscious intellect. But these are things for the psychologist to untangle." [27] Indeed, Hopper was sufficiently familiar with Freud and Jung to include their books in a caricature (Fig. 2). And when asked what he was after in his 1963 painting *Sun in an Empty Room* (Pl. 429), he replied: "I'm after ME." [28] During his formative years he painted, sketched, and etched his self-portrait repeatedly, a process of self-analysis not entirely motivated by the lack of another model (Pls. 1–22). One *Self-Portrait,* in oil, remains from his mature years, as well as two rather intense *Self-Portrait* sketches (Pls. 20, 21, 22). Hopper's identification of his art with his internal feelings is emphasized by a quotation from Goethe that he carried around in his wallet and cited for its relevance to artistic endeavor:

> The beginning and end of all literary activity is the reproduction of the world that surrounds me by means of the world that is in me, all things being grasped, related, recreated, moulded and reconstructed in a personal form and an original manner.[29]

That he attempted in his own paintings to convey his inner state of mind is clear from his statement for the catalogue of his first retrospective, held at the Museum of Modern Art in 1933:

> I believe that the great painters, with their intellect as master, have attempted to force this unwilling medium of paint and canvas into a record of their emotions. I find any digression from this large aim leads me to boredom.[30]

When asked why he selected certain subjects over others, he replied: "I do not exactly know, unless it is that I believe them to be the best mediums for a synthesis of my inner experience." [31] "Great art," he also wrote, "is the outward expression of an inner life in the artist, and this inner life will result in his personal vision of the world. . . . The inner life of a human being is a vast and varied realm." [32]

Thus, it is important to keep in mind that Hopper was directly concerned with emotional content in his art, even though he may not have intended that content to be clearly interpretable. And while the meaning of his paintings may not always be accessible to us, Hopper's admitted search for personal expression invites our investigation into the nature of his personality as a key to the understanding of his art. In his interviews, in his letters and those of his wife, in the large body of unexhibited work stretching from childhood drawings to his last sketches, in the comments he made in his ledgers, and in the memoirs and reminiscences of those who knew him, are the clues to the real personality he camouflaged out of a sense of privacy and self-protective anxiety (Fig. 3).

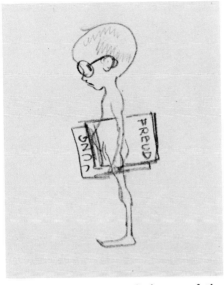

Fig. 2. Edward Hopper, Caricature of the artist as a boy holding books by Freud and Jung, c. 1925–35. Pencil on paper, 4¼ x 3¼ inches. Private collection.

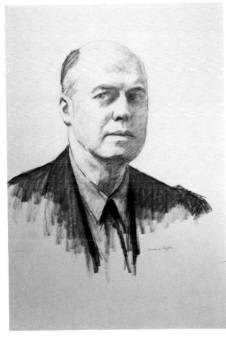

Edward Hopper, *Self-Portrait,* 1945 (see Pl. 22).

One of the most interesting sides to Hopper's character, consistently missed by the critics, was his romantic nature. While works such as his etchings *Les Deux Pigeons* of 1920 and *Summer Afternoon* of about 1919–23 (Figs. 4, 5), as well as his later painting, *Summer Evening* of 1947 (Pl. 367), all illustrate his nostalgic attitude toward romance in their presentation of couples courting, the majority of writers have perceived only loneliness. Although loneliness sometimes did concern him, Hopper objected to the critics' emphasis on it: "The loneliness thing is overdone." [33] On a personal level, he was sentimental about his youth and his experiences in Paris. This was something he shared with his wife Jo, sending her notes and greeting cards in French all through the years. Once, on the Christmas card he designed for her in 1923, shortly before their marriage, he depicted them together, reclining before an open window, with the full moon and the spires of Notre Dame visible in the Paris night outside (Pl. 35). Beneath this picture he included six lines about the exquisite evening sky from "La lune blanche," written by Verlaine for his own fiancée. All this was merely wishful thinking on Hopper's part, for he had not been in Paris for thirteen years and he had never been there with Jo.

Not many people came to know Hopper intimately over his eighty-four years. To Jo, however, he revealed his romantic nature, his wit, and intellectual sophistication during their courtship and throughout the forty-three years of their marriage. Also a painter, who both understood and nurtured

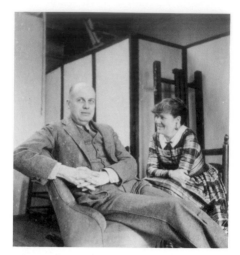

Edward and Jo Hopper in his New York studio, c. 1945.

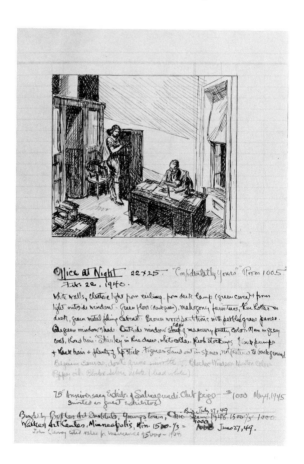

Fig. 3. Edward Hopper, page from the artist's ledger on *Office at Night*. Collection of Lloyd Goodrich.

Fig. 4. Edward Hopper, *Les Deux Pigeons*, 1920. Etching, 8½ × 10 inches. Philadelphia Museum of Art; Purchased, The Harrison Fund.

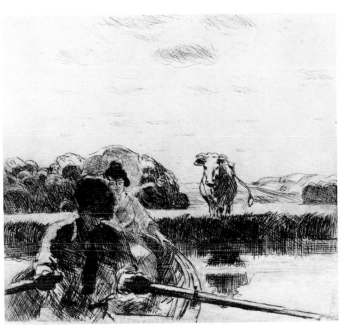

Fig. 5. Edward Hopper, *Summer Afternoon*, 1919–23. Etching, 8½ × 10 inches. Philadelphia Museum of Art; Purchased, The Harrison Fund.

these aspects of Hopper's personality, Jo was the object of his romance, of his wit, and his partner in intellectual and literary pursuits.

Nevertheless, the Hoppers' relationship was complicated by Jo's own ambitions as an artist (Fig. 6). While she faithfully encouraged him, keeping precise records and protecting him from curious journalists, she resented the fact that her own painting did not command much attention. She was possessive, insisting that she model for all of the female figures he painted. As a couple, they were a study in contrasts: he, very tall and imposing (nearly six feet five inches), had a quiet, retiring manner; she, a tiny, energetic, nonstop talker, sporting a bouncing ponytail like a perpetual teenager. She was not fond of domestic duties and often refused to cook at all, preferring modest meals in diners or shabby neighborhood restaurants.

In his interaction with Jo, Hopper's dry wit was put to good use. He often communicated with her through caricatures he drew to make very definite points. One, produced in the early years of their marriage and captioned "Status Quo," depicts Jo seated at the dinner table across from her cat Arthur while Edward crouches catlike on the floor begging for something to eat (Pl. 55). Apparently feeling that she catered to her cat more than to him, he also desired to be pampered. In another caricature, *Meal time*, Hopper depicted himself ignored by Jo: she sits in the clouds reading and he, a mere skeleton, begs for food and attention (Pl. 57). Another time, he portrayed himself as a tall saint, complete with halo, a "Non-Anger man" being attacked by "Pro-Anger woman"—tiny Jo complete with claws (Fig. 7). Although they never had children, Hopper fantasized what their offspring might have been like: in his caricature *Joseddy at*

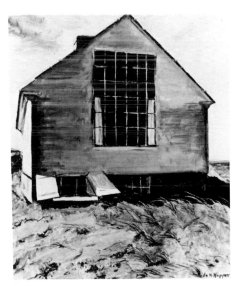

Fig. 6. Josephine N. Hopper, *North Window Chez Hopper, Cape*. Oil on canvas, 30 × 25 inches. Private collection.

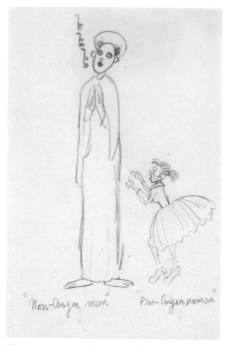

Fig. 7. Edward Hopper, caricature of "Non-Anger man" and "Pro-Anger woman," c. 1925–35. Charcoal and pencil on yellow paper, 8½ × 5½ inches. Private collection.

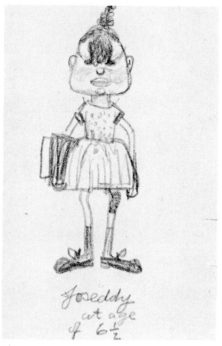

Fig. 8. Edward Hopper, *Joseddy at Age of 6½*, c. 1925–35. Pencil on paper, 6¾ × 5¼ inches. Private collection.

age of 6½, he somewhat pessimistically envisioned an awkward, bowlegged child (Fig. 8).

Hopper's sense of humor, carefully submerged, rarely surfaced in the somber paintings of his maturity.[34] Yet among his youthful works are sketches captioned "This is a comic picture you must laugh" and other cartoons (Pl. 53). In one from 1900, all four diners at a boardinghouse request chicken legs—to the consternation of the landlady who firmly asserts: "Gentlemen, a chicken is not a quadruped" (Pl. 325). While he presented a very serious public veneer, Hopper remained the tease, the prankster, that he had been since his boyhood when he reportedly dipped little girls' braids into inkwells.[35] Rockwell Kent later recalled their fun while classmates at the New York School of Art, where Hopper regularly participated in taunting new students.[36] Another of Henri's students, Walter Tittle, who from 1913 occupied the studio adjoining Hopper's, also remembered pranks such as the painted replicas of bedbugs that Hopper once placed on his pillow:

> Hopper, for all of his semi-funereal solemnity, had an active and definite sense of humor all his own. This served him well from time to time when his periods of inertia would otherwise have plunged him too deeply into unbearable "blues." It usually manifested itself in puckish nonsense, and at times in practical jokes.[37]

Hopper was extremely determined by nature. He preferred to live modestly than to make compromises in his work. He steadfastly refused to give up painting when for years all he could sell were illustrations. He worked as an illustrator only three days a week in order to allow himself time for his painting and his prints, which represented an important outlet for personal expression. Even after his later financial successes, the Hoppers chose to remain in the simple walk-up apartment building at 3 Washington Square North to which he had first moved at the end of 1913. Well into his later years, when he could have afforded greater luxury, he carried buckets of coal for the stove that heated his studio (Fig. 9). And, whether in New York or in the simple house he designed as a summer home on Cape Cod in 1934, he preferred bare, unembellished surroundings (Fig. 6).

Jo encouraged his thrift, shopping for most of their clothes at Woolworth's and at Sears, hooking rugs from rags she collected, cooking dinner out of cans. She too had known years of financial struggle as both an actress and a painter. Never yielding to the whims of fashion, the Hoppers always bought used cars and drove each until it would run no more. They also wore their clothes down to the threads. Their only splurges were for frequent theater tickets, movies, and books. Hopper's economy measures, even during the successful years, were undoubtedly motivated by habit, but no less by his self-critical nature and lingering insecurity: he never expected success to last.

Over the years, Hopper attempted to limit access to his personal life. Shy and reserved, he usually preferred to hide behind a controlled public image of an uncultivated, self-made painter, working in the narrow bounds of the American realist tradition, without imposing on his art any intellectual or

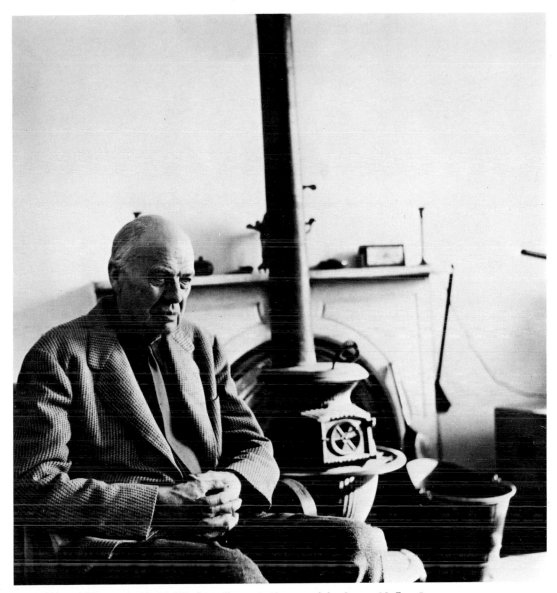

Fig. 9. Edward Hopper in his New York studio, 1958. Photograph by George Moffett, Jr.

private content. He insisted upon the cooperation of his sister Marion in keeping up this image, which was carefully orchestrated by Jo. In 1956, when he was being interviewed for a *Time* magazine cover story, Hopper wrote to Marion that their researchers had "probed quite enough" and warned that if anyone tried to interview her, "tell them absolutely nothing about me or our family." [38]

Despite Hopper's careful concern to conceal and thereby protect his own image, when asked by a writer about a suggestion he had made that "a book dealing exclusively with the lives of artists would be valuable," he admitted: "I didn't mean that. I meant with their characters—whether weak or strong, whether emotional or cold—written by people very close to them. The man's the work. Something doesn't come out of nothing." [39]

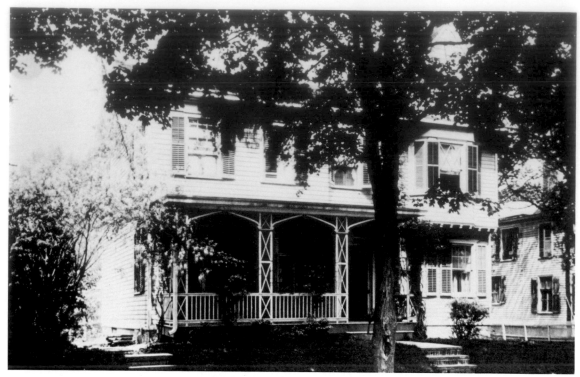

Fig. 10. Edward Hopper's home in Nyack, New York.

Fig. 11. Edward Hopper at age one year, 1883.

Fig. 12. Garrett Henry Hopper, the artist's father.

Fig. 13. Elizabeth Griffiths Smith Hopper, the artist's mother.

DEVELOPMENT

To fully comprehend Hopper's work, as he himself reluctantly acknowledged, is to come to terms with the artist himself—not the public persona he made accessible to most, but the complex personality concealed behind his facade. Hopper, as his work evolved, became one of the most consistent of all artists. He instinctually knew this, and realized that the search for his true character, for the reality which informed all of his art, must commence at the very beginning:

> In every artist's development the germ of the later work is always found in the earlier. The nucleus around which the artist's intellect builds his work is himself; the central ego, personality, or whatever it may be called, and this changes little from birth to death. What he was once, he always is, with slight modification. Changing fashions in methods or subject matter alter him little or not at all.[1]

In 1878 Elizabeth Griffiths Smith married Garrett Henry Hopper. They lived with her widowed mother in the small Hudson River town of Nyack, New York, in the house at 53 North Broadway built by her father about 1857 (Fig. 10). Their first child, Marion, was born in 1880 and their second and last child, Edward, arrived on July 22, 1882 (Fig. 11). In 1890 Garrett Hopper purchased a dry goods store on South Broadway, and his son sometimes worked in the store after school (Fig. 12). The Hoppers were a solidly middle-class family, who attended the neighborhood Baptist church (founded by Elizabeth Hopper's grandfather in the middle of the nine-

teenth century), and sent their children to the local private school for the early primary grades.

Elizabeth Hopper encouraged her children's interest in art and theater (Fig. 13). Marion staged puppet shows and plays at their home, often assisted by Eddie, as he was called (Fig. 14).[2] Eddie, the more precocious, began to sign and date his drawings by the age of ten (Fig. 15). The children were given illustrated books to augment their imaginations. Eddie, who drew constantly, copied drawings from volumes by Phil May and Gustave Doré (Pl. 58),[3] in addition to making little cutout soldiers and decorating the covers of his paint box.

The Hoppers' home was located at the top of a hill, with a clear view of the Hudson River, only one block away. During Eddie's childhood, Nyack was a prosperous port town, with a thriving shipyard that built racing yachts. All sorts of boats traveled up and down the river past Nyack, to the unending fascination of Eddie and his friends, who spent much of their free time down by the docks. They also had a variety of boats to play with on the local pond (Fig. 16), one of which was a catboat that Eddie built when he was about fifteen, with wood and tools supplied by his father (Fig. 17). "It didn't sail very well," he remembered—yet at one time he considered pursuing a career as a naval architect.[4] Hopper explained that his father bought him materials and encouraged him to build the boat to get him out into the fresh air and away from the books that he was constantly reading. The propensity for solitude which this passion for reading suggests may have begun several years earlier. For at about age twelve, Hopper suddenly grew to six feet in height, weakening him physically and setting him apart from his contemporaries.

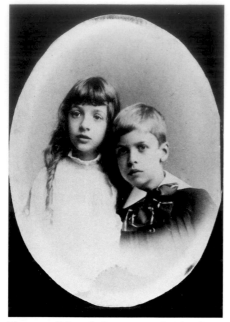

Fig. 14. Edward Hopper and his sister, Marion Hopper.

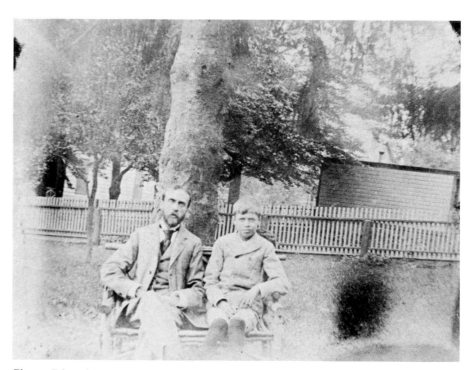

Fig. 17. Edward Hopper and his father, Garrett Henry Hopper.

Fig. 15. Edward Hopper, *Box*, December 12, 1892. Conté on paper, 9½ × 12¼ inches. Whitney Museum of American Art, New York; Bequest of Josephine N. Hopper. 70.1606.8

Hopper graduated from Nyack High School in 1899 with the intention of becoming an artist. His parents prevailed upon him to study commercial illustration, which they felt would offer a more secure income. That year he began to commute to New York City to attend the Correspondence School of Illustrating at 114 West Thirty-fourth Street (Fig. 18).

In 1900, Hopper transferred to the New York School of Art, popularly known as the Chase School, located at the corner of Sixth Avenue and Fifty-seventh Street. After two years of studying illustration, he had acquired enough self-confidence to begin to study painting with William Merritt Chase. As late as 1916, when conducting Saturday art classes at his family's house in Nyack, Hopper stated on his announcement cards that he had studied with Chase (Fig. 19). But it was Robert Henri, who first joined the faculty in the autumn of 1903, as well as Kenneth Hayes Miller, whom Hopper later cited as his teachers. In retrospect, he obviously felt that Chase's instruction had no particular influence on him: "Henri was the most influential teacher I had. Men didn't get much from Chase; there were mostly women in the class. . . . Henri was a magnetic teacher. . . . I was in the life and portraiture classes of Henri."[5] In later years, Hopper probably viewed Chase's style as regressive, particularly in comparison with Henri's.

Hopper's protestations aside, his earliest student work does show the influence of Chase, "the leading spirit and chief instructor" at the school.[6] Every Monday, Chase gave a public evaluation of all students' work in a large studio at the school; and once a month he painted a study from the model before his students as a "practical demonstration of his method."[7] Chase painted in an elegant realist style, characterized by surface virtuosity and broad sweeping brushstrokes. It is difficult, as we shall see, to precisely identify which features were inspired by Chase in Hopper's student work

Fig. 16. Edward Hopper as a child seated in a rowboat, Nyack, New York.

Fig. 18. Edward Hopper as a young man.

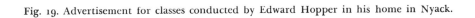

DRAWING PAINTING ILLUSTRATION

MR. EDWARD HOPPER WILL GIVE INSTRUCTION IN DRAWING, PAINTING, ILLUSTRATION AND THE COMPOSITION OF PIC-TURES AT 53 NORTH BROADWAY, NYACK, N. Y. ON AND AFTER OCTOBER 2ND EVERY SATURDAY MORNING FROM 9 TO 12. MR. HOPPER WAS A PUPIL OF CHASE, HENRI, K. H. MILLER AND OTHERS AND IS A FORMER INSTRUCTOR OF THE CHASE SCHOOL.

FOR TERMS ADDRESS 53 NORTH BROADWAY, NYACK OR 3 WASHINGTON SQUARE, NORTH, NEW YORK.

Fig. 19. Advertisement for classes conducted by Edward Hopper in his home in Nyack.

But Hopper clearly responded to Chase's advice that students visit the Metropolitan Museum of Art. Chase even lectured to his classes there, a practice later continued by Henri. Chase wanted his students to be inspired by great paintings and defended the need to assimilate the advances of others:

> Absolute originality in art can only be found in a man who has been locked in a dark room from babyhood. . . . Since we are dependent on others, let us frankly and openly take in all that we can. We are entitled to it. The man who does that with judgement will produce an original picture that will have value.[8]

Hopper's sketch of three men in a gallery carefully observing the paintings exhibited probably documents his trips with his classmates to study first-hand the paintings of the masters (Pl. 69).

Hopper also made sketches after other artists, a practice that may reflect Chase's advice. In one case, Chase instructed his students: "Fortuny [Mariano Fortuny y Carbo, 1838–74] had a most artistic temperament. Everything he did was interesting. Get a complete set of photographs of Fortuny's pictures. He also worked delightfully in pen-and-ink." [9] Hopper's own pen-and-ink study after Fortuny may well be a direct response to this suggestion (Pl. 64). His effort to learn from the work of others is also apparent in his drawings after Regnault's *Salomé* (Pl. 63), Manet's *The Fifer* and *Olympia,* and Millet's *Man With a Hoe* (Pls. 65, 66, 67), as well as from his studies after sculpture by Michelangelo, Rodin, and Thorvaldsen (Pls. 61, 62).[10]

Hopper's early style of drawing, in which he favored large shadowy masses and rubbed backgrounds, which emphasized the paper's texture, recalls drawings by Millet, or even Seurat, which he might have known in reproduction (Pls. 70, 71). These are among Hopper's most successful youthful efforts as a draughtsman, for he created an evocative atmosphere by obscuring details with dusky shadows.

Among Hopper's earliest paintings are several in grisaille (Pl. 73); he had probably learned to work with this palette limited to shades of gray in illustration class.[11] All of the oil paintings from Hopper's student period are dark and thickly painted. He worked largely from the life models at the school, sometimes depicting his fellow students at work (Fig. 20, Pls. 73, 76, 78). As with most young artists, this was a time of searching and experimentation for Hopper, a time when his work yielded to a variety of influences.

Chase's influence can be discerned in Hopper's *Blond Woman Before an Easel* (Pl. 76), where the elegance with which Hopper depicts a woman seen from behind as she paints is reminiscent of his teacher's. Hopper's preliminary sketch of her long graceful neck and upswept hair still exists as a document of his working process (Pl. 77). The model is painting a portrait, raising the possibility that she might be a member of Chase's celebrated portrait class, which Hopper remembered as being composed of mostly women.

Fig. 20. Robert Henri's lifedrawing class at the New York School of Art, c. 1903–4. Edward Hopper is third from right.

It is difficult to distinguish Henri's influence from Chase's in the experimental, unresolved paintings of Hopper's student period. Hopper was generous in his praise of Henri as a teacher, although not as an artist. While Hopper did not learn much in the way of style from Henri, he did work in the dark tones recommended by his teacher to better render mood and atmosphere. More than teach a specific style, Henri gave his students a philosophy. Hopper wrote that Henri's "courage and energy" did much to "shape the course of art in this country," and asserted that "no single figure in recent American art has been so instrumental in setting free the hidden forces that can make the art of this country a living expression of its character and its people." [12] Hopper claimed "first-hand knowledge" of Henri's "enthusiasm and his power to energize students," stressing that "few teachers of art have gotten as much out of their pupils, or given them so great an initial impetus." Thus Hopper insisted that Henri had no influence on him "other than his general philosophy of art" which he explained as "art is life, an expression of life, an expression of the artist and an interpretation of life." [13]

Another student in the Henri class, Rockwell Kent, later referred to Hopper as "the John Singer Sargent of the class" who could be expected to produce regularly "an obviously brilliant drawing." [14] Kent also praised Henri's teaching methods, which he contrasted to those of Chase:

Henri's criticisms made no pretense to such showmanship as Chase delighted in. They were earnest and, at times, impassioned; and being almost invariably

personal—that is, directed to one student at a time and while at work, and to none but such as might be working near at hand or who had grouped themselves to listen—they were mainly in the tones of quiet conversation.[15]

This is just the kind of personal consultation that Hopper depicted in his painting *Student and Teacher at the Easel,* which in all likelihood represents Henri (Pl. 78).

Henri's philosophy of art contributed to Hopper's development as an artist. In his statement in the catalogue of his retrospective in 1933, Hopper wrote: "My aim in painting has always been the most exact transcription possible of my most intimate impressions of nature." [16] This closely resembles Henri's statement: "The great artist has not reproduced nature, but has expressed by his extract the most choice sensation it has produced upon him." [17]

After Hopper left the Henri class, he worked out-of-doors for most of the next decade, after which he began to experiment with composing some of his oils in the studio through a process of improvisation often loosely based on memories and sketches, but in the end imaginary. The roots of his method of combining observation and imagination date back to his early training with Henri. In his most original conceptions, Hopper managed to convey an authentic sense of mood, which again recalls Henri's advice to his students: "Low art is just telling things, as, there is the night. High art gives the feel of night. The latter is nearer reality although the former is a copy." [18] Here one is reminded of Hopper's subsequent fascination with the "feel of night" in his etchings *Night on the El Train* of 1918, *Night in the Park* and *Night Shadows,* both of 1921 and in his paintings *Night Windows* of 1928 and *Nighthawks* of 1942 (Pls. 381, 386, Figs. 50, 21, 22).

Henri, like Chase, encouraged his students to study artists of the past—particularly Manet, `Hals, Rembrandt, Goya, Degas, and Daumier. But he also encouraged them to read and to attend the theater. According to Rockwell Kent, Henri students discussed such writers as Eugène Sue, Verlaine, Baudelaire, and "the French Decadents in general"—discussions which he dubbed "in keeping with a slightly morbid overtone of Henri's influence." [19]

Guy Pène du Bois, who served as monitor of Henri's class during most of the years Hopper attended, recalled that Henri believed he was "creating a class of men" who would have above all "a good strong conscience and the courage to live up to it." [20] The class which du Bois referred to as "an almost miraculously inspired closely knit unit" included himself, Hopper, and Kent, as well as Gifford Beal, George Bellows, Homer Boss, Patrick Henry Bruce, Arthur E. Cederquist, Oliver N. Chaffee, Clarence K. Chatterton, Glenn O. Coleman, Lawrence Dresser, Arnold Friedman, Julius Golz, Jr., Prosper Invernizzi, Edward Keefe, John Koopman, Vachel Lindsay, Walter Pach, Eugene Speicher, Carl Sprinchorn, Walter Tittle, and Clifton Webb. Henri advised Vachel Lindsay to abandon painting for poetry and Clifton Webb went into acting; but as for the rest, a surprising number made names for themselves as artists.

Fig. 21. Edward Hopper, *Night in the Park,* 1921. Etching, 7 × 8⅜ inches. Philadelphia Museum of Art; Purchased, The Harrison Fund.

Fig. 22. Edward Hopper, *Night Shadows,* 1921. Etching, 6⅞ × 8³⁄₁₆ inches. Whitney Museum of American Art, New York; Bequest of Josephine N. Hopper. 70.1048

Hopper also liked Kenneth Hayes Miller, his other teacher at the New York School of Art, whom he later credited with having "a fine sober influence on much of our contemporary painting." [21] From Miller, Hopper probably learned to focus on a consideration of the picture plane, of spatial organization, recession, and modeling forms "in the round." The latter feature is reflected in the painterly Rubenesque female Hopper depicted in *Nude Crawling into Bed* of about 1903–5 (Pl. 75). Rockwell Kent later compared the three teachers with whom he and Hopper had studied, saying that Chase had taught them to use their eyes, Henri to enlist their hearts, while Miller insisted that they use their heads:

> Utterly disregardful of the emotional values which Henri was so insistent upon, and contemptuous of both the surface realism and virtuosity of Chase, Miller, an Artist in a far more precious sense than either, exacted a recognition of the tactile qualities of paint and of the elements of composition—line and mass— not as a means toward the re-creation of life but as the fulfillment of an end, aesthetic pleasure. [22]

Kent saw Miller's emphasis on the elements of style as a corrective to Henri's disregard of it.

During Hopper's years at the New York School of Art, his talent was first recognized with prizes and scholarships, and eventually with the opportunity to teach the Saturday classes in lifedrawing, painting, sketching, and composition. [23] In 1904 his sketch of a woman opening an umbrella was one of several student works selected for reproduction in an article on the New York School of Art that appeared in the magazine, *The Sketch Book* (Fig. 23). [24] Although his name was listed as "Edward Hoppen," it was a mark of

Fig. 23. Edward Hopper, drawing reproduced in *The Sketch Book*, April 1904, p. 233.

his progress to have his work included among those chosen to represent the school.

By 1906 Hopper, like so many Henri students, had begun to feel he should travel to Europe to see the works of the great masters firsthand. He had started to work part-time at C. C. Phillips & Company, a New York advertising agency founded by Coles Phillips who had attended the New York School of Art during 1905 (Fig. 24). But Hopper was restless with his work as an illustrator; indeed, he never found it satisfying.

With his parents' help, Hopper left for Paris in October 1906 and did not return until the following August. Through the Baptist church in Nyack, his parents arranged for him to live with a French family—a widowed mother and her two teenaged sons—at 48, rue de Lille, a building owned by the Eglise Evangélique Baptiste. Years later Hopper recalled: "I could just go a few steps and I'd see the Louvre across the river. From the corner of the Rues de Bac and Lille you could see Sacre-Coeur. It hung like a great vision in the air above the city." [25] In a letter to his mother written soon after his arrival, he expressed his delight with Paris:

> Paris is a very graceful and beautiful city, almost too formal and sweet to the taste after the raw disorder of New York. Everything seems to have been planned with the purpose of forming a most harmonious whole which certainly has been done.[26]

It was not only the physical beauty of Paris that captured his imagination, but also the Parisians: "Every street here is alive with all sorts and condi-

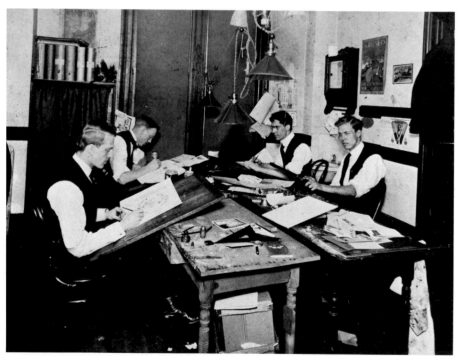

Fig. 24. Edward Hopper (right front) at work in C. C. Phillips & Company in 1906. Coles Phillips is seated across from him.

tion of people, priests, nuns, students, and always the little soldiers with wide red pants." [27] He was fascinated by their constant presence in the streets and cafés and by their apparent hedonism:

> The people here in fact seem to live in the streets, which are alive from morning until night, not as they are in New York with that never-ending determination for the "long-green," but with a pleasure loving crowd that doesn't care what it does or where it goes, so that it has a good time.[28]

Hopper repeatedly sketched the various Parisian types he observed and also produced a series of humorous watercolor caricatures (Pls. 91–96).

Hopper did not enroll in any school, but rather chose to visit exhibitions on his own and to paint out-of-doors around Paris. He saw the 1906 Salon d'Automne, which he described to his mother as "for the most part very bad," although "much more liberal in its aims than the shows at home." [29] During his first four months in Paris it was cold and rainy, so that he could not paint out-of-doors as he preferred. As a result, his initial city scenes were dark, matching his impression of his surroundings. The dark palette, as in his paintings of the stairway and the interior courtyard in his building on the rue de Lille (Pls. 82, 83), also matched the one he had favored as a student in New York. Not until the weather broke in the spring did Hopper begin to respond to the famous Paris light. Although the weather may have affected his art, it did not dampen his immediate appreciation of the city's infinite charms:

> Paris as you must know, is a most paintable city, particularly on and around the Isle du Cite [sic] which was the first Paris. Here the streets are very old and narrow and many of the houses slope back from the top of the first story which gives them a most imposing and solid appearance. The wine shops and stores beneath are darkened or green contrasting strongly with the plaster or stone above. On the roofs hundreds of pipes and chimney pots stick up into the air giving the sky a most peculiar appearance. The roofs are all Mansard type and either of slate or zinc. On a day that's overcast this same blue-grey permeates everything.[30]

Fig. 25. Edward Hopper in Paris, 1907.

His oil painting *Paris Street,* with its dramatic blue-gray tonality, exemplifies these first impressions of his new environment (Pl. 81). The city was soon to capture his heart: "I do not believe there is another city on earth so beautiful as Paris nor another people with such an appreciation of the beautiful as the French." [31] As the weather warmed, he began to paint out-of-doors (Fig. 25) along the Seine and by late May he frequently took the boat to nearby Saint-Cloud or Charenton (Pls. 104, 105, 106).[32]

During this time Hopper saw Patrick Henry Bruce, his former classmate in the Henri class who had settled in Paris in early 1904. He later acknowledged that Bruce had introduced him to the work of the Impressionists in Paris, "especially Sisley, Renoir, and Pissarro." [33] But Hopper did not meet any of the avant-garde who were soon to influence Bruce, and in a later recollection, denied the importance of his experience in Paris:

Whom did I meet? Nobody. I'd heard of Gertrude Stein, but I don't remember having heard of Picasso at all. I used to go to the cafés at night and sit and watch. I went to the theatre a little. Paris had no great or immediate impact on me.

I went to Paris when the pointillist period was just dying out. I was somewhat influenced by it. Perhaps I thought it was the thing I should do. So the things I did in Paris—the first things—had decidedly a rather pointillist [i.e., Impressionist] method. But later I got over that and later things done in Paris were more the kind of thing I do now.[34]

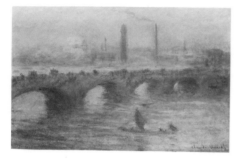

Fig. 26. Claude Monet, *Waterloo Bridge, Misty Morning*, 1903. Oil on canvas, 25¾ × 39½ inches. Philadelphia Museum of Art; Bequest of Anne Thomson.

Comparing the technique and palette of Hopper's student work and the paintings made during his first few months abroad with those produced in 1907, it is evident that he learned much from the Impressionist paintings he saw in the galleries and salons of Paris. The first Paris paintings are small, tentative panels in dark, almost monochromatic tones that recall the dark palette of his student days (Pls. 81, 82, 83). Moreover, the brushwork in these panels is rather smooth, nearly unbroken. Hopper's developing interest in the Impressionists is readily apparent in his ambitious paintings of 1907—in *Après midi de Juin, Tugboat at Boulevard Saint Michel,* and *Le Louvre et la Seine* (Pls. 102, 97, 101). In the last two pictures his brushstrokes have become noticeably shorter and broken. And his once dark palette, in response to the color of spring in Paris, no less than to the Impressionists, is lightened in all three paintings with pastel colors reminiscent of Renoir, Sisley, and Monet. Hopper later recalled of Paris: "The light was different from anything I had known. The shadows were luminous, more reflected light. Even under the bridges there was a certain luminosity." [35] This same response prompted the pinks, pale blues, and lavenders in Hopper's *Pont du Carrousel and Gare d'Orleans,* as well as the pinks, blues, and yellows in *Après midi de Juin* (Pls. 99, 102). Another light-hued painting of this period, *Pont du Carrousel in the Fog* (Pl. 100), specifically evokes Monet's series depicting London's Waterloo Bridge in fog, gray weather, smoke, and sunlight, begun seven years earlier (Fig. 26). Hopper would have seen some of the Monets at Durand-Ruel's Paris gallery, where they had first been exhibited in the spring of 1904.

Hopper later denied the impact of Paris on his work, as if embarrassed at having so eagerly absorbed the style of the French artists. But the letters he wrote from Paris clearly indicate his delight in the new art and experiences he encountered there. He visited many exhibitions, attended the theater, and even saw an automobile show held at the Grand Palais.[36] In all likelihood, he also saw Albert Marquet's one-man exhibition at the Galerie Druet in February 1907. Among the thirty-nine works were several views of places that Hopper would choose to paint in the months that followed; including Marquet's *Notre-Dame, Quai des Grands-Augustins, Quai du Louvre,* and *Pont Neuf, temps de pluie.* While not derivative of Marquet, Hopper's palette and prosaic approach sometimes seem to be closer to Marquet's canvases than to some of the Impressionists. In Hopper's *Le Pont des Arts* of 1907, he appears to have adopted Marquet's style of summarizing the human figure with a quick brushstroke (Pl. 103).

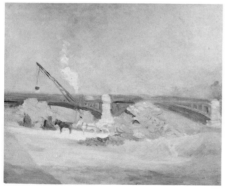

Edward Hopper, *Pont du Carrousel in the Fog*, 1907 (see Pl. 100).

Fig. 27. The Park at Saint-Cloud, Paris. Photograph by Daniel Abadie.

Edward Hopper, *Le Parc du Saint Cloud*, 1907 (see Pl. 106).

Certainly, Hopper's desire to repeatedly paint views of Paris corresponded to Marquet's own practice.

Hopper toured all of Paris, admiring the elegant Boulevard des Capucines, a "wonderful place at night with its theatres and coloured lights . . . lined with cafés where the Demimondanes [*sic*] sit with the silk hatted boulevardiers." [37] In the spring he frequented the Tuilleries garden concerts and traveled by boat to Charenton and Saint-Cloud, where he painted out-of-doors (Pls. 104, 105, 106).[38] In the large park at Saint-Cloud, Hopper turned his attention to architectural structures, such as a stairway and balustrade or an entrance gate and fence, as well as to the forest that other painters had found so attractive (Pl. 423).[39] His less than accurate treatment of the actual perspective of this space results from compositional adjustments he is already allowing his eye to dictate (Fig. 27).

On June 27, Hopper left for London, where he visited the National Gallery, the Wallace Collection, and Westminster Abbey. He found London "less beautiful . . . in contrast to the gay sparkle of Paris," and wrote home about his discovery of "a little French restaurant on Soho St. where I eat cheaply and well. You see I could not forget the French cooking. . . ." [40] He soon referred to London as "a sad, gloomy place" and announced: "Who could help returning to Paris—there is nothing like it." [41] He first went to Amsterdam, however, to visit the Rijksmuseum, where he described Rembrandt's *Nightwatch* as "the most wonderful thing of his I have seen, it is past belief in its reality—it almost amounts to deception." [42] He also visited Haarlem, saw there the Frans Hals paintings, and met Robert Henri, who was conducting a summer school for American students.

On August 21, 1907, after very brief visits to Berlin and Brussels and nearly three additional weeks in Paris, Hopper sailed for New York. While employed as an illustrator for the Sherman & Bryan advertising agency, he

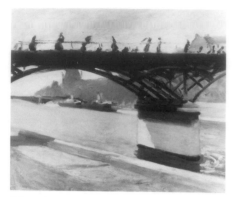

Edward Hopper, *The Bridge of the Arts,* 1907 (see Pl. 103).

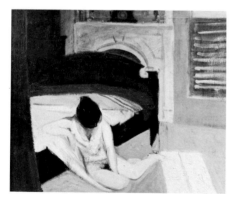

Edward Hopper, *Summer Interior,* 1909 (see Pl. 123).

continued to paint. His first chance to show his work came in the group exhibition organized by several former students of Robert Henri to protest the conservative tendencies of the juries at the National Academy. The "Exhibition of Paintings and Drawings by Contemporary American Artists" (held at 19 15 West Forty-second Street from March 9–31, 1908) included Arnold Friedman, Guy Pène du Bois, George Bellows, Rockwell Kent, and Glenn Coleman. Hopper exhibited three oils, *The Louvre and Seine, The Bridge of the Arts,* and *The Park at Saint Cloud,* and one drawing, *Une Demmiondaine* [*sic*] (Pls. 101, 103, 106). His decision to show only work done in France is indicative of the importance he placed on his experience there. Except for Hopper and his friend du Bois, who exhibited one scene of Paris, the other artists entered paintings of their American surroundings. Although, as noted earlier, the reviewer for the *New York American* hailed the exhibition as "one step nearer to a national art," Hopper's work still paid homage to the French capital.[43] On the whole, the results of the exhibition were not at all encouraging to the artists who participated, for the show was ignored by the establishment and the majority of critics.[44]

Back in America, Hopper painted both what he saw around him and occasional remembered views of Europe. His paintings of 1908 included scenes of New York, such as *The El Station,* as well as reminiscences of France (Pls. 261, 120). He was surrounded by his American contemporaries; his palette became darker as he distanced himself from the influence of Impressionism and reconsidered Henri's teaching. His *Railroad Train* (Pl. 262) was perhaps inspired by his own daily trip from Nyack to New York City—via train to Hoboken and ferry to New York. There he worked in his studio, but returned each evening to live with his family in Nyack.

Hopper went back to Paris in March 1909, and resumed painting along the Seine. He also made excursions to Fontainebleau, Chartres, and Saint-Germain-en-Laye.[45] He reported to his mother that he had chanced upon several "fellows" whom he knew from New York.[46] Due to unusually rainy weather, he cut short his second stay in Paris, and on July 31 sailed home.

The paintings that Hopper produced during this 1909 trip already manifest the solidity which would characterize his mature paintings; they also demonstrate a growing interest in the dramatic possibilities of light and shadow and an awareness of the ability of light to convey a sense of immediacy and vitality (Pls. 113, 114, 115). The color schemes of *Ecluse de la Monnaie* or *Bridge on the Seine* are darker in tone, less involved with the high-key pastel colors he had employed in Paris during the spring of 1907 (Pls. 118, 117). He is fascinated by the play of sunlight and cast shadows. The deep shadows beneath the bridge and on the apartment buildings down the narrow street in the background dramatize the painted light in the *Bridge on the Seine.* The shadows are even more striking in the restricted color scheme of *Ecluse de la Monnaie.* In these paintings Hopper abandoned the short choppy brushstrokes so notable in the 1907 Paris canvases.

One of the most remarkable paintings of 1909, *Summer Interior,* suggests Hopper's future interest in depicting a female nude alone in an interior

(Pl. 123), as well as in exploring the possibilities of the interior space itself. Like many of the later paintings, the mood here is introspective, calm, and contemplative. The broad areas of solid color—the tilted green floor and gold wall—set up a dynamic space emphatically accented by the abrupt diagonal thrust of the bed. The woman's position on the floor, leaning against the bed, with her face cast downward, heightens that sense of emotional intensity which Hopper would develop in his mature work. Although *Summer Interior* was probably painted in America, just after Hopper returned from Paris, both the space and theme clearly recall the paintings of Degas and other French Impressionists.

When Hopper made his last trip abroad in May 1910, he stayed only a few weeks in Paris, preferring to make a long-anticipated trip to Spain—to Madrid, where he saw a bullfight, and to Toledo, which he described as "a wonderful old town." [47] He then spent another few weeks in Paris and on July 1, 1910, sailed for New York. Although he never again visited Europe, his memories remained vivid and the experience had a significant impact on his later development.

Guy Pène du Bois, more than any other writer, perceived the depth of Hopper's intellectual sophistication and recognized his close friend's knowledge and admiration of French culture: "Something about the French appeals to him. He has studied their language and knows their literature to an extent exceedingly rare among Americans. He has painted Paris with love in a series of pictures." [48] Hopper was probably reading French literature before he first went abroad, including the romantic novels of Victor Hugo. His design for a cover or frontispiece to an edition of Hugo's *Les Misérables* was most likely done as an assignment for his illustration class (Fig. 28). Later, possibly just after his first trip to France in 1906–7, he painted an impressive series of watercolor illustrations for an unpublished edition of Hugo's *L'Année Terrible,* a book of poems about the Paris Commune, originally published in 1872 (Fig. 29). Hopper also developed an interest in popular French illustration, and brought home from Paris three issues of *Les Maîtres Humoristes,* and a copy of the humor magazine *Le Sourire* for May 15, 1909. [49]

The period following his last trip to Europe was a time of economic and aesthetic struggle for Hopper. In New York he continued to paint reminiscences of Paris (Pl. 122). Years later he admitted, "It seemed awfully crude and raw here when I got back. It took me ten years to get over Europe." [50] And as late as 1962, he insisted, "I think I'm still an impressionist." [51]

Hopper's second opportunity to publicly exhibit his work was the "Exhibition of Independent Artists," organized primarily by John Sloan and Robert Henri and held at 29–31 West Thirty-fifth Street from April 1–27, 1910. Hopper showed only one oil, *The Louvre,* probably because of the entrance fees—ten dollars for one picture and eighteen for two. His painting was not sold, nor did it receive special mention in the press. In all, there were 344 entries by 102 artists, including Henri, Sloan, Arthur B. Davies, George Bellows, Maurice Prendergast, Everett Shinn, Ernest Lawson, William Glackens, Walt Kuhn, Julius Golz, Rockwell Kent, Guy Pène du Bois, and Glenn Cole-

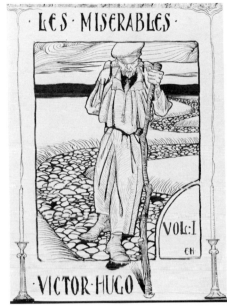

Fig. 28. Edward Hopper, illustration for Victor Hugo's *Les Misérables,* c. 1900–1909. Pen and ink on paper, 8½₆ × 6¼ inches. Whitney Museum of American Art, New York; Bequest of Josephine N. Hopper. 70.1561.190

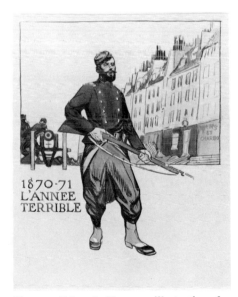

Fig. 29. Edward Hopper, illustration for Victor Hugo's book of poems *L'Année Terrible,* 1906–7 or 1909. Watercolor and ink on paper, 19⁹⁄₁₆ × 14¾ inches. Whitney Museum of American Art, New York; Bequest of Josephine N. Hopper. 70.1350

man. This popular exhibition was compared to the French Salon des Refusés because it included artists shunned by the establishment, in this case, the National Academy of Design. Participating in the show was important for Hopper because it further identified him as one of the young, independent artists in the new movement started by Robert Henri.

Among the paintings in this exhibition repeatedly singled out by critics was *Blackwell's Island* (now Roosevelt Island) by Julius Golz, Hopper's fellow student in the Henri class. Referred to as a "surprising picture" and praised as an "admirable view," it may have inspired Hopper to attempt the same subject the following year (Pl. 124).[52] Hopper's *Blackwell's Island*, which has a soft blue-gray Tonalist effect, perhaps indicates his interest in an exhibition of Whistler's paintings and pastels held in New York at the Metropolitan Museum of Art in the spring of 1910.[53] *Blackwell's Island*, successfully conveying the bleak mood of a gray Manhattan day, may also owe to Hopper's knowledge of Henri's 1900 painting *Blackwell's Island, East River* (Fig. 30) and George Bellows' painting *The Bridge, Blackwell's Island* of 1909. Certainly Hopper's stress on the feeling of the locale was in keeping with the lessons Henri had taught him.

Fig. 30. Robert Henri, *Blackwell's Island, East River*, 1900. Oil on canvas, 20 × 24¼ inches. Whitney Museum of American Art, New York; Lawrence H. Bloedel Bequest. 77.1.24

Hopper next participated in a group exhibition held at the MacDowell Club at 108 West Fifty-fifth Street from February 22–March 5, 1912. This was one of a series of jury-free exhibitions initially suggested by Henri, held at the club. The club allowed groups of eight to twelve artists to organize their own shows for two-week periods. In the February–March 1912 show, Bellows, du Bois, Leon Kroll, Mountfort Coolidge, Randall Davey, Rufus J. Dryer, and May Wilson Preston exhibited along with Hopper. Hopper showed five oils: *Valley of the Seine* and *British Steamer,* both of 1908; *The Wine Shop (Le Bistro)* and *Riverboat* of 1909; and the 1911 painting, *Sailing* (Pls. 120, 122, 113, 125). Thus, his selection was predominantly French—*Riverboat* was painted in Paris, while *Valley of the Seine* and *Le Bistro* were painted in America as reminiscences of France. Only *Sailing,* executed the previous summer, was American in theme. None of the pictures sold.

Hopper spent the summer of 1912 in Gloucester, Massachusetts, painting with Leon Kroll, a former student at the Art Students League and the more conservative National Academy. Hopper's paintings that summer focused on the picturesque waterfront and the rocky shore of Gloucester. In the painting *Squam Light,* a lighthouse on Cape Ann near Annisquam (Pl. 128), he was largely concerned with rendering solid forms with emphatic lights and shadows. Hopper's handling of light as a means to achieve drama is also apparent in *Gloucester Harbor* and *Tall Masts, Gloucester* (Pls. 126, 127). In these Gloucester scenes, Hopper's boyhood enchantment with the nautical world he had known along the Hudson River reasserted itself.

Edward Hopper, *Blackwell's Island*, 1911 (see Pl. 124).

The following January Hopper again showed at the MacDowell Club, this time with Kroll, Henri, Bellows, and eight other artists. Again, too, he exhibited an example of his most recent work and one of his Paris pictures—*Squam Light* and *La Berge,* neither of which sold.

In February 1913 Hopper showed one oil painting, *Sailing*, in the "International Exhibition of Modern Art," familiarly known as the Armory Show (Pl. 125). He had been invited to participate by the Domestic Exhibition Committee, which requested of all the artists that they enter "works in which the personal note is distinctly sounded." [54] Despite the fact that the avant-garde European art attracted tremendous attention and the works by the American participants seemed less exciting in comparison, Hopper's painting sold for two hundred and fifty dollars.[55] This was his first sale of a painting, and, therefore, of great significance. But it did not generate the sale of other works, and throughout the next decade Hopper continued to struggle financially, able to sell only his illustrations and prints—and even then at very modest prices.

In December 1913 he moved his New York studio from 53 East Fifty-ninth Street to 3 Washington Square North where, gradually renting additional space as his financial situation permitted and his subsequent marriage necessitated, he would remain for the rest of his life. Since 1912, along with producing commercial advertisements, he had been illustrating for several periodicals—*Sunday Magazine, The Metropolitan Magazine, Everybody's*, and *System, the Magazine of Business* (Fig. 31). He found working as an illustrator exasperating: "Partly through choice, I was never willing to hire out more than three days a week. I kept some time to do my own work. Illustrating was a depressing experience. And I didn't get very good prices because I didn't often do what they wanted." [56] Hopper's frustration at having to support himself in this way, as well as his love of everything French, are revealed in a humorous sign he made, written in French, captioned "Hopper Maison Fondée 1882" ("House of Hopper, founded 1882," the year of his birth):

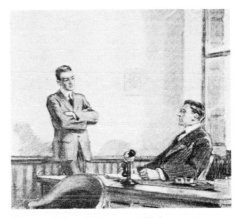

Fig. 31. Edward Hopper, "Living up to your employment system," printed illustration for *System*, July 1919, p. 29.

> Maison E. Hopper. Objects of art and utility. Oil painting, engravings, etchings, courses in painting, drawing and literature, repairing of electric lamps and windows, removal and transportation of trunks, guide to the country, carpenter, laundry, hair dresser, fireman, transportation of trees and flowers, marriage and banquet rooms, lectures, encyclopedia of art and science, mechanic, rapid cures for the ill in spirit such as flightiness, frivolity and self-esteem. Reduced prices for widows and orphans. Samples on request. Demand the registered trademark. Maison E. Hopper, 3 Washington Square (Fig. 32).

In 1914 Hopper exhibited in two more group shows at the MacDowell Club. In the first, from January 22 to February 1, he had two oils, *Gloucester Harbor* and *The Bridge* (Pl. 126). In the second, from April 30 to May 17, Hopper chose to return to work that he had produced in Paris: *On The Quai, Street in Paris, The Railroad, The Port*, and *Land of Fog* (Pls. 86, 89). Walter Tittle, his neighbor at this time and a former classmate, later recalled that while Hopper was "groping to find himself . . . his principal product consisted of occasional caricatures in a style smacking of both Degas and Forain, and drawing from memories of his beloved Paris." [57]

Hopper spent the summer of 1914 painting in Ogunquit, Maine, which he liked well enough to return to the next summer. His pictures from

Edward Hopper, *The Railroad*, 1906–7 or 1909 (see Pl. 89).

MAISON E. HOPPER
OBJETS D'ART ET D'UTILITÉ

Peinture a l'huile, gravures, eaux fortes, cours de peinture, de dessein et de literature, reparation des lampes electriques et des fenetres, enlevement et transportation des malles, guide de compagne, charpentier, blanchisseur, coiffeur, pompier, transportation d'arbres et de fleurs, salles de noces et de banquets, lectures, encyclopédie d'art et de science, mecanicien, guerison rapide pour les maladies de l'esprit, tel que la legerete, la frivolité et l'amour propre. Prix reduits pour les veuves et les orphelines Echantillons sur demande, Exigez la marque de fabrique Maison E Hopper 3 Place Washington

Fig. 32. Edward Hopper, *Maison E. Hopper*, c. 1913–19. Ink on paper, 5 × 7¼ inches. Private collection.

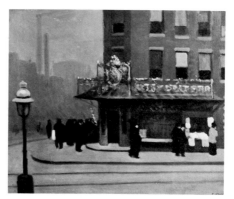

Edward Hopper, *New York Corner* or *Corner Saloon*, 1913 (see Pl. 233).

Ogunquit concentrate on the rocky terrain and coastline, and some of the local architecture (Pls. 131–135). That autumn of 1914, from October 10–31, he was able to exhibit *Road in Maine* at the Montross Gallery in its "Opening Exhibition" of the season (Pl. 131). Hopper's *Road in Maine,* which captures the solitude of the empty open road enlivened only by sunlight and strongly cast shadows, is an early example of an important theme of his maturity—the open road confronted by the traveler.

Several events of significance for Hopper occurred during 1915. First, his friend Martin Lewis, an Australian artist who, like Hopper, also worked in commercial art and illustration, had begun to etch. He provided Hopper with technical advice on etching and encouraged him to try the medium. Hopper's initial efforts were tentative, but he would soon master the etching process (Fig. 33). The second important event took place in February 1915, when Hopper again participated in a group show at the MacDowell Club: for the first time, his work was singled out by the critics for discussion. The two paintings he exhibited were the monumental *Soir Bleu* of about 1914, and a much smaller canvas, *New York Corner,* of 1913 (Pls. 378, 233). *Soir Bleu,* one of the largest canvases he ever painted, represented a major commitment for Hopper and, at the same time, revealed his continuing involvement with French subject matter. Although xenophobic critics dismissed it as only an "ambitious fantasy," praising instead the small New York scene, *New York Corner, Soir Bleu* reflects Hopper's sentimental recollections of a French world of intrigue and romance.[58] True, he had only known this world as an observer on the periphery, but it had captured his imagination and left a lasting impression. Indeed, Hopper's French experience provided some of the liveliest and most exotic moments of his memory. In May of 1907 he had written to his mother of the "carnival" of

Mi-Carême, which he explained was "one of the important fêtes of the year":

> Everyone goes to the "Grand Boulevards" and lets himself loose. . . . Do not picture these in costume, they are not for the most part . . . perhaps a clown with a big nose, or two girls, with bare necks and short skirts. . . . The parade of the queens of the halles (markets) is also one of the events. . . . Some are pretty but look awkward in their silk dresses and crowns, particularly as the broad sun displays their defects—perhaps a neck too thin or a painted face which shows ghastly white in the sunlight.[59]

This letter helps explain the eerie look of the standing woman with her painted face and long thin neck, the presence of the clown, and the scant attire worn by the women. Hopper titled his sketch for the man on the far left of *Soir Bleu,* "un maquereau" (French slang for procurer), suggesting that the woman with the heavily painted face is a prostitute approaching prospective clients (Pl. 379). The café appears to be located on the outskirts of the city along the fortifications, the old ramparts encircling Paris where people met to socialize.

In representing a fête, Hopper was working in the tradition of the *fête galante,* a pictorial genre invented by Watteau in the eighteenth century, which explores the psychological subtleties of human nature without reverting to an overt story. Hopper's clown, dressed in white, recalls Watteau's *Gilles,* also silhouetted against a dramatic blue sky (Fig. 34). The strange

Fig. 34. Antoine Watteau, *Gilles,* c. 1721. Oil on canvas, 72 × 59 inches. Musée du Louvre, Paris.

Edward Hopper, *Soir Bleu,* 1914 (see Pl. 378).

Fig. 33. Edward Hopper in his New York studio, November 20, 1955. Photograph by Sidney Waintrob, Budd Studio.

woman with the painted face, however, suggests a more recent inspiration—the ghastly colored face of Toulouse-Lautrec's lady in the right foreground of *At the Moulin Rouge* of 1892 (Fig. 35). Moreover, the man on the far right of Hopper's composition sits in stiff profile not unlike the central seated figure in the Lautrec. Yet for all his borrowings, Hopper created a scene that is conceptually his own. None of the seven figures looks at any other; each one is aloof, lost in a world of personal thoughts. These are the kinds of figures that populate the pictures of Hopper's maturity. It is as if Hopper endows his painted characters with his own introspective nature.

Despite the negative critical reaction to *Soir Bleu,* Hopper remained involved with French imagery (Pl. 378). But he never again exhibited *Soir Bleu.* He chose many French subjects for his etchings and even gave four prints French titles: *Les Poilus* and *La Barrière,* both of 1915–18, *Les Deux Pigeons* of 1920, and *Aux Fortifications* of 1923 (Figs. 36, 4, 1). Other prints include subject matter that is clearly French: *Evening, The Seine, Café, Street in Paris,* and *Somewhere in France,* all of 1915–18, and *Train and Bathers* of 1920.

When Hopper next exhibited at the MacDowell Club in November 1915, he showed *American Village* of 1912, *Rocks and Houses* of 1914, and *The Dories* of 1914—three oils of American scenes, as if in response to the criticism of *Soir Bleu.* This time his work was ignored by the reviewers. Nonetheless, the three paintings were important steps in the evolution of

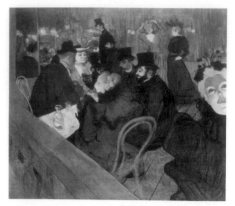

Fig. 35. Henri de Toulouse-Lautrec, *At the Moulin Rouge,* 1892. Oil on canvas, 48⅜ × 55¼ inches. The Art Institute of Chicago; Helen Birch Bartlett Memorial Collection.

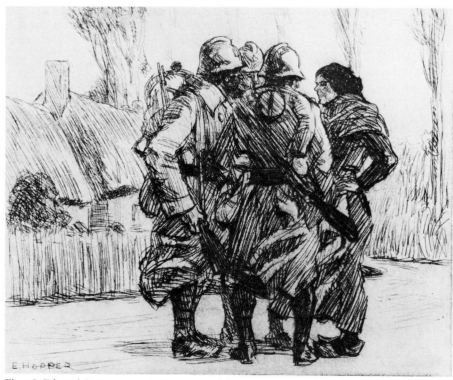

Fig. 36. Edward Hopper, *Les Poilus,* 1915–18. Etching, 9⁵⁄₁₆ × 10½ inches. Whitney Museum of American Art, New York; Bequest of Josephine N. Hopper. 70.1069

Hopper's mature style. *American Village,* the earliest of the three, is a view of a city street seen from high above, over a window ledge, which itself forms the foreground of the painting (Pl. 130). Hopper would use this high, oblique vantage point that renders the human figures small and insignificant even more effectively several years later in his 1921 etching *Night Shadows* (Fig. 22). The blue-gray tonality of *American Village,* like that in Hopper's *Blackwell's Island,* creates a somber, unfriendly mood—a depressing glimpse at small-town America (Pl. 245). This, in fact, is how Hopper felt about his native Nyack, which he considered cloistered, gossipy, and provincial. Years later Hopper would develop such city views into powerfully evocative and even more intensely personal works. Here, however, his roots in the tradition of Robert Henri and The Eight are still quite evident.

The experimental nature of these years of development becomes apparent when *American Village* is compared with *The Dories, Ogunquit,* and *Rocks and Houses, Ogunquit,* painted only two years later in Ogunquit (Pls. 133, 132). Both of these canvases are full of light; the somber tonality seen two years earlier has vanished. But in *Rocks and Houses, Ogunquit,* the horizontal composition is simple and straightforward—rocks, trees, New England wooden houses rendered in subtle tones. *The Dories, Ogunquit,* however, is strikingly open, asymmetrical, and filled with intense light and strong color, most notably the deep blue of the water and the softer blues of the sky. The rocks are highlighted with warm orange tones, while the dories stand out like white crescent moons on the water. The composition is arranged so that the viewer is drawn into the painting's depth, through the rocky cliffs to the strip of land highlighted in the distance. Hopper's achievements here would later be developed in his sunny canvases of nautical scenes on Cape Cod.

About this time, Hopper began to give art instruction in Nyack, perhaps in the hope of doing less illustration, but certainly to earn more income. The classes were held in his family's house on Saturdays, and his mother provided the young pupils with lemonade and cookies. First he had the students sketch with charcoal on large sheets of paper from plaster casts of antique sculpture, then his mother posed for them, seated in a chair; eventually they worked in oil (Fig. 37). One of his former students, then about age eleven, recalled her disappointment when Hopper, who never did develop much patience for children, told her mother that she was too silly to continue.[60]

In February 1916, eight of Hopper's Paris watercolor caricatures were reproduced on a page in the magazine *Arts and Decoration.*[61] In the first magazine to feature his work, he permitted himself to be represented by caricatures that he had made in Paris, again indicating the importance he placed on that aspect of his career (Pls. 91–96).

For the summer of 1916 Hopper went to Monhegan Island, Maine, "a small island quite a way out to sea," where Henri, Kent, Bellows, and Golz had also painted.[62] Monhegan, with "its rock-bound shores, its towering headlands, the thundering surf with gleaming crests and emerald eddies, its forest and its flowering meadowlands," completely captivated

Fig. 37. Cast of head used by Hopper for classes held in his mother's home in Nyack, New York.

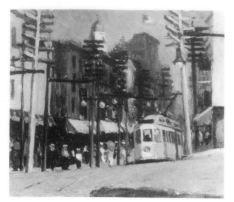

Edward Hopper, *Yonkers* or *Summer Street*, 1916 (see Pl. 234).

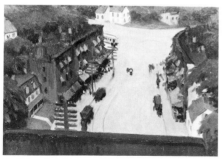

Edward Hopper, *American Village*, 1912 (see Pl. 130).

Hopper.[63] Working out-of-doors, he painted the island's extraordinary rugged coastline composed of high bluffs dropping off dramatically into the turbulent sea (Pls. 145–150). He painted a series of small wood panels of Blackhead, his favorite view on the island; he worked from its twin headland, Whitehead, which stretched out to sea at a height of one hundred and fifty feet, affording a stunning panorama (Pls. 140–143). Delighted with Monhegan, he returned to spend the next several summers there, no doubt to escape the tedium of his illustration work. "Maine is so beautiful and the weather is so fine in the summer—that's why I come up here to rest and to paint a little, too." [64] Some of the paintings he produced on Monhegan Island approach abstraction, although in fact they were interpretations of the remarkably solid, natural forms around him as seen in light and shadow (Pls. 145, 152). His uneasiness about producing such abstract pictures may explain his reluctance to exhibit these works, most of which he withheld from public view, and is in part responsible for Alfred Barr's incorrect conclusion that "after a mediocre summer's work in 1915 he began to devote most of his time to pot boiling illustration." [65]

During February 1917 Hopper showed three paintings at the MacDowell Club, among them *Summer Street,* one of his earliest improvised canvases (Pl. 234). *Summer Street,* which Hopper painted from memory in his studio, was later retitled *Yonkers* after the city that inspired it. An unusual and experimental painting with a bright, almost Post-Impressionist color scheme and strong blue shadows, it is thickly pigmented and full of movement and life, if not yet completely successful.

The following spring, Hopper entered *American Village* and *Sea at Ogunquit* in the "First Annual Exhibition" at the American Society of Independent Artists (Pls. 130, 135). He received little attention or encouragement and made no sales. His commercial work, however, was flourishing; he was now illustrating regularly for the *Farmer's Wife* and *Country Gentleman,* and producing covers for the *Wells Fargo Messenger* and *The Dry Dock Dial,* the employee magazine of a shipbuilding company.

In 1918 Hopper exhibited only his etchings, once in a show with the Chicago Society of Etchers, and again in a group show at the MacDowell Club. That October he won his first award since art school in a wartime poster competition conducted by the United States Shipping Board. His four-color poster, entitled *Smash the Hun,* won the first prize of three hundred dollars in a contest of fourteen hundred entries (Pl. 155). The contest officials had gone on record as opposing the "German commercial art idea" and urged contestants to design "American posters," prompting the usually taciturn Hopper to write a long letter stating his opinion and revealing his knowledge of poster design:

Almost every poster maker in America has been influenced by the work of the modern Germans. . . . The best German work carries at a distance, has large design, few tones and simple and harmonious color. Poster technic in Germany has been carried to a perfection that has been attained in no other country, but it has been made of rather more importance than idea.[66]

Praising the English, whom he said "made good use of black and white or monochrome in their work," he also indicated his own preference for French posters, which he described as full of feeling, "fire and vivacity." [67] Winning this award brought Hopper more publicity and attention than he had ever known. One newspaper identified him as a "Well Known Illustrator," taking him out of the obscurity which he had long endured and at last placing him in the limelight. Hopper, who had managed to touch the very nerve of a nation at war with his emphatic poster design, described his intentions in making the poster. In so doing, he revealed the extent to which he already understood the potential of a figure's posture, placement, and other formal elements to convey meaning, aspects of style which would become significant in his mature work.[68]

In addition to this poster Hopper also made others, including *With the Refugees,* for the American Red Cross, and various movie posters. Soon, however, he began to focus his attention on his etchings, which had begun to find acceptance through numerous juried exhibitions and sales.

In January of 1920 Hopper, at the age of thirty-seven, finally had his first one-man show of paintings at the Whitney Studio Club at 147 West Fourth Street. The club, officially begun two years earlier by the sculptor Gertrude Vanderbilt Whitney, was open for membership to any serious artist introduced by another member. Among the artists associated with the club in its early days were du Bois, Coleman, Sloan, Davies, Henri, Glackens, Sheeler, Davis, and Hopper. Evidently it was Hopper's friend du Bois, rather than Juliana Force, the club's director, who arranged Hopper's exhibition.[69] Du Bois later recalled that the show "was, curiously enough, composed entirely of pictures painted in Paris." [70] Of the sixteen oil paintings exhibited, eleven were painted in France over ten years earlier and the remainder during the more recent summers spent in Massachusetts or Maine (Pls. 101, 102, 103, 106, 108, 111, 122, 128, 131, 132). Hopper now listed the French titles in the catalogue, rather than the English translations he had used for three of the same paintings in 1908. That he chose to exhibit primarily his French works indicates the significance he still attached to these pictures and his stay in Paris. During the exhibition, a concurrent one of drawings and etchings by his former teacher Kenneth Hayes Miller was held in an adjacent space at the club. Neither artist's work attracted many reviewers, although the reviewer for the *New York Tribune* did write: "Both artists express unusual talent and their work is well worth a visit." [71] None of Hopper's paintings sold.

The response to Hopper's etchings, however, was more positive, and he began to show them with increasing success, both financially and critically. His etching *Evening Wind,* which he exhibited that year in Los Angeles and in New York at the National Academy of Design, prompted one critic to remark that Hopper had "a genius for finding beauty in ugliness" (Fig. 38).[72] In 1923 he won awards for his etching *East Side Interior* of 1922 at both the Art Institute of Chicago and at the Los Angeles County Museum (Fig. 39). Etching forced Hopper to deal with compositional issues with a fresh intensity, enabling him to further refine his ideas into stronger and more consistent designs.[73] His experience producing etchings in the studio

Edward Hopper, *Smash the Hun,* 1918 (see Pl. 155).

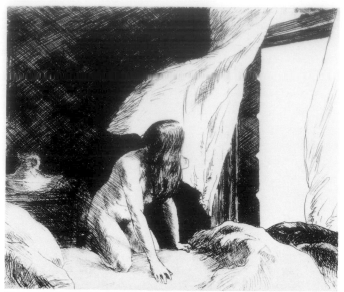

Fig. 38. Edward Hopper, *Evening Wind*, 1921. Etching, 6⅞ × 8¼ inches. Whitney Museum of American Art, New York; Bequest of Josephine N. Hopper. 70.1022

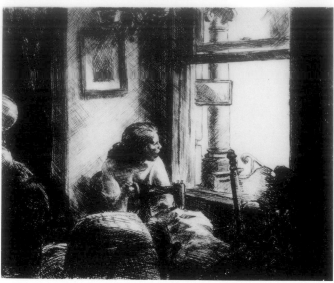

Fig. 39. Edward Hopper, *East Side Interior*, 1922. Etching, 13½ × 18 inches. Whitney Museum of American Art, New York; Bequest of Josephine N. Hopper. 70.1020.

encouraged him to improvise both subject and composition—a creative process that he carried over into his oils.

In the summer of 1923, while in Gloucester, Hopper began to paint watercolors of the local landscape and architecture. Except for illustrations and caricatures of Frenchmen, this was his first use of the medium since art school days. He may have been encouraged to experiment by his friend Jo Nivison, who was already exhibiting her own watercolors, some painted out-of-doors in Provincetown the previous summer.[74] Both students of Henri and Miller, they first met at the art school, where Henri had painted a portrait of Jo in January 1906, entitled *The Art Student* (Fig. 40). By chance, Hopper and Jo saw each other during summers in Ogunquit and on Monhegan Island. They were included in the same group exhibition in December 1922 at the Belmaison Gallery at John Wanamaker's in New York, and both spent the following summer in Gloucester where they went on sketching trips together. Although of contrasting personalities, Jo and Hopper shared many interests: both were well-read, had traveled in Europe, loved the theater, poetry, and were romantic. Years later, Jo reminisced that Hopper once "started quoting Verlaine on Bass Rock in Gloucester" and that she surprised him by continuing the poem when he stopped.[75]

The Brooklyn Museum invited Jo to exhibit six of her watercolors in a group exhibition of American and European artists to be held in late 1923. She recalled: "I got over there and they liked the stuff and I started writing and talking about Edward Hopper, my neighbor. . . . They knew him as an etcher, but they didn't know he did watercolors." Jo suggested that Hopper "bring some of his things over for the show."[76] Six of his watercolors were accepted for the exhibition, where they hung next to hers. She also remembered that he "carried my stuff back when the time came . . . didn't have me hauling them through the subway, what a sorry

sight I'd have made." [77] Jo's generous gesture in bringing Hopper to the attention of the Brooklyn Museum proved to be significant for, while the critics ignored her work, they raved about his. In December the Brooklyn Museum purchased *The Mansard Roof* for one hundred dollars—Hopper's first sale of a painting since 1913 (Pl. 197).

Hopper later remarked of *The Mansard Roof* that he had painted it in Gloucester during the summer of 1923 "in the residential district where the old sea captains had their houses. . . . It interested me because of the variety of roofs and windows, the Mansard roof, which has always interested me. . . . I sat out in the street . . . it was very windy. . . . I think it's one of my good watercolors of the early period." [78] This watercolor, thinly painted, is full of light and loosely executed, but with careful control of the medium. Hopper liked the complex shapes of the Victorian structure and painted a corner view so as to take in more of the angular protuberances. That same summer he had also painted the other five works in the Brooklyn exhibition: *Deck of a Beam Trawler, House With a Bay Window, Beam Trawler Seal, Shacks at Lanesville,* and *Italian Quarter, Gloucester.* Critic Royal Cortissoz exclaimed in the *New York Tribune* that he found Hopper's watercolors "exhilarating" and that "we rejoice that he is using the medium." [79] Helen Appleton Read wrote in the *Brooklyn Daily Eagle* that Hopper's watercolors suggested those of Winslow Homer and she praised them for their "vitality and force and directness" and as an example of "what can be done with the homeliest subject if only one possesses the seeing eye." [80]

Encouraged by his recent success, Hopper entered a period of uncharacteristic optimism. On July 9, 1924, at the Eglise Evangélique on West Sixteenth Street, shortly before his forty-second birthday, he and Jo were married. Guy Pène du Bois, who was the best man, visited the Hoppers in Gloucester, where they went for the summer, although Jo had wanted to go to Cape Cod. Hopper produced more watercolors over the summer and in that fall the Frank K. M. Rehn Gallery gave him his second one-man show—his first in a commercial gallery. All eleven watercolors he exhibited and five additional ones were sold. The exhibition was a critical success as well. Henry McBride pronounced Hopper "interesting" and declared that his own enthusiasm for the artist's watercolors was "considerable," while the *Times* critic spoke of "a striking group of watercolors." [81] The more successful George Bellows purchased two of the watercolors.

This exhibition proved to be the turning point in Hopper's career, for he was finally able to cease working as an illustrator and devote himself entirely to painting. He had already given up etching a year earlier, when he had become preoccupied with watercolor. Now his renewed sense of confidence, after years of struggle, encouraged him to work more frequently in oil, tackling more ambitious canvases and working toward what would become his mature style.

In 1923, he had begun to attend evening sketch classes held at the Whitney Studio Club, which had moved to larger quarters at 10 West Eighth Street. For the modest fee of twenty-five cents he could sketch from the life model provided (Pls. 156, 157). Soon after their marriage, however,

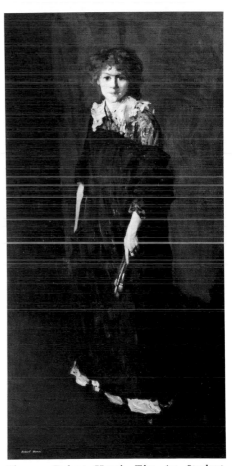

Fig. 40. Robert Henri, *The Art Student (Miss Josephine Nivison)*, 1906. Oil on canvas, 77¼ × 38½ inches. Milwaukee Art Center Collection.

Jo insisted that she alone should pose for him, and for the rest of his life she modeled for all of his female figures.

During the 1920s Hopper's mature painting style began to crystallize, perhaps as a result of his experience as an etcher. When Hopper etched his plates in his studio, he had to rely on memory or on sketches. Thus, rather than work directly in front of his subject as he did in the early oils, he gradually learned to invent his subject matter and composition in the studio—an etching such as *Monhegan Boat* was based on his recollection (Fig. 41). His mature oils eventually became presentations of imagined images or were based on simple sketches he made on location and synthesized in his studio. As his mature style emerged, Hopper developed several compositional formats which he frequently used throughout his career. These include a simple frontal view parallel with the picture plane, a scene viewed at an angle from above, and a subject placed on an oblique diagonal axis cutting into the picture's depth. By this time, Hopper had experimented with views through a window both into an interior and out to an exterior space. The window served as both a romantic symbol of the expansive world beyond and a barrier separating the viewer-voyeur from the drama within.

In his mature style can be seen the remarkable results of Hopper's youthful experiments with light. Through the skillful manipulation of light, shadow, and tone, he could animate an entire composition. The light is clear and strong, and only occasionally would he resort to the more obviously evocative Tonalist effect of his early paintings like *Blackwell's Island* or *American Village* (Pls. 124, 130).

Some of Hopper's transitional paintings, such as *Park Entrance* of about 1918–20, which he exhibited in 1921 at the Whitney Studio Club, reveal the stages in his development of a mature style. *Park Entrance* is still sketchy and unresolved but, like *Summer Street* of 1916, it was improvised

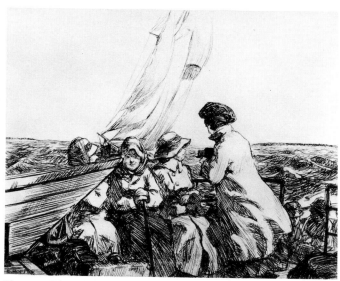

Fig. 41. Edward Hopper, *Monhegan Boat*, 1919. Etching, 7 × 9 inches. Whitney Museum of American Art, New York; Bequest of Josephine N. Hopper. 70.1044

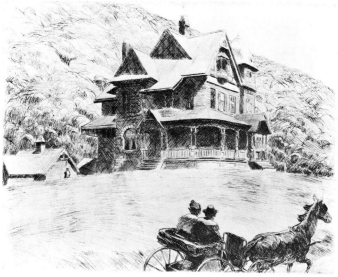

Fig. 42. Edward Hopper, *House on a Hill* or *The Buggy*. Etching, 8 × 10 inches. Philadelphia Museum of Art; Purchased, The Harrison Fund.

in the studio (Pl. 235). Hopper said that *Park Entrance* did not represent any particular place;[82] the tiny figures remain quite generalized, as in *Summer Street* and the 1913 painting *New York Corner* (Pls. 234, 233). Hopper often excluded figures entirely from his landscapes. When present in his mature work, the figures are larger and given more emphasis. The subdued lighting of *Park Entrance* still recalls the tonal effects of 1912, as if he wished to convey the feeling of twilight. Each of these three paintings is viewed from above, a vantage point Hopper would use less and less in his mature work.

In his *East River* of about 1920–23, Hopper reverted to a simpler, completely frontal composition, and successfully relied on the intense light at sunrise to create drama (Pl. 236). He had used a similar format in *Canal at Charenton*, painted in France in 1907, and would later make use of it in his mature paintings (Pls. 303, 304, 383). He later remarked of the improvised East River scene that he thought the water was "pretty good"—an extravagant comment from one so self-critical.[83]

Moonlight Interior of 1921–23 is close in mood and composition to his 1921 etching *Evening Wind* (Pl. 380, Fig. 38). The scene is an intimate one, making the viewer assume the role of voyeur looking in at the lone nude woman, as the wind suggestively disturbs the curtain at the window. Hopper has effectively used a limited palette of cool blue and green tones to convey the mood. We glimpse not only the woman unaware, but, through the window, a gabled house in the moonlight, setting up a tension between interior and exterior. Here Hopper has arrived at a theme he would continue to explore in his maturity.

Hopper exploited the interior-exterior device in a different way in *Apartment Houses* of 1923, where a woman at work is seen from above through a window, with the building next door visible in the congested city (Pl. 159). His interesting rendition of this domestic interior again makes the spectator snoop, pulled in by the unusual angular perspective.

In *New York Pavements* of about 1924, Hopper not only used a view from above, but also dramatically cropped the figure of the nurse pushing the baby carriage (Pl. 237). He had recently tried out separate aspects of this kind of cropped, angular composition in his 1920 etching *House on a Hill* and in *Night Shadows* of 1921 (Figs. 42, 22). In these etchings, as well as in *New York Pavements*, Hopper's understanding of Degas proved helpful, for it taught him important compositional devices—cropping, emphatic diagonals, and unusual angles of vision. It is no small coincidence that Jo presented him with an elaborate book on Degas in 1924.[84]

With *House by the Railroad* of 1925, Hopper arrived at his artistic maturity, having resolved a variety of influences and experiments into the creation of a personal statement (Pl. 264). In a skillfully constructed composition, a mansard-roofed Victorian house stands starkly alone against the cutting edge of railroad tracks. This conception evolved from his 1920 etching *American Landscape*, although in the earlier work details such as trees and cows distracted from the drama of the solitary house (Fig. 43). By contrast, the starkness of the *House by the Railroad* is unmitigated by the appearance of secondary elements. And now the once horizontal line

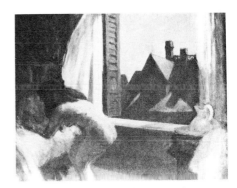

Edward Hopper, *Moonlight Interior*, 1921–23 (see Pl. 380).

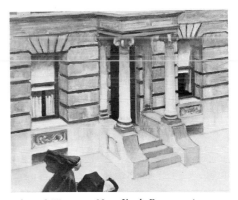

Edward Hopper, *New York Pavements*, 1924 (see Pl. 237).

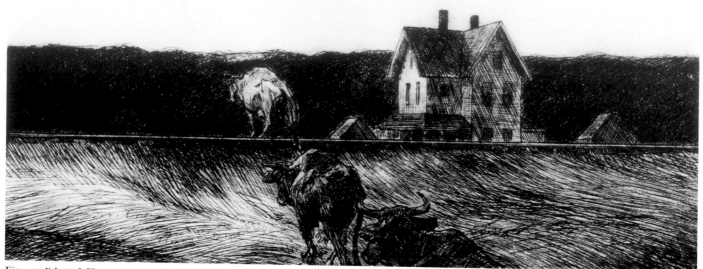

Fig. 43. Edward Hopper, *American Landscape*, 1920. Etching, 13¹³⁄₁₆ × 18¼ inches. Whitney Museum of American Art, New York; Bequest of Josephine N. Hopper. 70.1005

of the tracks cuts inward on a diagonal to create a deeper space and a more powerful image, one of the enduring symbols in American art. This solitary house seems to recall America's more innocent past—a simpler moment that has been left behind by modern urban life and its complexities. Hopper has presented us with a glimpse back in time, as though seen by chance while passing through on the way to some other place. *House by the Railroad* seems to embody the very character of America's rootless society.

From this time forward, few significant changes occurred in Hopper's art or in his life. He and Jo continued to live at 3 Washington Square North, leaving the city every summer for the New England coast. From 1930 on, they spent most of their summers in South Truro on Cape Cod, where they built a house in 1934.

Hopper's art, too, remained relatively unchanged for the rest of his life. Hence, unlike most artists, Hopper's work cannot easily be divided into early, middle, and late periods, or even more complex divisions based on style. Rather, by the mid-1920s, after he achieved his mature style, the formal elements of Hopper's vocabulary altered very little. Moreover, the subjects that Hopper explored in his subsequent paintings were almost all variations on themes which had fascinated him before—as a child, a student, an illustrator, and a struggling artist.

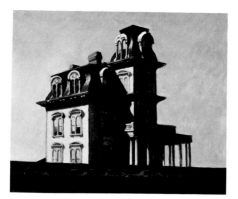

Edward Hopper, *House by the Railroad*, 1925 (see Pl. 264).

THEMES

Given the remarkable consistency of both Hopper's style and choice of subject matter, it is more illuminating to study his mature art in terms of the themes he went on to investigate again and again. These themes were rich in personal meaning for him. Having considered the nature of Hopper's personality we can better understand the underlying content of his art.

As Hopper reached artistic maturity, he discarded themes that were no longer of interest to him. After his student period and the years immediately following, portraiture ceased to hold his attention and he rarely depicted anyone other than Jo. He eliminated the many small figures that, during his formative years, had animated his cityscapes in the manner of John Sloan. As Hopper gradually removed figures from his urban scenes entirely, these scenes became empty evocative settings into which he could project a mood. Hopper also developed certain subjects which at that time were unusual, if not unique, in the history of art—especially his gas stations, hotel lobbies, and offices. The themes that repeatedly preoccupied him are those under consideration here, for they reveal the core of meaning in Hopper's art.

SOLITARY FIGURES

Perhaps most personal are the lone figures Hopper depicted in various settings, particularly interiors. As noted earlier, the nude female in *Summer Interior* of 1909 is one of the earliest manifestations of this theme (Pl. 123). Characteristically, the solitary figure is presented lost in thought, as if a

projection of Hopper's own introspective nature. Sometimes the figure is shown at work, as in *Girl at a Sewing Machine* (about 1921), or the man raking leaves in *Pennsylvania Coal Town* (1947) (Pls. 158, 159, 169). At other times, people read, as does the manicurist in *Barber Shop* (1931), or just wait, as in *Sunday* (1926), *French Six-Day Bicycle Rider* (1937), or *Summertime* (1943) (Pls. 161, 160, 164, 166). Even when, as in *Barber Shop* or *French Six-Day Bicycle Rider,* other figures are visible, the central characters are psychologically remote, existing in a private space of dreams and contemplation.

Hopper's interest in the young bicycle racer probably reveals some degree of self-identification from his own days of bicycle riding (Fig. 44). In November 1936, one year before he painted the French cyclist, he had attended the International Six-Day Bicycle Race held at Madison Square Garden. He later described his intentions in this painting:

> I did not attempt an accurate portrait, but it resembles him in a general way. . . . He is supposed to be resting during the sprints while his team mate is on the track or at the time when "The Garden" is full in the afternoon or evening, when both members of a team are on the alert to see that no *laps* are stolen from them. This rider that suggested the one I painted, was young and dark and quite French in appearance.[1]

Fig. 44. Edward Hopper, *Meditation, 10 Miles from Home*, 1899. Pen, ink, and pencil on paper, 10 × 7¾ inches. Whitney Museum of American Art, New York; Bequest of Josephine N. Hopper. 70.1605.42

While at Madison Square Garden, Hopper made many quick pencil sketches from which he then synthesized the final composition in his studio (Pl. 165). He had actually obtained a photograph of a bicycle rider resting and eating, but it served as a reminder at most, not a direct model (Fig. 45). In the final painting, the young athlete's intensity and concentration is Hopper's imaginative interpretation of an emotional experience rather than a physical one.

Among Hopper's several paintings of solitary figures are those of women alone, often nude or in a state of undress, poised before a window or waiting in a doorway—for example, *Eleven A.M.* (1926), *Morning in a City* (1944), *High Noon* (1949), and *Morning Sun* (1952) (Pls. 393, 394, 398, 400). All of these paintings, however, are also concerned with the symbolism of time and are more appropriately considered in that context (see p. 61). On the whole, critics have often misinterpreted these solitary figures as symbols of loneliness, rather than comprehended Hopper's personal preference for quiet and solitude.

Fig. 45. Photograph owned by Edward Hopper. Bicycle track, Six-Day Bicycle Race.

NAUTICAL

Hopper's love of solitude also figured in his enthusiasm for nautical subjects which, as we have seen, began during his boyhood along the banks of the Hudson River. His early pen-and-ink sketch of a sailboat expresses the sense of escape and freedom that sailing gave him (Pl. 171). He was not only drawn to sailboats—even though he eventually had to give up sailing at Jo's insistence—but to every type of seagoing vessel. To this attraction we can credit such works as his *Tramp Steamer* (1908), *Beam Trawler Osprey* (1926), and *Trawler and Telegraph Pole* (1936) (Pls. 172, 177, 178).

Some of Hopper's most successful watercolors depict nautical themes, for it is in this medium that, painting on location, he was best able to capture the joy of sunlight, wind, and sea air. *Gloucester Harbor* (1926), *The Dory* (1929), and *Yawl Riding a Swell* (1935) bear witness to his personal involvement with this subject matter: although his vessels appear to have been forever frozen in motion, they convincingly convey the romance of the seafarer (Pls. 179, 180, 183). While perhaps some of this feeling was lost when Hopper transferred his conceptualizations to oils painted in the studio, these canvases still evoke the beauty of the sea (Pls. 185, 186, 187). Some of them even have a specific biographical content. Hopper remarked about *The Martha McKean of Wellfleet* (Pl. 187):

> The young lady that the picture is named after has taken us sailing in Wellfleet harbor so often that the title has a sentimental value for us and Martha McKean also. The title was given purposely to please her.... There is no vessel with this name as far as I know. It was named after our friend.[2]

LIGHTHOUSES

Hopper was naturally drawn to lighthouses, for they gave him the chance to combine his love of the sea and of architecture. From a simple ink sketch of his student days, he went on to paint the lighthouses on Monhegan Island and Cape Ann (Pls. 188, 189). He even made etchings of lighthouses, but his most effective renditions were paintings produced in Maine during the late 1920s (Fig. 46). Hopper depicted the lighthouse at Two Lights, near Cape Elizabeth, Maine, several times in conté, oil, and watercolor (Pls. 190, 191, 192, 193, 194). In these pictures, still working out-of-doors on location, he captured the stark forms of the architecture set dramatically against the blue sky. The buildings are bathed in sunlight, which animates these otherwise static images, and creates a lively contrast with the cast shadows.

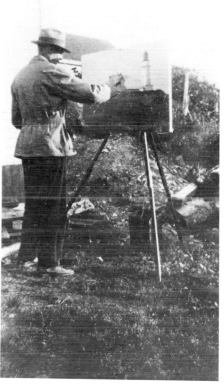

Fig. 46. Edward Hopper painting *Lighthouse Hill* at Two Lights near Cape Elizabeth, Maine, 1927.

GLOUCESTER

In the picturesque New England coastal village of Gloucester, Massachusetts, Hopper found the kind of quaint architectural setting which enchanted him, along with the intense sunlight he preferred. He first worked there, with his friend Leon Kroll, during the summer of 1912. He was not only attracted by the boat-filled harbor, but he also began to explore the effect of sunlight on the interesting buildings of the village, such as in his canvas *Italian Quarter, Gloucester* (Pl. 196). This painting still includes the diminutive, generalized figures that populate early oils like *New York Corner* or *American Village* (Pls. 233, 130).

When Hopper returned to Gloucester in 1923, he began to work in watercolor, and nearly always avoided including figures, concentrating instead on light and architecture. He worked outside, in front of the place he was painting, rendering the intricate forms of the wooden houses. One of these watercolors, *The Mansard Roof* of 1923, brought him acclaim

Edward Hopper, *Lighthouse Hill*, 1927 (see Pl. 193).

Fig. 47. Cold storage plant, North Truro, Cape Cod.

Edward Hopper, *Cold Storage Plant*, 1933 (see Pl. 224).

when, as we have seen, the Brooklyn Museum purchased it that year (Pl. 197). During the next summer in Gloucester on his honeymoon, he produced *Haskell's House,* where ornate architectural structures cast patterns of shadows in the sunlight (Pl. 200). Hopper recalled: "At Gloucester when everyone else would be painting ships and the waterfront I'd just go around looking at houses. It is a solid looking town. The roofs are very bold, the cornices are bolder. The dormers cast very positive shadows. The sea captain influence I guess—the boldness of ships." [3]

Hopper used watercolor with a sense of confidence, improvising as he went along. He would apply the pigments with only a pencil sketch faintly outlining the structures he intended to paint. What interested him was not the creation of textures or the manipulation of the medium, but the recording of light. Light was the language through which Hopper expressed the forms and views before him.

In 1928 Hopper spent his last summer in Gloucester. One of the watercolors made during that visit is *Prospect Street, Gloucester,* a view looking down toward the towers of the Portuguese church (Pl. 209). Here are the shapes and forms that fascinated Hopper to such a degree that six years later he painted an oil, *Sun on Prospect Street,* based upon this watercolor (Pl. 210). Later Hopper felt dissatisfied with the canvas, perhaps because, in retrospect, it seemed to lack mood or psychological statement, as well as the immediacy of the watercolor medium. With few exceptions his mature oils were painted indoors, improvised in the studio from rough black-and-white sketches, simple notations, and his imagination.

ARCHITECTURE

Commenting on the years he was forced to work as an illustrator, Hopper insisted: "I was always interested in architecture, but the editors wanted people waving their arms." [4] His interest in architecture, which is first evident in childhood drawings, persisted throughout his career. He often painted both interior and exterior views of buildings, either without figures, or with generalized figures as subsidiary elements. Sometimes he pictured specific architectural details such as rooftops (Pls. 203, 221). Occasionally, one such detail, as in *House with Bay Window,* would become a focal point of whatever else might exist in the picture (Pl. 213). Hopper knew how to crop forms severely when it suited him in order to present only the most visually absorbing shapes, as in his watercolor *Custom House, Portland* of 1927 (Pl. 217). At times he portrayed architecture as if it were a stage set—particularly in oils like *Pretty Penny* of 1939 (Pl. 228). *Pretty Penny* was actually commissioned by the owners of the house in Nyack.[5] In his watercolors, however, Hopper made nearly accurate records of buildings that he had closely observed, such as the *Cold Storage Plant* on Cape Cod, painted in 1933 (Fig. 47, Pl. 224). He apparently chose to paint buildings not for their beauty, but for their fascinating forms—a rather abstract sensibility that he tried to deny when it was brought to his attention.[6] In *Two Puritans* (1945), the houses seem strangely animated, as

if they had personalities all their own (Pl. 231). The windows, shutters, and doors read almost like facial features, elements of personalities that make their presence felt. Then, too, this work has a strange, subtle tonality recalling early canvases like *Blackwell's Island* of 1911 and *Moonlight Interior* of about 1921–23 (Pls. 124, 380).

Hopper's visual memory was so sharply cast in terms of architecture that he even evaluated cities according to the kind of architecture they offered. In 1953 he wrote Guy Pène du Bois, who was urging him to travel once again to Paris:

> I agree with you about the beauty of the buildings in France and one certainly sees nothing as impressive in Mexico. The great cathedral in Mexico City can not stack up with Notre Dame de Paris or Chartres or any of the others. . . .[7]

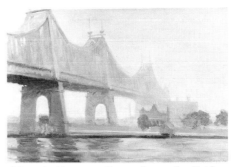

Edward Hopper, *Queensborough Bridge,* 1913 (see Pl. 232).

CITIES

Hopper was drawn to cities, not only for their architecture, but also for their interior life—the kind of scenes he observed through windows, in restaurants, offices, and apartments. Indeed, he had chosen to live in New York City to escape the limitations of small-town life.

All of New York was subject matter for Hopper, who as late as 1935 reminded a critic: "You must not forget that I was for a time a student of Henri's who encouraged all his students to try to depict the familiar life about them."[8] Cityscapes occur frequently among Hopper's early paintings, including *Blackwell's Island* (1911), *Queensborough Bridge* (1913), and *New York Corner* (1913) (Pls. 124, 232, 233). The gray, misty tonality of these works brightens in the 1916 picture *Summer Street*, creating a less gloomy mood (Pl. 234). Hopper liked the buildings and bridges along the river and loved to depict the effects of light on them: in *East River* a luminosity at sunrise makes the tenements and factory buildings seem otherworldly (Pl. 236).

Hopper's mature cityscapes were generally undisturbed by human presence. There is often an eerie feeling born of this desertion, this absence of activity. *Drug Store* (1927) is such a street seen at night—a silent, haunted place pregnant with possibility, where lights cast unnerving shadows (Pl. 242).

When figures do appear in cityscapes they are often diminished, insignificant in relation to the massive architectural environment. Thus, the tiny figure of a man walks away, almost out of view, in Hopper's *Manhattan Bridge Loop* (Pl. 247). Hopper remarked of this painting:

Edward Hopper, *Drug Store*, 1927 (see Pl. 242).

> The picture was planned very carefully in my mind before starting it, but except for a few black and white sketches made from the fact, I had no other concrete data, but relied on refreshing my memory by looking often at the subject. . . . The color, design, and form have all been subjected, consciously or otherwise, to considerable simplification.[9]

He went on to provide a rare insight into his conceptual method:

> I spend many days usually before I find a subject that I like well enough to do, and spend a long time on the proportions of the canvas, so that it will do for the design as nearly as possible what I wish to do. The very long horizontal shape of this picture, "Manhattan Bridge Loop," is an effort to give a sensation of great lateral extent. Carrying the main horizontal lines of the design with little interruption to the edges of the picture, is to enforce this idea and to make one conscious of the spaces and elements beyond the limit of the scene itself.[10]

A later photograph of the site Hopper painted reveals the degree to which he was willing to manipulate the space and perspective he observed for the purposes of compositional refinement (Fig. 48).

Also in 1928, Hopper again painted *Blackwell's Island,* which he had once depicted in 1911 (Pl. 124). This time he paid more attention to the architecture than to the misty atmosphere of the river. Clearly his interest in structure had developed since he had first considered the island. Hopper often went even further afield to find subjects to paint, crossing the Hudson River to New Jersey for *East Wind Over Weehawken* (Pl. 248). Closer to home, he painted *The City* in 1927, a view of Washington Square (Pl. 241). He would sometimes travel uptown to Central Park, where he found material for *Bridle Path* in 1939 and *Shakespeare at Dusk* in 1935 (Pls. 254, 389). Along Riverside Drive, near the park next to the Hudson River, he discovered an intriguing building with a Gothic doorway and a rounded bay window, which he recorded in *August in the City* in 1945 (Pl. 258).

Hopper's most famous cityscape is undoubtedly *Early Sunday Morning* of 1930, which he later noted "was almost a literal translation of Seventh Avenue." [11] In fact, he originally titled it *Seventh Avenue Shops* and later pointed out: "It wasn't necessarily Sunday. That word was tacked on later by someone else." [12] That "someone else" was obviously impressed by the uncanny silence of this painting. Hopper had used a similar horizontal format, with the structures parallel to the picture plane, in earlier works—*East River* of about 1920–23 and *Railroad Sunset* of 1929 (Pls. 236, 382). In *Early Sunday Morning,* however, the sense of immediacy is achieved through the placement of the buildings close to the picture plane (Pl. 383). The shadows cast by the sunlight are effectively conveyed, leading the viewer out of the bounds of the visible, as if, as in reality, this row of shops extends beyond the canvas.

TRAVELING MAN

While Hopper found inspiration in New York City where he resided most of the year, he often grew restless or found himself unable to paint. One of his means of coping with this feeling was to travel with Jo. They went to famous tourist attractions, as well as to extremely ordinary places. In the latter, Hopper was often able to discover visually interesting subject matter despite the commonplace surroundings. Although he never returned to

Fig. 48. Later photograph of site Hopper painted in *Manhattan Bridge Loop.*

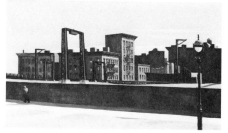

Edward Hopper, *Manhattan Bridge Loop,* 1928 (see Pl. 247).

Europe after 1910, he and Jo did visit Mexico several times and they traveled in New England, the South, and the far West. Along the way, Hopper became preoccupied with the psychology and environment of travelers—in hotels, motels, trains, highways, and gas stations. He found a group of settings and moods which offered many expressive possibilities and produced some of his most poignant paintings.

Trains had attracted Hopper since his childhood in Nyack when he often sketched them (Pl. 260). He drew trains in Paris and painted *Railroad Train* in 1908 between trips abroad (Pls. 89, 262). Perhaps more than trains themselves, Hopper was intrigued by train stations and the chance glimpses one caught while riding in trains—such as in his 1925 *House by the Railroad* (Pl. 264). Trains had also preoccupied Hopper during his careers as an illustrator and as a printmaker.[13]

Hopper's remarkable consistency in theme and approach is demonstrated by comparing his early oil painting *The El Station* of 1908 with *Dawn in Pennsylvania* of 1942 and *Approaching a City* of 1946 (Pls. 261, 281, 294). By 1908 he had effectively expressed his fascination with a train station and the sense of change which is always imminent there. It was the quiet moment of anticipation, when the station is deserted or nearly empty, that Hopper favored. He charged these scenes with drama, conveyed through light and through the shadows cast by ordinary structures—but the result is an aura of eerie expectation. Hopper's tracks, angled from left to lower right, are similar in *The El Station* and *Dawn in Pennsylvania,* as is the use of contrasting vertical accents—chimneys in the former and smokestacks in the latter. *Approaching a City,* which actually depicts tracks passing under a viaduct rather than a station, recalls, in its compositional structure, one of Hopper's 1906–7 drawings, *Figures under a Bridge in Paris,* and the etching *The Locomotive* of 1923 (Pl. 90, Fig. 49).

Railroad tracks were clearly of symbolic significance to Hopper throughout his career (Pls. 260, 263, 264, 265, 266, 268). In *Approaching a City* he said he wanted to express "interest, curiosity, fear"—the emotions one has arriving by train into a strange city.[14] In works like *House by the Railroad* (1925), *Lime Rock Railroad, Rockland, Me.,* a watercolor of 1926, and *New York, New Haven, & Hartford* (1931), Hopper used the tracks both to set off buildings and to lead the viewer's eye on beyond the confines of the picture. Railroad tracks seem to suggest for Hopper the continuity, mobility, and rootlessness of modern life as they merely pass by small towns and rural areas all but forgotten by the forces of progress.

In several illustrations and etchings, Hopper had explored the theme of train interiors (Fig. 50). The theme still interested him years later, when he painted *Compartment C, Car 293* (Pl. 272). His subject is a solitary woman engrossed in reading, while the landscape passing outside the window goes unobserved except by the viewer. The overall green tonality and the harsh glare of the electric bulbs cast this picture in a light that disturbs an otherwise calm and quiet mood. One of Hopper's rough sketches for this painting shows that he once considered having the woman turn and look out the window rather than read (Pl. 273). His final resolution seems more deliberately introspective.

Edward Hopper, April 1959. Huntington Hartford Foundation, Pacific Palisades, California.

Edward Hopper, *Approaching a City*, 1946 (see Pl. 294).

Fig. 49. Edward Hopper, *The Locomotive*, 1922. Etching, 13⁹⁄₁₆ × 16⅛ inches. Whitney Museum of American Art, New York; Bequest of Josephine N. Hopper. 70.1039

Edward Hopper, *Compartment C, Car 293*, 1938 (see Pl. 272).

Fig. 50. Edward Hopper, *Night on the El Train*, 1918. Etching, 7½ × 8 inches. Philadelphia Museum of Art; Purchased, The Harrison Fund.

This kind of mood is expressed with much greater severity in *Chair Car* of 1965, one of Hopper's last paintings (Pl. 305). It is a very strange setting: a high ceiling, with glaring sunlight pouring in through the window obscuring the exterior world entirely. The chairs, like the space itself, seem too large. The curious gaze of the woman on the left, who looks across the aisle at the woman reading, is perhaps a projection of Hopper's own observations while riding in parlor cars.[15]

Edward Hopper, *Hotel Lobby*, 1943 (see Pl. 283).

Reaching his various destinations, usually accompanied by Jo, Hopper found provocative settings in hotel bedrooms and lobbies. The first of these canvases, and perhaps the greatest, is *Hotel Room,* a large oil of 1931 (Pl. 269). In Hopper's best works, a masterful geometric simplicity achieves monumentality. The spare vertical and diagonal bands of color and sharp electric shadows in *Hotel Room* present a concise and intense drama in the night. The tall, slender, pensive woman sits on a bed, head downward, pondering the letter she has just read. Whatever she has learned in the letter confuses and upsets her, as Hopper conveys by the clothing strewn about the room. Combining poignant subject matter with such a powerful formal arrangement, Hopper produced a composition of strength and refinement—pure enough to approach an almost abstract sensibility—yet layered with poetic meaning for the observer.

Hopper's interest in the psychology of his figures is revealed by comparing his 1943 painting *Hotel Lobby* with several of the preparatory drawings (Pls. 283, 284, 285, 286, 287). In the painting, an old man, standing near a seated woman who is presumably his wife, does not look or turn toward her, but rather casts his gaze blankly ahead. Across the room, an attractive young woman sits, relaxed and engrossed in her reading. There is very little communication in the picture, only the older woman regards the old man, but he does not respond to her glance. In one of the preparatory drawings, however, a man sits in the place of the young woman. He does not read; rather he stares blankly across the room (Pl. 284). He sees the older man and woman engrossed in conversation; the man turns toward her and rests his arm on the back of her chair. Still another female figure sits in the chair adjacent to the couple, which in the painting is empty. In the evolution from drawings to the final painting, Hopper apparently tried to accentuate the sense of noncommunication, to reveal a poignant lack of emotional interaction. It is likely that the drawings reflect the figures he actually observed in the lobby, while the painting demonstrates the changes he made to create drama. Other sketches show how Hopper had Jo pose for both the older woman in the hat and the younger woman reading (Pls. 286, 287).

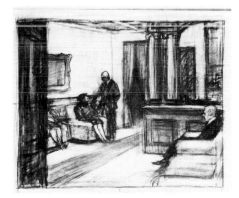

Edward Hopper, drawing for painting, *Hotel Lobby,* 1943 (see Pl. 284).

The psychological drama of *Hotel Lobby* is repeated in Hopper's *Hotel by a Railroad* of 1952, only in a more intimate setting—an older couple's bedroom (Pl. 297). What is again shown is a lack of communication. She reads and he gazes somewhat longingly out the window, at the railroad tracks. Bleak and wistful, impatiently waiting to depart, he seems to wish he were elsewhere. A similar longing for places beyond the window and a sense of waiting characterize *Hotel Window* of 1956 and *Western Motel* of 1957 (Pls. 300, 302). In *Western Motel* the woman also appears anxious, as

she waits to drive off in the car, which is visible through the window, with the luggage left in the foreground. Interestingly, Hopper's sketch for *Hotel Window* indicates that he initially considered placing a man reading across from the woman—again absence of communication (Pl. 301). In *Rooms for Tourists* of 1945 Hopper portrayed the exterior of a quaint boardinghouse in Provincetown, Massachusetts: the contrast between the darkened street and the warmly lit interior convey the traveler's sense of transience—at last finding respite from the night in an unfamiliar setting (Pl. 290). He made study drawings of this house, and then traveled there repeatedly at night while he painted it (Pls. 291, 292, 293).

For inspiration, Hopper also liked to drive, particularly in rural New England (Jo used to complain that he would not let her take the wheel). Hence, highways and filling stations appear as subjects in these paintings (Pls. 275, 278, 288, 296). He obviously enjoyed the solitude of the quiet country road. The woman shouting at the gas station attendant in *Four Lane Road* of 1956 was probably inspired by Jo's garrulous nature (Pl. 296). Hopper's joyful contemplation of a peaceful country road is especially evident in *Solitude* of 1944 (Pl. 288). Again, as in *Two Puritans,* this little house seems to have a personality all its own (Pl. 231). Hopper's 1962 *Road and Trees* is remarkable not only for the enchantingly deep, dark woods which the highway passes gracefully by, but for its striking compositional similarity to his much earlier canvas *Canal at Charenton,* painted in France in 1907 (Pls. 303, 304). Both compositions are arranged in horizontal bands stretching across the canvas—simple, frontal compositions that make a direct visual statement.

Perhaps Hopper's most effective highway painting, the 1940 *Gas,* evokes the anxious feelings of isolation one can confront alone at nightfall on a country road (Pl. 275). The composition is arranged to carry our eye past the brightly lit oasis into the dense, dark, and threatening woods beyond. No actual site is represented; rather, Hopper made several sketches of various places, and then invented his own synthesis in the studio—in fact, he rarely made oil paintings while away from the studio after the 1920s.

LOCAL COLOR

"To me the most important thing is the sense of going on. You know how beautiful things are when you're traveling." [16] In recording local color, often in watercolors, he tended to choose unusual subjects rather than typical tourist sights. Always, he portrayed a sense of place with a notably individual vision. His trip to Santa Fe, New Mexico, in the summer of 1925 was characteristic. He found it difficult to work with such picturesque beauty and intensity of light. At first he painted a train there, but eventually he made watercolors of local sights—*St. Michael's College, Adobe Houses,* and *St. Francis Tower, Santa Fe* (Pls. 306, 308, 310). He and Jo went horseback riding, as he reported to his mother in a letter accompanied by cartoons of him and Jo in their new environment (Fig. 51):

> Jo and I and some others took a twenty five mile horseback ride through the mountains yesterday. It being only the fifth time I had ridden I thought much

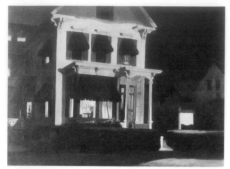

Edward Hopper, *Rooms for Tourists*, 1945 (see Pl. 290).

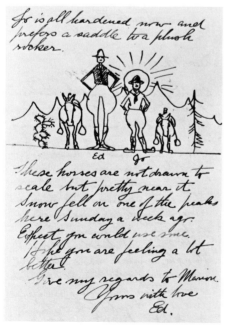

Fig. 51. Edward Hopper, letter to his mother, July 27, 1925. Pen and ink on paper, 8⅞ × 5⅛ inches. Private collection.

more about the hard saddle than I did of the mountains, but they seemed fine when I could look at them.[17]

Two other locales that prompted unusual watercolors were Charleston, South Carolina, which he visited in 1929, and Mexico, where he and Jo first traveled in 1943. In Charleston, Hopper tried the unusual procedure of making a finished drawing before he attempted a watercolor of the same subject (Pls. 311, 312). Interestingly, he never finished painting the sky of *Cabin, Charleston, S.C.* He also executed a very atypical still-life drawing of a cloth he observed and later painted in its setting in the *Baptistry of Saint John's* (Pls. 313, 314).

On his first trip to Mexico (he returned several times during the 1940s and early 1950s), Hopper made watercolors of the local architecture in Saltillo, a small town in the north (Pls. 320, 321). These were less spontaneous, more carefully painted than his earlier watercolors had been. He also made watercolors of the Mexican landscape and pencil sketches of some of the natives in colorful costumes. Hopper liked what he saw in Mexico but he did not find there the kind of visual stimulation he had once found in Paris. Writing to Guy Pène du Bois in Paris, Hopper admitted that "France has quite an edge on Mexico," and then explained why he had made several trips to Mexico and never returned to Paris:

Edward Hopper, *Le Bistro* or *The Wine Shop*, 1909 (see Pl. 122).

> The thing is that to get to Mexico all you have to do is put your luggage in your car at the door and drive until you get there—as easy as that! Getting back into the States is somewhat more bothersome because of the U. S. Customs, but one can put up with it and one does not get seasick on the way.[18]

RESTAURANTS

From his youth, Hopper had observed people in restaurants—he sketched one such scene when he was only fourteen (Pl. 324). Here his interest was in the interaction of the diners and waiters, in the spatial arrangement, and in the setting. Just after he returned from Paris in 1909, he painted *Le Bistro*, a reminiscence of a couple sitting in a café along the Seine (Pl. 122). He etched several scenes set in French cafés (Fig. 4); as an illustrator, he also represented restaurants and café scenes.[19] Hopper explained *New York Restaurant* of about 1922 (Pl. 326), which was the first restaurant painting of his mature period, in this way:

Edward Hopper, *New York Restaurant*, c. 1922 (see Pl. 326).

> In a specific and concrete sense the idea was to attempt to make visual the crowded glamour of a New York restaurant during the noon hour. I am hoping that ideas less easy to define have, perhaps, crept in also.[20]

Here, in a rare admission, Hopper reveals his true interest in the intangible issues that so often concerned him—emotions and interpersonal relationships.

Hopper went on to develop the restaurant theme and achieved an impressive variety of moods through his compositions, light, and the figures he depicted. He shared an affinity for this theme with other members of the

Edward Hopper, *Automat,* 1927 (see Pl. 327).

Fig. 52. Edward Hopper, study of illustration for *Ibsen,* c. 1900–1906. Pen and ink on paper, 14½ × 15⅝ inches. Whitney Museum of American Art, New York; Bequest of Josephine N. Hopper. 70.1565.51

Henri circle, especially John Sloan and William Glackens. Of course, the French Impressionists, particularly Degas, Manet, and Renoir, had earlier explored café and restaurant settings. Hopper's restaurants, however, were settings for the introspective figures he favored. In *Automat* of 1927, he presented another solitary figure, a young woman contemplating her life over a cup of coffee (Pl. 327). This sense of preoccupation, and even the composition itself, developed much earlier in Hopper's *oeuvre* in a work like *Soir Bleu.* In *Automat* the woman sits at a round table at the same angle as does the clown in *Soir Bleu* (Pl. 378), and even the empty chair recalls the angle of the chair in the earlier painting. Hopper has replaced the lanterns with electric lights, but the horizontal and vertical accents are quite similar. In *Chop Suey* (1929) the viewer's attention is held in the foreground by the two women engrossed in quiet conversation, but the entire canvas is remarkably unified by the interplay of bands of light and color (Pl. 328). *Tables for Ladies* (1930) presents both the waitress and the cashier as if each were lost in a world of private thoughts (Pl. 329). Hopper paid unusual attention to the items of food lined up in the implied plate-glass window that the viewer looks through. In the background space, in the shadows, a couple converse, their communication contrasted with the solitude of the two females in the foreground. In *Sunlight in a Cafeteria* (1958) Hopper used the restaurant setting to portray the tensions between a man and a woman, who, while sensing each other's presence, have not met each other's stolen glances (Pl. 330). He gazes in her direction, perhaps only pretending to look out of the window to the street beyond, while she lingers on, her coffee finished, shyly pondering the situation. The entire scene is animated by the sunlight which, as it falls diagonally across the entrance wall, focuses our attention on the drama within.

THEATER

Hopper's penchant for presenting dramatic encounters may have evolved from his love of theater and movies. His enthusiasm for theater, as we have seen, dated back to his childhood in Nyack and was nurtured by his teacher Robert Henri. Even Hopper's fascination with the plays of Henrik Ibsen was probably prompted by Henri, for in Henri's book, *The Art Spirit,* Ibsen is cited as "supreme order in verbal expression." [21] Hopper made both an illustration and a cartoon referring to Ibsen, who, like him, was concerned with the problems of the individual as a spiritual being (Fig. 52).[22] Both the playwright and the painter considered symbolic value within a context of seeming realism. Hopper's respect for Ibsen was also expressed in the essay he wrote for the catalogue of his exhibition at the Museum of Modern Art in 1933. Discussing "definite personalities that remain forever modern by the fundamental truth that is in them," he observed: "[Modern art] makes Molière at his greatest as new as Ibsen." [23]

In Paris Hopper pursued his love of the theater and wrote home about what he saw to his mother, an equally enthusiastic fan of the stage. He went to the opera, saw Shakespeare's *Julius Caesar,* and he noted: "I saw

Coquelin in Cyrano de Bergerac—he looked pretty good to me." [24] Hopper
also enjoyed observing French pageantry for, as we have seen, he recalled
the carnival of Mi-Carême in his painting *Soir Bleu* (Pl. 378).

When Hopper married in 1924, he found in Jo not only a fellow painter,
but a former actress who also adored the theater.[25] Their frequent attend-
ance at plays and movies had two direct effects on his painting: his choice
of theaters as subject matter and the development of compositions that
were often influenced by set design, stage lighting, and cinematic devices
such as cropping and unusual angles of vision.

Two on the Aisle of 1927, Hopper's first important painting on a theater
theme, presents an elegantly dressed couple taking their seats near the stage
before a play begins (Pl. 338). They have arrived early; only one other
woman is visible in an adjacent box and she is reading. We look down at
this scene as if we too have just arrived and have taken our seats in an
upper balcony. *First Row Orchestra* (1951) depicts a similar theme, another
stylishly clad couple seated near the stage before the show begins (Pl. 350).
These treatments recall several of Hopper's earlier magazine illustrations
of theaters.[26]

Hopper had once depicted a solitary patron seated in an empty theater
before what is either a stage or an early movie screen, in a grisaille of about
1902–4 (Pl. 335). His theater or movie-house interiors are distinguished from
those of other artists—for example, John Sloan's *Movies, Five Cents* of
1907—in that Hopper characteristically focused on the theatergoers' con-
centration, while Sloan was captivated with the lively interaction of the
audience. Likewise, Hopper's 1936 exterior view of *The Circle Theatre*
(Pl. 339) reveals a nearly deserted street corner, while Sloan's view of the
Carmine Theater in 1912 represented the more animated scene of "wistful
little customers hanging around a small movie show." [27]

In *The Sheridan Theatre* of 1937, Hopper shows a woman resting, lean-
ing against the balustrade (Pl. 344). He made numerous preparatory
sketches while visiting the theater (Pls. 345, 346), paying careful attention
to details of the architecture which, along with the artificial electric light-
ing, figures importantly in the painting. Hopper has created drama and
mood through a vast interior space enhanced by emphatic lighting.

Although the architecture remains important in *New York Movie* of
1939, Hopper's central concern is the figure of the usherette leaning against
a wall, bored, presumably having seen the movie more times than she cared
to remember (Pl. 340). The members of the audience do not draw our
attention, for they are intently watching the film. On the contrary, it is
the evocative lighting of this fictive world of dreams (both on the screen
and in the ornate details of movie-palace architecture itself) which captures
our imagination. Hopper appears to have drawn inspiration from Degas
for both his composition and his sense of nocturnal drama. As in Degas'
Interior of about 1868–69 (which was on view at the Metropolitan Mu-
seum),[28] Hopper organized his composition with a sharply receding diago-
nal, thrusting emphatically into space and culminating in an off-center
vanishing point (Fig. 53). Even the pose of the usherette in *New York Movie*
closely resembles the stance of the man in *Interior*. And the dramatic

Edward Hopper, *Two on the Aisle*, 1927
(see Pl. 338).

Edward Hopper, *First Row Orchestra*, 1951
(see Pl. 350).

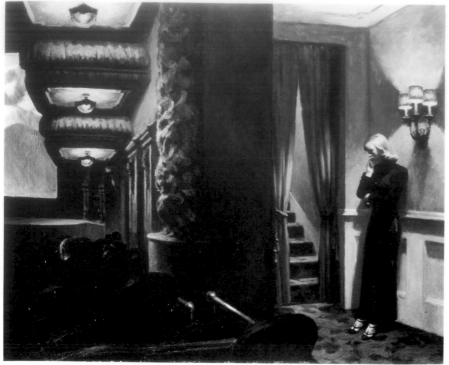

Edward Hopper, *New York Movie*, 1939 (see Pl. 340).

Fig. 53. Edgar Degas, *Interior*, 1868–69. Oil on canvas, 32 × 45 inches. Henry P. McIlhenny Collection.

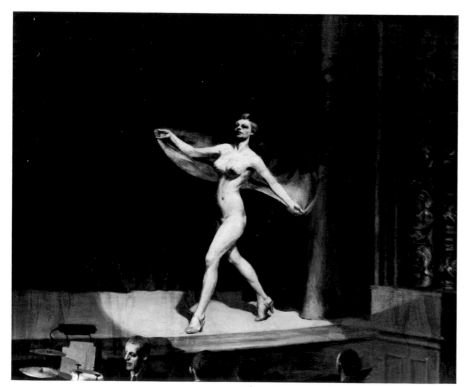

Edward Hopper, *Girlie Show*, 1941 (see Pl. 347).

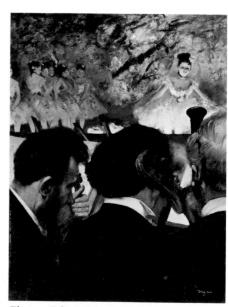

Fig. 54. Edgar Degas, *Musicians of the Orchestra*, 1872. Oil on canvas, 27⅛ × 19¼ inches. Städelsches Kunstinstitut und Städtische Galerie, Frankfurt am Main.

lights and shadows of Hopper's dimly lit movie house also recall the Degas picture. Hopper made many sketches for *New York Movie* at the Strand, Palace, Republic, and Globe theaters; for the usherette he had Jo pose in the hallway of their apartment (Pls. 341–343).

One of Hopper's most surprising theatrical paintings, *Girlie Show* of 1941, depicts a nearly nude burlesque dancer seductively waving her skirt behind her as she prances across a floodlit stage above the members of an all-male orchestra (Pl. 347). Such overt sexuality is unique in Hopper's work. Quite possibly, in aligning the eye level with the musicians' heads, Hopper was inspired by Degas' *Musicians of the Orchestra,* painted in 1872 (Fig. 54).

The significance of theatrical themes for Hopper is emphasized by *Intermission* (1963) and *Two Comedians* (1965), two of the last four pictures that he painted before his death in 1967 (Pls. 352, 353). In *Intermission* Hopper again presented a solitary figure, a seated woman calmly waiting for the others to return and for the play to continue. Two years later, Hopper painted *Two Comedians,* which Jo described as "a dark stage (and what a stage, strong as the deck of a ship) and two small figures out of pantomime. *Poignant.*" [29] Jo later confirmed that in the tall male comedian and the diminutive female comedian Hopper had represented the two of them.[30] It was intended as a personal statement, a farewell of sorts, for when he showed them gracefully bowing out, he had been ill and would die less than two years later. Hopper's conception of a comedian on stage first occurred in a drawing he made in 1905—which nevertheless seems especially close to his sketches for *Two Comedians* (Pls. 336, 354, 355). An early unpublished illustration showed a couple on stage, as if about to bow, with the man holding a palette (Fig. 55).

Even in his last painting, Hopper appears to have recalled French art. His composition is reminiscent of Daumier's lithograph *The Recall of the Singer,* while the costumes suggest those of the Commedia dell'Arte characters painted frequently by Watteau (Figs. 56, 34). Hopper appears to have cast himself and his wife as the young lovers Pierrot and Pierrette. They appear as two comedians who, by their last act, have discovered the most ironic comedy of all human existence. Since Hopper chose to portray himself as a clown here, it is tempting to speculate that, at the very least, he had also felt some degree of identification with the downcast, bald-headed clown in his early painting *Soir Bleu* (Pl. 378).[31]

Hopper, it seems clear, saw the theater as a metaphor for life, and himself as a kind of stage director, setting up scenes to paint based on events he saw take place around him, casting his characters from types he observed.[32] He had learned to use light as only a master stage craftsman could to create drama. Although his dramas were imaginary, his directing was inspired. Even in his habit of having Jo pose for all the women he painted, he acted like a director giving a favorite actress many roles to play. Jo, who had actually acted in theater, was well prepared for her duties.

During the 1920s and 1930s we know that Hopper frequently attended the theater, for he saved many ticket stubs and carefully recorded the

Fig. 55. Edward Hopper, *A Couple on a Stage*, c. 1917–20. Wash on illustration board, 20 × 15 inches. Whitney Museum of American Art, New York; Bequest of Josephine N. Hopper. 70.1348

Fig. 56. Honoré Daumier, *The Recall of the Singer*, 1857. Lithograph, 8 × 10½ inches. The Metropolitan Museum of Art, New York; Rogers Fund, 1922.

Edward Hopper, *Two Comedians*, 1965 (see Pl. 353).

name of the play on the reverse of each. The 1920s marked the establishment of mature and original drama in America, with the emergence of a group of inspired playwrights, including Eugene O'Neill, Maxwell Anderson, and Elmer Rice. Just as Hopper's painting was coming of age, he was partaking of the fruits of the American theater. In the often brilliant sets designed for these stage productions, as well as in the content of the plays, Hopper found inspiration for his own painting.

On February 14, 1929, Hopper and his wife saw Elmer Rice's *Street Scene*, which had just opened a month earlier at the Playhouse theater. The set for this Pulitzer Prize-winning play was designed by Jo Mielziner, whose mother became the Hoppers' neighbor in Truro on Cape Cod when they began to spend almost every summer there in 1930. That the Hoppers found this set memorable is indicated by a letter Jo wrote to Hopper's sister Marion in July of 1936: "My friend, Mrs. Mielziner has invited me to bring you there. She's the mother of that Street Scene set we loved so much. Jo Mielziner, the artist and Kenneth MacKenna, the actor, are her sons. They come sometimes." [33] The set, representing the exterior of a two-story apartment house, with its flat facade extending across the width of the stage, may well have inspired Hopper to paint a similar row of New York apartments in a shallow space, parallel to the picture plane, extending across the face of the canvas (Fig. 57).[34] Originally Hopper had put a figure in one of the windows, as in the set, but he painted it out.[35]

Hopper's *Early Sunday Morning* of 1930 is the quintessential street scene (Pl. 383). The buildings are viewed at an angle from above as if seen from a building across the way. In fact, the Hoppers saw Mielziner's

Edward Hopper, *Early Sunday Morning*, 1930 (see Pl. 383)

Fig. 57. Jo Mielziner, set for *Street Scene* by Elmer Rice at the Playhouse Theater, January 10, 1929. Photograph, Theater and Music Collection, Museum of the City of New York.

Street Scene set from the second balcony, and it is this experience that may have suggested the slightly elevated vantage point found in *Early Sunday Morning.* In a more general way, the dramatic lighting in the painting also speaks for the influence of theater. Hopper's interest in both stage sets and lighting is confirmed by a comment he made upon seeing some foliage illuminated by light coming from a restaurant window at night: "Notice how artificial trees look at night? Trees look like a theater at night." [36]

Hopper was an especially avid fan of movies. He once reportedly told a friend: "When I don't feel in the mood for painting I go to the movies for a week or more. I go on a regular movie binge!" [37] As late as 1962 Hopper said: "If anyone wants to see what America is, go and see a movie called 'The Savage Eye.'" [38] He told an interviewer that he was looking forward to seeing Jean-Luc Goddard's *Breathless,* a film set in Paris, and that he admired French "producers" (he meant directors).[39] Hopper often cropped his pictures very aggressively as though seen through a shifting camera lens. Paintings like *New York Pavements* of about 1924, *The Barber Shop* of 1931, or *Office in a Small City* of 1953 might well be frozen frames from a movie (Pls. 237, 161, 363). Recent cinematographers have drawn inspiration from Hopper's compositions for their own films, just as he had once borrowed ideas from earlier movies.[40]

OFFICES

Although it is a rather unusual subject for painting, Hopper, as a part of his observations of city life, found the office an intriguing setting (Pls. 356–365). He had depicted many offices as an illustrator, especially for *System* magazine, and these sometimes reveal a close relationship with his paintings, particularly *Office at Night* of 1940 (Pl. 356, Fig. 31). Hopper wrote an explanation of this painting at the request of the Walker Art Center, which had purchased it:

> The picture was probably first suggested by many rides on the "L" train in New York City after dark and glimpses of office interiors that were so fleeting as to leave fresh and vivid impressions on my mind. My aim was to try to give the sense of an isolated and lonely office interior rather high in the air, with the office furniture which has a very definite meaning for me.[41]

It appears that Hopper turned for inspiration once again to the work of Degas.[42] Degas' *The Cotton Exchange, New Orleans* of 1873 is one of the few paintings of an office interior and Hopper knew it in reproduction (Fig. 58).[43] In *Office at Night* Hopper has employed Degas' high, oblique view of the floor, tilted out toward the picture plane, and the sharply angled wall of glass windows on the left side. Other similarities to Degas are visible only in the studies for *Office at Night*: the device of one picture within another and the slat-back wooden chair poised with its back to the viewer, placed in the lower left corner of the composition (Pls. 357, 358, 359). Hopper's figure of the contemplative man at the desk is somewhat reminiscent of Degas' portrayal of the old man Michel Musson, father-in-law

Fig. 58. Edgar Degas, *The Cotton Exchange, New Orleans*, 1873. Oil on canvas, 29⅛ × 36¼ inches. Musée des Beaux-Arts, Pau.

Edward Hopper, drawing for painting, *Office at Night*, 1940 (see Pl. 359).

of Degas' brother René, who sits examining a sample of cotton in the foreground of the painting. Both figures share a sense of concentration expressed by the eyes, cast downward. Hopper's withdrawn, meditative man is probably in part autobiographical, corresponding to his own quiet aloofness. Interestingly, this French Impressionist painting that so fascinated Hopper was an American scene—painted by Degas during a visit with his family in America.

Perhaps what is most intriguing in Hopper's *Office at Night* is the apparent psychic tension between the curvaceous woman and the man who ignores her. The earliest studies for this work do not reveal her now alluring figure. In the ledger where the Hoppers recorded this work, he captioned the sketch that designated the painting " 'Confidentially Yours,' 'Room 1005,' " and referred to the woman as "Shirley," noting that she wore a "blue dress, white collar, flesh stockings, black pumps and black hair and plenty of lipstick" (Fig. 3). At the end of this explanation, which is really only a visual description, Hopper cautioned, "Any more than this, the picture will have to tell, but I hope it will not tell any obvious anecdote, for none is intended." Nevertheless, the nighttime drama cannot be overlooked. The implied sexual and psychic tension is a source of intrigue for the viewer, who becomes a witness to the encounter.

Hopper's idea of casting the spectator as witness goes back at least to the art of the Netherlands with which he was certainly familiar, and it is an essential component of Rembrandt's *Nightwatch* which he admired.[44] When Hopper saw the *Nightwatch*, it had not yet undergone the restoration which revealed that it was not really a nocturnal scene. Hopper was undoubtedly attracted to the dramatic possibilities inherent in representing the contrast of light in a darkened setting. In his explanation of *Office at Night* he detailed his preoccupation with light:

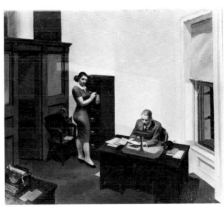

Edward Hopper, *Office at Night*, 1940 (see Pl. 356).

There are three sources of light in the picture—indirect lighting from above, the desk light and the light coming through the window. The light coming from outside and falling on the wall in back made a difficult problem, as it is almost painting white on white, it also made a strong accent of the edge of the filing cabinet which was difficult to subordinate to the figure of the girl.

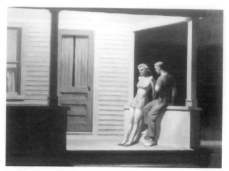

Edward Hopper, *Summer Evening*, 1947 (see Pl. 367).

The light that Hopper painted on the back wall emphasizes the wall's angular thrust, which creates a very oddly shaped room. Thus one writer has described the observer's sensation in this painting as "being suspended in air . . . unable to determine his own position." [45] Here Hopper goes beyond Degas: his canvas entices and holds the spectator in a tense, intimate, stagelike space by three walls, instead of the two walls in Degas' *The Cotton Exchange, New Orleans*. Once there, in the arena where the drama is taking place, the viewer confronts the players' psychic intensity—indeed, is engulfed by a powerful emotional dimension.

COUPLES

Hopper's interest in emotional interaction—or, more often, the lack of it—is evident from his many representations of couples. The theme appears in paintings as early as *Le Bistro* of 1909 and is developed in etchings such as *Night on the El Train* (1918) and *Les Deux Pigeons* (1920) (Pl. 122, Figs. 50, 4). In *Room in New York*, an oil painting of 1932, a man reads his newspaper, while the woman he is ignoring turns halfheartedly toward a piano and picks out a tune (Pl. 366). The viewer, looking in through the window, has been assigned the role of voyeur. In *Summer Evening* of 1947 a young couple, seen in the harsh glare of electric light, appear to be engrossed in a tense discussion while uncomfortably leaning against the wall of a porch (Pl. 367).

The sense of estrangement seems to heighten for Hopper over the years. His 1949 *Summer in the City* shows a woman, rather restless or depressed, with her arms tensely folded, sitting on the edge of a narrow bed, on which a man is asleep—oblivious to her discomfort (Pl. 368). In *Seawatchers* (1952) the couple in the sun gaze joylessly at a beautiful stretch of blue sea; their boredom and failure to communicate set the somber mood of this painting (Pl. 369). In *Sunlight on Brownstones* (1956) a younger couple not only glance away from each other, but do so with bored and disheartened stares (Pl. 370). Hopper's concern with this overriding and pervasive sense of malaise was perhaps summarized in his 1959 *Excursion into Philosophy* (Pl. 371). In this painting, a man with a troubled expression rests on the edge of an unforgivingly hard bed while a woman sleeps, turned away from him. He has just put down a book: "He has been reading Plato rather late in life," Hopper reportedly remarked.[46] When, late in life, Hopper was asked if he was a pessimist, he responded: "A pessimist? I guess so. I'm not proud of it. At my age don't you get to be?" [47]

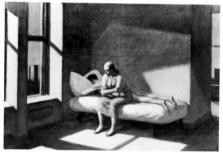

Edward Hopper, *Summer in the City*, 1949 (see Pl. 368).

MILITARY

A most unusual theme is Hopper's fascination with military history, especially that of the Civil War. The only history paintings he ever executed are

Dawn Before Gettysburg of 1934 and *Light Battery at Gettysburg* of 1940 (Pls. 373, 375). These are most unusual for a painter so involved with the present and his own surroundings. Yet Hopper's interest in military subjects began during his boyhood, when he did numerous sketches of soldiers. One example, made at the age of fourteen, both reveals his prodigious talent and helps to explain the two later canvases. He also depicted various soldiers during his career as an illustrator and in several of his prints.[48] Hopper treasured his ten-volume photographic history of the Civil War published in 1912, particularly for its Mathew Brady photographs which he admired: "There was something about the way he took pictures. Somebody said it was the lens they had in those days—not sharp. But anyway the pictures aren't cluttered up with detail; you just get what is important. Very simplified." [49] It is not surprising that Brady's photographs inspired *Dawn Before Gettysburg* and *Light Battery at Gettysburg*. Most of the soldiers in *Dawn Before Gettysburg* appear tired and bored as they wait, recalling the people who sit and wait in so many of Hopper's other paintings.

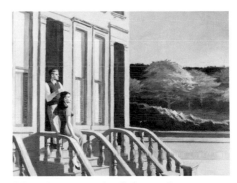

Edward Hopper, *Sunlight on Brownstones,* 1956 (see Pl. 370).

TIMES OF DAY

Many of Hopper's paintings also represent a specific time of day, emphasizing a mood through the varying effects of light. Frequently, he actually entitled works with an hour or time of day. Hopper seems to have had very definite associations with the various times of day he chose. One could say that, at least on a subconscious level, Hopper ascribed symbolic content to evening, night, morning, and midday—all of which he painted. This interpretation is further supported by his fondness for certain poems about times of the day. On several occasions, for example, Hopper quoted in French from Paul Verlaine's poem, "La lune blanche," on evening:

> Un vaste et tendre
> Apaisement
> Semble descendre
> Du firmament
> Que l'astre irise
> C'est l'heure exquise.[50]

Hopper also liked to quote from Goethe's "Wanderer's Nightsong," which he described as "an extraordinary visual picture":

> Over all the hills is quiet
> Over all the dells you can hardly hear a sound
> All the birds are quiet in the woods
> Soon you will rest too.[51]

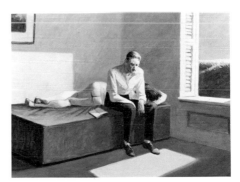

Edward Hopper, *Excursion into Philosophy,* 1959 (see Pl. 371).

Hopper particularly admired Robert Frost and cited more than once Frost's poem "Come In," which creates such an evocative picture of dusk.[52]

In his own depictions of evening, Hopper often conveyed something of a sense of mystery, of the enchantment which Verlaine, Goethe, and Frost associated with the twilight hour. This is especially evident in *Soir Bleu* of

about 1914, *Railroad Sunset* of 1929, *House at Dusk* and *Shakespeare at Dusk*, both of 1935, and *Cape Cod Evening* of 1939 (Pls. 378, 382, 384, 389, 418). In *Cape Cod Evening*, as in Robert Frost's poetry, the woods are "lovely, dark and deep" and enigmatic; the waning sunlight of evening contrasts sharply with the dense woods where, in the shadows, nightfall has already arrived.[53] Hopper's comment on the painting confirms that it was in fact a personal conceptualization which, like the poems he loved, evoked his own reflections on evening:

> It is no exact transcription of a place but pieced together from sketches and mental impressions of things in the vicinity. The grove of locust trees was done from sketches of trees nearby. The doorway of the house comes from Orleans about twenty miles from here. The figures were done almost entirely without models, and the dry, blowing grass can be seen from my studio window in late summer or autumn . . . The dog is listening to something, probably a whippoorwill or some evening sound.[54]

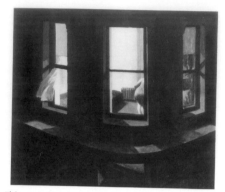

Edward Hopper, *Night Windows*, 1928 (see Pl. 381).

Hopper's original impetus toward suggestive content, at least regarding times of the day, may have begun under the impact of French Symbolist poetry which, as we have seen, he first came to know as a student in the Henri class.[55] Hopper's interest in Symbolist literature was shared by others in the Henri coterie, including John Sloan.[56] The Symbolists were still quite in fashion when Hopper first arrived in Paris in 1906. He probably read about them in contemporary magazines and he might have known *The Symbolist Movement in Literature* by Arthur Symons, the first book in English to analyze these writers, which was published in 1899 and appeared in its first revised edition in 1908.[57] As late as 1951, Hopper gave Jo a volume of poetry by Arthur Rimbaud for Christmas, complete with his own inscription to her in French.[58]

In a painting like *Soir Bleu*, Hopper recalled Symbolist poems in spirit if not with specific references. For example, one such poem, "Sensation" by Rimbaud, begins "Par les soirs bleus d'été . . ." ("In the blue summer evenings . . .") and Hopper's painting seems to embody its mood, even to the silent people staring with apparently blank minds: "Je ne parlerai pas, je ne penserai rien . . ." ("I will not speak, I will have no thoughts").[59] Likewise, it is comprehensible that the mysterious, intoxicating sky of *Railroad Sunset* was conceived by an artist who had savored poems like Charles Baudelaire's "Harmonie du Soir," which reads: "The sky, like an altar, is sad and magnificent; drowning in curdled blood, the sun sinks lower. . . ." [60]

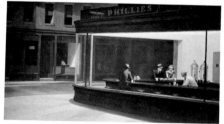

Edward Hopper, *Nighthawks*, 1942 (see Pl. 386).

Hopper was equally fascinated with the night, which he seems to have equated with both eros and anxiety in works ranging from his 1918 etching *Night on the El Train* to his later oil paintings—*Night Windows, Office at Night, Nighthawks* (Pls. 381, 356, 386, Fig. 50). The initial impulse for *Night Windows* as a subject was clearly the 1910 etching of the same title by John Sloan.[61] As in Sloan's etching, Hopper turns the viewer into a voyeur, but his composition is more subtle and more sensual. Hopper's focus is closer, more intimate. The nude female, seen from behind, is unaware of being watched. At the same time, a curtain blowing out of the

window hints at the restlessness one senses in his 1921 etching *Evening Wind* (Fig. 38) and entices the spectator-voyeur to come in. Hopper said: "*Nighthawks* seems to be the way I think of a night street. I didn't see it as particularly lonely. I simplified the scene a great deal and made the restaurant bigger. Unconsciously, probably, I was painting the loneliness of a large city." [62] The setting of *Nighthawks*, which was "suggested by a restaurant on Greenwich Avenue where two streets meet," [63] expresses the vulnerability of these people out alone in the disquieting night. The couple whose hands almost touch accentuate the isolation of the solitary diner across the counter: a juxtaposition of eros and the loneliness of night.

A sense of longing appears to be Hopper's major association with morning. This seems especially apparent in works like *Eleven A.M.* of 1926, where a nude woman sits in a chair looking out of the window, in *Morning in a City* of 1944, where a standing nude woman gazes out of a window, and in *Cape Cod Morning* of 1950, where a woman in a red dress leans out to observe the world from her bay window (Pls. 393, 394, 399). In *Five A.M.* of 1937 and *Seven A.M.* of 1948, however, Hopper depicted deserted scenes (Pls. 385, 388), which embodied his thoughts and feelings beyond observed reality.[64]

Seven A.M. presents a storefront where there is no early morning activity, juxtaposed with the menacing but beckoning woods beyond. Here, the woods may have suggested to Hopper an escape from the day's trials—his longed-for solitude. This feeling contrasts sharply with the positive sense of expectation in the full midday sunlight that illuminates *High Noon* of 1949 (Pl. 398).

Edward Hopper, *Seven A.M.*, 1948 (see Pl. 388).

CAPE COD

Hopper's many summers spent in South Truro on Cape Cod enabled him to acquire an intimate knowledge of the area. He painted both the simple buildings, the roads, and the natural forms of the landscape. Focusing on the effect of sunlight, he conveyed the drama of the forms he observed and saved them from banality. Among his initial Cape Cod subjects were *South Truro Church, Corn Hill, Hills, South Truro,* all of 1930, the first summer spent on the Cape (Pls. 404, 405, 407). For the first four summers, the Hoppers rented A. B. Cobb's house, which they called "Bird Cage Cottage" because rain, wind, and animals entered it with equal freedom. After an especially rainy summer in 1933 they built their own home with space enough to enable them to paint indoors.

Edward Hopper, Cape Cod, Massachusetts, c. 1933.

SUNLIGHT

On the Cape, Hopper indulged his love of sunlight in an area where the summer light is especially intense. Yet his interest in painting sunlight dates back to his acquaintance with Impressionist painting in Paris—to the 1907 *Trees in Sunlight, Parc du Saint Cloud* (Pl. 423). His mature attempts at painting sunlight resulted in *Rooms by the Sea* (1951) and *Sun in an Empty Room* (1963), two intense paintings (Pls. 424, 429). *Rooms by the Sea*

was actually inspired by the spectacular view from the Hoppers' house on the Cape down over the dunes to the vast stretch of sea beyond.

Hopper claimed his *Second Story Sunlight* of 1960 was only

> an attempt to paint sunlight as white with almost no yellow pigment in the white. Any psychological idea will have to be supplied by the viewer. . . . There is a sort of elation about sunlight on the upper part of a house. You know, there are many thoughts, many impulses that go into a picture.[65]

Although he occasionally denied the existence of meaning in his paintings, Hopper once sent Lloyd Goodrich a letter he received from the critic James Thomas Flexner praising *Second Story Sunlight* and interpreting it as an allegory of "winter and spring, life and death." [66] Hopper noted of the letter: ". . . I thought it would interest you. Since I took the trouble of having a photostat made of it, it may indicate that I am not as modest as I am said to be." [67]

While Hopper was in no sense a narrative painter and had long since transcended his own work in illustration, his canvases are much more than mere representations of reality—paintings which do not intend to be just descriptive or topical, but aspire to the universal. By refusing to be narrative and aiming only at suggestive symbolic content, Hopper at his best created paintings which express the psychological pulse of their time and yet speak for all time.

Edward Hopper, *Second Story Sunlight*, 1960 (see Pl. 425).

Edward Hopper at the Institute of Arts and Letters, 1961. Photograph by Sidney Waintrob, Budd Studio.

NOTES

THE IDENTITY OF THE ARTIST

1. Both quotes appear in Brian O'Doherty, "Portrait: Edward Hopper" *Art in America,* 52 (December 1964), pp. 42 and 69.
2. Brian O'Doherty, "The Hopper Bequest at the Whitney," *Art in America,* 59 (September–October 1971), pp. 68 69. Other recent estimates have concurred: John I. H. Baur (quoted in Grace Glueck, "Art Is Left by Hopper to the Whitney," *New York Times,* 19 March 1971) described Hopper as "the foremost realist in 20th-century art"; John Perreault ("Hopper: Relentless realism, American light," *Village Voice,* 23 September 1971) said: "Edward Hopper was and is one of our greatest American painters"; Hilton Kramer ("Art: Whitney Shows Items from Hopper Bequest," *New York Times,* 11 September 1971) declared that Hopper had a "firm position as the leading realist painter of his generation"; cf. also Barbara Rose, "Edward Hopper: Greatest American Realist of the 20th Century," *Vogue,* 1 September 1971, p. 282.
3. Carl Baldwin, "Realism: The American Mainstream," *Réalités,* April 1973, p. 117.
4. See Gail Levin, "Edward Hopper, Francophile," *Arts Magazine,* 53 (June 1979), pp. 114–21 and Gail Levin, *Edward Hopper: The Complete Prints* (New York: W. W. Norton & Company in association with the Whitney Museum of American Art, 1979), pp. 15–19 and 27–28.
5. Edward Hopper, "John Sloan and the Philadelphians," *The Arts,* 11 (April 1927), p. 174.
6. William Innes Homer with the assistance of Violet Organ, *Robert Henri and His Circle* (Ithaca: Cornell University Press, 1969), p. 131. Homer noted that it was probably Henri who was quoted in the *New York Sun,* 15 May 1907, as saying of The Eight that "all are men who stand for the American idea." For further details on the "Exhibition of Paintings by Arthur B. Davies, William J. Glackens, Robert Henri, Ernest Lawson, George Luks, Maurice Prendergast, Everett Shinn, John Sloan" from February 3–15, 1908 at the Macbeth Galleries, see Bennard B. Perlman, *The Immortal Eight* (Westport, Connecticut: North Light Publishers, 1979).
7. Homer, *Robert Henri,* pp. 136 and 139. Giles Edgerton [Mary Fanton Roberts], "The Younger American Painters: Are They Creating a National Art?" *Craftsman,* 13 (February 1908), pp. 523, 524, 531.
8. "One Step Nearer to a National Art," *New York American,* 10 March 1908. This review was evidently written by Guy Pène du Bois, the paper's critic, who omitted his own name from the list of artists. The exhibition was entitled "Exhibition of Paintings and Drawings by Contemporary Americans."
9. "Shows and Sales. Mr. Bellows Paints Cross-Eyed Boy," *New York Herald,* 13 February 1915.
10. "Strong Man at the MacDowell" and "Exhibit at Mac-Dowell Club," unidentified newspaper clippings saved by Hopper.

11. For Hartley's interest in European art, see Gail Levin, "Marsden Hartley, Kandinsky, and Der Blaue Reiter," *Arts Magazine,* 52 (November 1977), pp. 156–60 and Gail Levin, "Marsden Hartley and the European Avant-garde," *Arts Magazine,* 54 (September 1979), pp. 158–63. Critics in the Stieglitz circle who called for a more American art include Paul Rosenfeld and Waldo Frank. Rosenfeld, for example, in *Port of New York* (Urbana: University of Illinois Press, 1961), pp. 99–100, insisted "Hartley will have to go back to Maine . . . to this soil . . . his own people. . . ."

12. Marsden Hartley, "Red Man Ceremonials: An American Plea for American Esthetics," *Art and Archaeology,* 9 (January 1920), p. 14.

13. Hopper, "John Sloan," pp. 177–78.

14. "America Today," *Brooklyn Daily Eagle,* 7 March 1926, p. E7.

15. Lloyd Goodrich, "The Paintings of Edward Hopper," *The Arts,* 2 (March 1927), p. 136.

16. Peyton Boswell, Sr., in *The Americana Annual, 1932* (New York: Americana Corporation, 1932), p. 72; Thomas Craven, *Modern Art. The Men. The Movement. The Meaning* (New York: Simon and Schuster, 1934).

17. Guy Pène du Bois, "The American Paintings of Edward Hopper," *Creative Art,* 8 (March 1931) p. 187.

18. Ibid., p. 191

19. Mary Morsell, "Hopper Exhibition Clarifies a Phase of American Art," *The Art News,* 32 (4 November 1933), p. 12.

20. *Exhibition of Paintings Drawings and Etchings,* Whitney Studio Club, 147 West Fourth Street, January 14–28, 1920. Hopper exhibited sixteen paintings of which eleven were scenes of Paris.

21. Helen Appleton Read, "Racial Quality of Hopper Pictures at Modern Museum Agrees With Nationalistic Mood," *Brooklyn Daily Eagle,* 5 November 1933, p. 12B-C.

22. "Trial by Jury," *The Bulletin Index,* 28 September 1939.

23. Edward Alden Jewell, "Early Art Shown of Edward Hopper," *New York Sun,* 11 January 1941.

24. Quoted in O'Doherty, "Portrait: Edward Hopper," p. 72.

25. This and the following quote are from William Johnson's unpublished account of his interview with Edward Hopper, 30 October 1956. Hopper recounted that his grandfather had been killed in a "runaway" accident when Garrett Hopper was a small boy, forcing him to go to work at an early age to help support his mother. Hopper said of his father: "He never should have been a merchant."

26. Quoted in O'Doherty, "Portrait: Edward Hopper," p. 72.

27. Edward Hopper to Charles H. Sawyer, letter of 29 October 1939. Quoted in Lloyd Goodrich, *Edward Hopper* (New York: Harry N. Abrams, 1971), p. 164. Hopper also indicated his awareness of modern psychology in a remark he made about the short stories of Thomas Mann: "Rough going. Well depressing. Freudian. A great writer of fiction" (O'Doherty, "Portrait: Edward Hopper," p. 73).

28. Ibid., p. 79.

29. Ibid., p. 72.

30. Edward Hopper, "Notes on Painting," in Alfred H. Barr, Jr., *Edward Hopper: Retrospective Exhibition* (New York: The Museum of Modern Art, 1933), p. 17.

31. Quoted in Goodrich, *Edward Hopper,* p. 152.

32. Edward Hopper, "Statements by Four Artists," *Reality,* 1 (Spring 1953), p. 8.

33. Quoted in O'Doherty, "Portrait: Edward Hopper," p. 72.

34. Several critics originally saw humor in Hopper's 1926 painting *Sunday*: "Edward Hopper's 'Sunday' shows the artist at home in a medium less frequently essayed by him. . . . Out of such commonplaceness has Hopper created beauty as well as injected humor and an astute characterization of place and type" ("America Today," *Brooklyn Daily Eagle*); "Into the conventional ugly setting, Mr. Hopper manages to insert a sardonic humor without the slightest vestige of caricature that gives to his pictures a peculiarly individual appeal" ("A Limited Group of Americans of To-day," unidentified clipping of 28 February 1926).

35. Author's interview with Florence Blauvelt, childhood acquaintance of Edward Hopper, 7 May 1979.

36. Rockwell Kent, *It's Me O Lord: The Autobiography of Rockwell Kent* (New York: Dodd, Mead & Co., 1955), p. 131.

37. Walter Tittle, "The Pursuit of Happiness" (unpublished autobiography, written before 1949), Wittenberg University Library, Springfield, Ohio.

38. Edward Hopper to Marion Hopper, 24 August 1956. The story was "The Silent Witness," *Time,* 68 (24 December 1956), cover, pp. 28, 37–39. Hopper was dismayed by the content, which he felt portrayed him inaccurately as a folksy, unsophisticated man who cracked his knuckles.

39. Quoted in Katharine Kuh, *The Artist's Voice. Talks with Seventeen Artists* (New York: Harper & Row, 1962), p. 131.

DEVELOPMENT

1. "Edward Hopper Objects" (letter from Hopper to the editor, Nathaniel Pousette-Dart), *The Art of Today,* 6 (February 1935), p. 11.

2. Author's interview with Berta Ward, childhood friend of Hopper's sister Marion.

3. Hopper owned, for example, Edmund Ollier's *Masterpieces from the Works of Gustave Doré* (New York: Cassell Publishing Co., 1887).

4. Goodrich, *Edward Hopper,* p. 17. Of his sailboat, he remarked: "It wasn't very good. I had put the centreboard well too far aft and she wouldn't sail upwind very well" (William Johnson interview with Hopper, p. 4).

5. Bennard Perlman, unpublished interview with Edward Hopper, 3 June 1962.

6. Lolan C. Read, Jr., "The New York School of Art," *The Sketch Book,* 3 (April 1904), p. 219.

7. Ibid., p. 220.

8. Quoted in "From a Talk by William M. Chase with Benjamin Northrop of the *Mail and Express,*" *Art Amateur,* February 1894, p. 77.

9. Frances Lauderbach, "Notes from talks by William M. Chase," *The American Magazine of Art,* September 1917, p. 434.

10. For information on Chase's teaching and taste, see Ronald G. Pisano, *William Merritt Chase. In the Company of Friends* (Southampton, New York: The Parrish Art Museum, 1979), p. 13. Chase, who himself owned a painting by Manet, had, as early as 1881, recommended that the American collector Erwin Davis acquire Manet's *Boy With a Sword* and *Woman With a Parrot;* Davis subsequently donated these to the Metropolitan Museum of Art, making it the first museum in America to own Manet's work.

11. It would have been wasteful to paint an illustration in color if it was to be reproduced in black and white. He chose *Don Quixote* as a theme for one such grisaille (Pl. 74). He was particularly fond of Cervantes' tale, for he made several early sketches of Don Quixote and Sancho Panza and produced a finished illustration complete with caption. Years later, after he took up printmaking, he executed an etching of the subject.

12. Hopper, "John Sloan," pp. 174–75.

13. Ibid., p. 176; Edward Hopper, transcript of taped interview with Arlene Jacobwitz at the Brooklyn Museum, 29 April 1966.

14. Kent, *Autobiography,* p. 84.

15. Ibid., p. 81.

16. Hopper, "Notes on Painting," p. 17.

17. Robert Henri, "A Practical Talk to Those Who Study Art," *The Philadelphia Press,* 12 May 1901, reprinted in Robert Henri, *The Art Spirit,* ed. Margery Ryerson (Philadelphia: J. B. Lippincott Co., 1923), pp. 73–82, as "An Address to the Students of the School of Design for Women, Philadelphia."

18. Ibid., pp. 274–75.

19. Kent, *Autobiography,* p. 91.

20. Guy Pène du Bois, *Artists Say the Silliest Things* (New York: American Artist Group, Inc., and Duell, Sloan, and Pearce, Inc., 1940), p. 88.

21. Hopper, "John Sloan," p. 178.

22. Kent, *Autobiography,* p. 83.

23. Hopper taught the Saturday classes along with Douglas John Connah, the head of the entire school, and W. T. Benda.

24. *The Sketch Book,* 3 (April 1904), p. 233. The faculty representative for the magazine was Susan F. Bissell.

25. Quoted in O'Doherty, "Portrait: Edward Hopper," p. 73.

26. Edward Hopper to his mother, unpublished letter of 30 October 1906.

27. Ibid.

28. Edward Hopper to his mother, unpublished letter of 23 November 1906.

29. Edward Hopper to his mother, unpublished letter of 30 October 1906.

30. Edward Hopper to his sister, unpublished letter of 29 November 1906.

31. Edward Hopper to his mother, unpublished letter of 8 December 1906.

32. Edward Hopper to his mother, unpublished letter of 26 May 1907.

33. Barr, *Edward Hopper: Retrospective Exhibition,* p. 10.

34. O'Doherty, "Portrait: Edward Hopper," p. 73.

35. William Johnson interview with Hopper, p. 7.

36. Edward Hopper to his mother, unpublished letters of 8 December 1906 and 6 January 1907.

37. Edward Hopper to his mother, unpublished letter of 8 December 1906.

38. Edward Hopper to his mother, unpublished letter of 26 May 1907.

39. Many artists before Hopper had painted at Saint-Cloud. During the previous autumn, the Russian painter Wassily Kandinsky, then also living in Paris, painted *Im Park von Saint Cloud* (1906; Städtische Galerie im Lenbachhaus, Munich), focusing his attention on the thick growths of trees there and their autumn colors.

40. Edward Hopper to his mother, unpublished letter of 4 July 1907.

41. Edward Hopper to his mother, unpublished letter of 18 July 1907.

42. Edward Hopper to his mother, unpublished letter of 27 July 1907.

43. See the preceding chapter, "The Identity of the Artist," note 8.

44. George Bellows, however, was singled out for praise when a writer for the *Evening Mail* dubbed his painting *Jimmy Flannigan* the "pearl of the gutter"; quoted in Charles H. Morgan, *George Bellows: Painter of America* (New York: Reynal and Company, 1965), p. 82.

45. Edward Hopper to his mother, unpublished letters of 29 May 1909, and 7 June 1909. Edward Hopper to his father, unpublished letter of 18 June 1909.

46. Edward Hopper to his mother, unpublished letter of 18 May 1909. The "fellows" might have been Patrick Henry Bruce, Walter Pach, or other classmates from the New York School of Art.

47. Edward Hopper to his sister, unpublished letter of 9 June 1910.

48. Du Bois, "The American Paintings of Edward Hopper," p. 191.

49. Of the three issues, one was devoted to the cartoons of Albert Guillaume, and two to the satirical illustrations of Jean-Louis Forain: *Les Maîtres Humoristes, A. Guillaume* (Paris: Société d'Edition et de Publications, October, 1908); ibid., *Jean-Louis Forain,* January and November 1908).

50. Quoted in O'Doherty, "Portrait: Edward Hopper," p. 73.

51. Quoted in Kuh, *The Artist's Voice,* p. 135.

52. "Around the Galleries," *New York Sun,* 7 April 1910; "Panic Averted in Art Show Crowd," *New York Mail & Express,* 2 April 1910. Julius Golz (1878–19??) is an example of one of Hopper's classmates who, initially more successful than Hopper, faded into obscurity. In 1909 Golz taught a summer art class with Rockwell Kent on Monhegan Island.

53. "Paintings in Oil and Pastel by James A. McNeill Whist-

ler," The Metropolitan Museum of Art, New York, March 15–May 31, 1910. For a discussion of Tonalism, "a style of intimacy and expressiveness, interpreting very specific themes in limited color scales and employing delicate effects of light to create vague, suggestive moods," see Wanda M. Corn, *The Color of Mood. American Tonalism 1890–1910* (San Francisco: M. H. De Young Memorial Museum and the California Palace of the Legion of Honor, 1972), p. 4 and cf. pp. 9–11.

54. Milton W. Brown, *The Story of the Armory Show* (New York: The Joseph H. Hirshhorn Foundation, 1963), p. 65.

55. Hopper had actually listed the price as $300, but agreed to accept Thomas F. Victor's offer of $250 as he was very eager to sell his painting. A letter of 24 March 1913, from Hopper to Walt Kuhn, one of the exhibition's organizers, documents this decision. (The letter is preserved in the Elmer L. MacRae Papers, Hirshhorn Museum and Sculpture Garden, Washington, D. C.)

56. Quoted in Suzanne Burrey, "Edward Hopper: The Emptying Spaces," *Arts Digest,* 1 April 1955, pp. 9 and 33.

57. Tittle, "The Pursuit of Happiness," chap. 22, p. 2. The existence of French themes executed on American illustration board probably indicates the accuracy of Tittle's account.

58. "Strong Man at the MacDowell" and "Exhibit at MacDowell Club," unidentified newspaper clippings saved by Hopper. See p. 5 for other reviews of this exhibition.

59. Edward Hopper to his mother, unpublished letter of 11 May 1907.

60. Elizabeth Cornell Benton, sister of the artist Joseph Cornell, was in Hopper's class along with her cousin Janet Voorhis. Letter from Mrs. Benton to the author, 29 April 1979; related information also provided by Linda Roscoe Hartigan, National Collection of Fine Arts, letter to the author, 24 April 1979.

61. "Walkowitz and Hopper," *Arts and Decoration,* 6 (February 1916), pp. 190–91.

62. Kent, *Autobiography,* p. 116. It was Henri who had recommended Monhegan to Kent.

63. Ibid., p. 120.

64. Edward Hopper, quoted in "Maker of Poster *Smash the Hun* is Visitor here," unidentified clipping from [Rockland?] Maine newspaper, summer 1918.

65. Barr, *Edward Hopper: Retrospective Exhibition,* p. 11.

66. Edward Hopper, quoted in "True American Art Sought in Posters," *New York Sun,* undated clipping of 1918 (before July 25). For additional discussion of this poster, see Gail Levin, *Edward Hopper as Illustrator* (New York: W. W. Norton & Company in association with the Whitney Museum of American Art, 1979), pp. 24–25.

67. Ibid. "The modern French poster stands at almost opposite poles with the German. It has more of real character, a quality that can in nowise be faked by a calculating use of design and color, but must be felt. It has the surprise that comes through an ever fresh sight of the object to be drawn, be it soldier, rifle or a line of barbed wire defense.

While it has not perhaps the carrying power of the German work it has more intimacy of drawing. The war posters of the French have been unequalled in fire and vivacity."

68. Edward Hopper, quoted in Pete Shea, "Poster Model, Joins Navy," *New York Sun,* undated clipping of 1918: "In my poster I tried to show the real menace to this country, as symbolized by the bloody German bayonets. The resistance of the worker to that menace is evident, I think, in his pose and the design. The way the worker's feet are spread out has a meaning to me of a certain solidity and force. They are set there for all time against this threatened invasion. The work to which the special appeal is directed is typified by a silhouette of a shipyard, smokestack and smoke."

69. Barr, *Edward Hopper: Retrospective Exhibition,* p. 11. Gertrude Vanderbilt Whitney had originally held informal exhibitions of works by fellow artists in her studio in MacDougal Alley from 1907 on. She began the Whitney Studio at 9 West Eighth Street in 1914.

70. Guy Pène du Bois in *Juliana Force and American Art: A Memorial Exhibition* (New York: Whitney Museum of American Art, 1949), p. 44.

71. "Random Impressions in Current Exhibitions," *New York Tribune,* 25 January 1920, p. 5.

72. "Exhibitions for the Holidays," *New York Times Magazine,* 4 December 1921, p. 5.

73. See Levin, *Edward Hopper: The Complete Prints,* pp. 25–36.

74. For example, in "The Hundred Dollar Holiday Exhibition" at the New Gallery, 600 Madison Avenue, December 12, 1922–January 2, 1923. The catalogue for this exhibition stated: "The watercolors of Nivison add a gay note of color."

75. O'Doherty, "Portrait: Edward Hopper," p. 80.

76. Josephine Verstille Nivison Hopper, interviewed with Edward Hopper by Arlene Jacobwitz at the Brooklyn Museum, 29 April 1966, transcript of tape. To Jo's annoyance, Hopper did not recall the circumstances of his entry in the exhibition at the time this interview took place.

77. Ibid.

78. Ibid.

79. Royal Cortissoz, "A Fine Collection at The Brooklyn Museum," *New York Tribune,* 25 November 1923, p. 8.

80. Helen Appleton Read, "Brooklyn Museum Emphasizes New Talent in Initial Exhibition," *Brooklyn Daily Eagle,* 18 November 1923, p. 2B.

81. Henry McBride, "Edward Hopper's Water Colors Prove Interesting—Also Sell," *The Sun,* 25 October 1924, p. 4; "Art: Exhibition of Water-colors," *New York Times,* 19 October 1924, section 10, p. 13.

82. Edward Hopper in conversation with Lloyd Goodrich, 21 April 1947, as recorded in Goodrich's notes.

83. Edward Hopper in conversation with Lloyd Goodrich, spring 1964, as recorded in Goodrich's notes.

84. Jo gave him Paul Jamot's *Degas* (Paris: Editions de la

Gazette des Beaux-Arts, 1924), a beautiful book filled with illustrations. Cf. also the following chapter, "Themes," note 28.

THEMES

1. Edward Hopper to Lloyd Goodrich, unpublished letter of 4 September 1944.

2. Edward Hopper to Samuel Golden, unpublished letter of 2 November 1945, referring to the use of this painting as the frontispiece of the monograph *Edward Hopper* (New York: American Artists Group, Inc., 1945).

3. William Johnson interview with Hopper, p. 17.

4. Quoted in Archer Winsten, "Wake of the News: Washington Square North Boasts Strangers Worth Talking To," *New York Post*, 26 November 1935.

5. "Pretty Penny," located just up the road from his boyhood home in Nyack, was owned by Helen Hayes and her husband Charles MacArthur.

6. Lloyd Goodrich noted that *High Noon* of 1949 "is almost pure geometry." When he told Hopper that he had shown *High Noon* together with a painting by Piet Mondrian in a lecture, Hopper's only comment was "You kill me." Goodrich, *Edward Hopper*, p. 149.

7. Edward Hopper to Guy Pène du Bois, unpublished letter of 2 August 1953.

8. "Edward Hopper Objects," Edward Hopper to the editor, Nathaniel Pousette-Dart, published in *The Art of Today*, 6 (February 1935), p. 11.

9. Edward Hopper to Charles H. Sawyer, 29 October 1939, quoted in full in Goodrich, *Edward Hopper*, pp. 163–64. Sawyer was then Director of the Addison Gallery of American Art, Andover, Massachusetts, which organized an exhibition entitled "The Plan of A Painting: An Interpretive Study of Manhattan Bridge Loop by Edward Hopper," January 13–March 10, 1940.

10. Ibid.

11. Kuh, *The Artist's Voice*, p. 131. Hopper also remarked: "These houses are gone now."

12. Ibid., p. 134.

13. See Levin, *Edward Hopper as Illustrator*, pp. 40–42 and Levin, *Edward Hopper: The Complete Prints*, pp. 22–23 and Pls. 49, 74, 62, 87, 100, 103.

14. Quoted in Goodrich, *Edward Hopper*, p. 106.

15. Hopper always preferred trains to airplanes because, he admitted, "I'm afraid to die"; typescript of television interview with Edward and Jo Hopper by Brian O'Doherty, Boston, 1961.

16. Quoted in William C. Seitz, *Edward Hopper in São Paulo 9* (Washington, D.C.: Smithsonian Press, 1969), p. 22.

17. Edward Hopper to his mother, unpublished letter of 27 July 1925, from Santa Fe, New Mexico.

18. Edward Hopper to Guy Pène du Bois, unpublished letter of 2 August 1953.

19. See Levin, *Edward Hopper as Illustrator*, Pls. 14, 336, 355, 350, 358, 453, as examples of restaurant illustrations and

Levin, *Edward Hopper: The Complete Prints*, Pl. 48, for an etching of another café scene.

20. Edward Hopper to Maynard Walker, unpublished letter of 9 January 1937.

21. Henri, *The Art Spirit*, p. 143.

22. See Levin, *Edward Hopper as Illustrator*, Pl. 504. This concern appears in the work of Ibsen in his last six plays: *The Lady from the Sea, Hedda Gabler, The Master Builder, Little Eyolf, John Gabriel Borkman,* and *When We Dead Awaken.* Hopper attended a performance of *The Master Builder* in New York on December 15, 1925; the ticket stub was among those saved by him.

23. Hopper, "Notes on Painting," p. 18.

24. Edward Hopper to his mother, unpublished letters of 17 April 1907 and 6 January 1907. In this latter letter, Hopper wrote that the Opéra and the Théâtre Odéon were both "supported by the government as is also the Theatre Français."

25. Josephine Nivison had acted in New York with the Washington Square Players.

26. See Levin, *Edward Hopper as Illustrator*, Pls. 341, 350, 99a, 316, 485, 504.

27. David W. Scott, *John Sloan 1871–1951: His Life and Paintings* (Washington, D.C.: National Gallery of Art, 1971), p. 117, Pl. 73. Plate 57, p. 102, reproduces Sloan's *Movies, Five Cents.*

28. Hopper probably saw Degas' *Interior* at the Metropolitan Museum, where it was on extended loan from the Whittemore collection from 1921 to 1935. This painting is reproduced in Jamot, *Degas*, inscribed "for Edward Hopper from Jo" and given to Hopper in 1924, the year of their marriage. The Hoppers also owned the catalogue of a Degas exhibition at the Durand-Ruel Galleries in New York in 1928.

29. Jo Hopper to Margaret McKellar, unpublished letter of 14 November 1965.

30. Goodrich, *Edward Hopper*, p. 154.

31. For Hopper's anxiety about his progressive baldness, see the unpublished letter of 27 April 1907 to his mother. Hopper, who was already balding at the time he was in Paris, was so self-conscious during these years that he always wore a hat when photographed. From Paris he wrote to his mother to report that his hair had "ceased to fall out in such large quantities."

32. Few critics have commented in any depth on the relationship of Hopper's art to theater. By far the most incisive is Bryan Robertson, "Hopper's Theater," *New York Review of Books*, 17 (16 December 1971), in a review of Goodrich, *Edward Hopper*. Robertson touched briefly but brilliantly on a number of crucial points, but did not explore them fully.

33. Jo Hopper to Marion Hopper, unpublished letter of 5 July 1936.

34. Norma Springford, Professor of Theatre Arts at Concordia University, Montreal, suggested this influence to Noreen Corrigan, who sent me her insightful paper on Edward Hopper. Springford made the remarkable deduction with-

out the knowledge that Hopper attended *Street Scene* or of Jo's letter to Marion about the set.

35. O'Doherty, "Portrait: Edward Hopper," p. 78.

36. Ibid., p. 80.

37. Richard Lahey Papers, "Artists I Have Known," Archives of American Art, roll 378, frames 919–1053. Lahey (1927–61), a painter and friend of Hopper's, reported this conversation in his memoirs as having taken place in front of the original Whitney Museum on Eighth Street.

38. O'Doherty, "Portrait: Edward Hopper," p. 76. *The Savage Eye* (1960) was directed by Ben Maddow, Sidney Meyers, and Joseph Strick.

39. O'Doherty, televised interview (see above, note 15).

40. For example, Hopper's *Office in a Small City* of 1953 recalled the opening scene from *Dodsworth,* a film by William Wyler of 1936. The film *Days of Heaven* (1978) recalled Hopper's *House by the Railroad* in its opening setting; the house in Alfred Hitchcock's *Psycho* (1960) also resembled the one in this painting.

41. Edward Hopper, "Office at Night," explanatory statement accompanying letter of 25 August 1948, to Norman A. Geske, Walker Art Center, Minneapolis, Minnesota. For a fuller discussion of this painting, see Gail Levin, "Edward Hopper's 'Office at Night,' " *Arts Magazine,* 52 (January 1978), pp. 134–37. The quotations by Hopper about this painting cited subsequently are also from the explanation sent to Geske.

42. Kuh, *The Artist's Voice,* p. 135, quotes Hopper as listing artists that he admired: "Rembrandt above all, and the etcher Meryon . . . I also like Degas very much." In Rodman, *Conversations with Artists,* p. 199, Hopper had listed Rembrandt, Goya, Degas, Eakins, and Meryon as his favorite artists.

43. It was reproduced in Jamot, *Degas,* owned by Hopper, who also might have seen the painting in Philadelphia in the Degas exhibition of 1936 at the Pennsylvania [Philadelphia] Museum of Art.

44. Hopper, "John Sloan," p. 173. In this article Hopper mentioned "the honest simplicity of early Dutch and Flemish masters. . . ." A well-known example where the spectator becomes witness is Jan van Eyck's *Giovanni Arnolfini and his Bride* of 1434 in the National Gallery, London, which Hopper would have seen on his visit there during early July 1907. For his reaction to Rembrandt's *Nightwatch,* see p. 25, above.

45. Jean Gillies, "The Timeless Space of Edward Hopper," *The Art Journal,* 31 (Summer 1972), p. 409.

46. Author's interview with John Clancy, Hopper's longtime dealer in the Frank K. M. Rehn Gallery. This comment was also recorded by Jo in the ledger entry for this painting.

47. O'Doherty, "Portrait: Edward Hopper," pp. 72–73.

48. See Levin, *Edward Hopper as Illustrator,* Pls. 10, 11a, 12a, 16, 235a, 237, 287, 445, 446, 37, 308, 309a, 309b, 310a, 310b, 312, and Levin, *Edward Hopper: The Complete Prints,* Pls. 28, 34, and 46.

49. William Johnson interview with Hopper, p. 24.

50. "Now a tender and vast appeasement seems to descend from the firmament with the irised star . . . Ah, exquisite hour"; *Paul Verlaine, Selected Poems,* translated by C. F. MacIntyre (Berkeley: University of California Press, 1948), p. 95. Hopper quoted this poem in French in his Christmas card of 1923 for Jo (Pl. 35); and to O'Doherty, "Portrait: Edward Hopper," p. 80; and again in an unpublished letter of 7 August 1955 to Donald Adams, editor of the *New York Times Book Review.*

51. O'Doherty, "Portrait: Edward Hopper," p. 80. Hopper quoted these lines in both German and English.

52. Ibid., p. 80, and Hopper to Adams, letter of 7 August 1955.

53. "The woods are lovely, dark and deep/But I have promises to keep. . . ." Earlier this poem described "the darkest evening of the year"; Robert Frost, "Stopping by Woods on a Snowy Evening," from *New Hampshire: A Poem with Notes and Grace Notes* (New York: Holt, 1923).

54. As quoted in Goodrich, *Edward Hopper,* p. 129.

55. See the preceding chapter, "Development," p. 20. Earlier Whistler had been fascinated with the depiction of crepuscular scenes and had been influenced by French Symbolist poetry. Hopper would have known some of Whistler's *Nocturnes.* Henri had also admired Whistler.

56. John Sloan's interest in Symbolist poetry is documented by his copy of *Poems of Paul Verlaine,* translated by G. Hall, illustrated by Henry McCarter (Chicago: Stone & Kimball, 1895), preserved in the John Sloan Memorial Library, Delaware Art Museum, Wilmington.

57. Arthur Symons, *The Symbolist Movement in Literature* (New York: E. P. Dutton and Co., Inc., revised edition, 1919). Some of the early articles on Symbolists in periodicals of the time were H. T. Peck, "Stéphane Mallarmé," *The Bookman,* November 1898, and "Baudelaire Legend," *Scribner's,* 45 (February 1909).

58. The volume was Arthur Rimbaud, *Poésies* (Paris: Mercure de France, 1950). He inscribed it: "à la petite chatte qui découvre ses griffes presque tous les jours. Joyeux Noel, 1951." They also owned a typescript of "Extraits de Morceaux Choisis, Autres Fragments sur Mallarmé," by Paul Valéry.

59. Arthur Rimbaud, *Complete Works, Selected Letters,* translated by Wallace Fowlie (Chicago: University of Chicago Press, 1966), pp. 16–17.

60. Quoted in C. F. MacIntyre, *French Symbolist Poetry* (Berkeley: University of California Press, 1961), pp. 14–15.

61. Hopper was inspired by Sloan's subjects more than by his style. Compare, for example, Hopper's restaurant, theater, and movie scenes to Sloan's earlier ones, and to Sloan's etching *Barber Shop* of 1915, which preceded Hopper's oil painting *Barber Shop* of 1931.

62. Quoted in Kuh, *The Artist's Voice,* p. 134.

63. Ibid.

64. Hopper wrote of *Five A.M.*: "The idea of this picture had been in mind a long time before I started to paint it, and I think was suggested by some things that I had seen while travelling on the Boston, New York boats on Long

Island Sound. The original impression grew into an attempted synthesis of an entrance to a harbour on the New England coast"; Edward Hopper to Mrs. Elizabeth Navas, unpublished letter of 12 July 1939, Archives of American Art, roll D251, frames 1033–34.

65. Quoted in Kuh, *The Artist's Voice,* pp. 135 and 140.

66. James Thomas Flexner to Edward Hopper, unpublished letter of 13 May 1961. Flexner also wrote: "I felt both in the formal and emotional tensions of your painting a pull between restraint and the opulence of nature. Restraint represented by the peaked architecture and the old lady for whom all passion is spent; opulence, by the line of trees, the sky, and the marvelously buxom young lady sitting on the edge of the porch, not waiting for anything in particular, yet fertile and sure in the movement of the seasons to be fulfilled."

67. Edward Hopper to Lloyd Goodrich, unpublished letter of 18 May 1961.

SELECTED BIBLIOGRAPHY

Baigell, Matthew. "The Silent Witness of Edward Hopper." *Arts Magazine*, 49 (September 1974), pp. 29–33.

Baldwin, Carl. "Realism: The American Mainstream," *Réalités*, November 1973, pp. 42–51.

Barker, Virgil. "The Etchings of Edward Hopper." *The Arts*, 5 (June 1924), pp. 323–25.

Barr, Alfred H., Jr. *Edward Hopper: Retrospective Exhibition*. New York: The Museum of Modern Art, 1933.

Bernard, Sidney. "Edward Hopper, Poet-Painter of Loneliness." *Literary Times*, April 1965, p. 11.

Brace, Ernest. "Edward Hopper." *Magazine of Art*, 30 (May 1937), pp. 274–78.

Brown, Milton W. "The Early Realism of Hopper and Burchfield." *College Art Journal*, 7 (Autumn 1947), pp. 3–11.

———. *American Painting from the Armory Show to the Depression*. Princeton, New Jersey: Princeton University Press, 1955.

———. *The Story of the Armory Show*. New York: The Joseph H. Hirshhorn Foundation, 1963.

Burchfield, Charles. "Hopper: Career of Silent Poetry." *Art News*, 49 (March 1950), pp. 14–17.

Burrey, Suzanne. "Edward Hopper: The Emptying Spaces." *Arts Digest*, 1 April 1955, pp. 8–10+.

Campbell, Lawrence. "Hopper: Painter of 'thou shalt not!'" *Art News*, 63 (October 1964), pp. 42–45.

Cortissoz, Royal. "A Fine Collection at The Brooklyn Museum." *New York Tribune*, 25 November 1923, section 6, p. 8.

Crowninshield, Frank. "A Series of American Artists, No. 3—Edward Hopper." *Vanity Fair*, 38 (June 1932), pp. 30–31.

du Bois, Guy Pène. "Edward Hopper, Draughtsman." *Shadowland*, 7 (October 1922), pp. 22–23.

———. "The American Paintings of Edward Hopper." *Creative Art*, 8 (March 1931), pp. 187–91.

———. *Artists Say the Silliest Things*. New York: American Artists Group, Inc., and Duell, Sloan, and Pearce, Inc., 1940.

Eliot, Alexander. *Three Hundred Years of American Painting*. New York: Time, Inc., 1957.

Getlein, Frank. "The legacy of Edward Hopper: painter of light and loneliness." *Smithsonian*, 2 (September 1971), pp. 60–67.

Gillies, Jean. "The Timeless Space of Edward Hopper." *Art Journal*, 32 (Summer 1972), pp. 404–12.

Glueck, Grace. "Art Is Left by Hopper to the Whitney." *New York Times*, 19 March 1971, pp. 1 and 28.

Goodrich, Lloyd. "The Paintings of Edward Hopper." *The Arts*, 2 (March 1927), pp. 134–38.

———. *Edward Hopper*. Harmondsworth, England: Penguin Books, 1949.

———. *Edward Hopper Retrospective Exhibition*. New York: Whitney Museum of American Art, 1950.

———. *Edward Hopper. Exhibition and Catalogue*. New York: Whitney Museum of American Art, 1964.

———. "Portrait of the Artist." *Woman's Day*, February 1965, pp. 37+.

———. *Edward Hopper*. New York: Harry N. Abrams, 1971.

———. *Edward Hopper: Selections from the Hopper Bequest to the Whitney Museum of American Art*. New York: Whitney Museum of American Art, 1971.

Heller, N. and Williams, J. "Edward Hopper: Alone in America." *American Artist*, 40 (January 1976), pp. 70–75.

Hopper, Edward. "Books" (review of Malcolm C. Salaman, *Fine Prints of the Year, 1925*). *The Arts*, 9 (March 1926), pp. 172–74.

———. "John Sloan and the Philadelphians." *The Arts*, 11 (April 1927), pp. 168–78.

———. "Books" (review of Vernon Blake, *The Art and Craft of Drawing*). *The Arts*, 11 (June 1927), pp. 333–34.

———. "Charles Burchfield: American." *The Arts*, 14 (July 1928), pp. 5–12.

———. "Edward Hopper Objects" (letter to Nathaniel Pousette-Dart). *The Art of Today*, 6 (February 1935), p. 11.

———. "Statements by Four Artists." *Reality*, 1 (Spring 1953), p. 8.

———. Collected correspondence. Whitney Museum of American Art, New York.

Jewell, Edward Alden. "This American Painter's Work Admirably Presented at Museum of Modern Art." *New York Times*, 5 November 1933, p. 12.

———. "Early Art Shown of Edward Hopper," *New York Sun*, 11 January 1941.

Kent, Rockwell. *It's Me O Lord: The Autobiography of Rockwell Kent*. New York: Dodd, Mead & Co., 1955.

Kingsley, April. "Edward Hopper." *The Provincetown Advocate Weekly Summer Guide*, 25 July 1974, pp. 12–13.

Kramer, Hilton. "Art: Whitney Shows Items from Hopper Bequest." *New York Times*, 11 September 1971, p. 23.

Kuh, Katharine. *The Artist's Voice. Talks with Seventeen Artists*. New York: Harper & Row, 1962.

Lanes, Jerrold. "Edward Hopper: French Formalist, Ash Can Realist, Neither or Both." *Artforum*, 7 (October 1968), pp. 44–50.

Levin, Gail. *Edward Hopper at Kennedy Galleries*. New York: Kennedy Galleries, Inc., 1977.

———. "Edward Hopper's 'Office at Night.'" *Arts Magazine*, 52 (January 1978), pp. 134–37.

———. "Edward Hopper, Francophile," *Arts Magazine*, 53 (June 1979), pp. 114–21.

———. *Edward Hopper as Illustrator*. New York: W. W. Norton & Company in association with the Whitney Museum of American Art, 1979.

———. "Edward Hopper as Printmaker and Illustrator: Some Correspondences." *The Print Collector's Newsletter*, 10 (September–October 1979), pp. 121–23.

———. *Edward Hopper: The Complete Prints*. New York: W. W. Norton & Company in association with the Whitney Museum of American Art, 1979.

———. "Some of the finest examples of American printmaking." *Art News*, 78 (September 1979), pp. 90–93.

McBride, Henry. "Hopper's Watercolors." *The Dial*, May 1924, pp. 201–3.

———. "Edward Hopper's Water Colors Prove Interesting—Also Sell." *The Sun*, 25 October 1924, p. 4.

Mellow, James R. "Painter of the City." *Dialogue*, 4, no. 4 (1971), pp. 74–84.

———. "The World of Edward Hopper." *New York Times Magazine*, 5 September 1971, pp. 14–17+.

Morse, John. "Interview with Edward Hopper." *Art in America*, 48 (March 1960), pp. 60–63.

Morsell, Mary. "Hopper Exhibition Clarifies a Phase of American Art." *Art News*, 32 (4 November 1933), p. 12.

O'Connor, John, Jr. "Edward Hopper, American Artist." *Carnegie Magazine*, 10 (March 1937), pp. 303–6.

O'Doherty, Brian. "Portrait: Edward Hopper," *Art in America*, 52 (December 1964), pp. 68–88.

———. "The Hopper Bequest at the Whitney." *Art in America*, 59 (September 1971), pp. 68–69 and 72.

———. *American Masters: The Voice and the Myth*. New York: Random House, 1973.

Perlman, Bennard B. *The Immortal Eight*. Westport, Connecticut: North Light Publishers, 1979.

Perreault, John. "Hopper: Relentless realism, American light." *Village Voice*, 23 September 1971, p. 27.

Price, Matlock. "*The Sun*'s Poster Contest Shows Art's Value in War." *The Sun*, 25 August 1918, section 3, p. 8.

Read, Helen Appleton. "Brooklyn Museum Emphasizes New Talent in Initial Exhibition." *Brooklyn Daily Eagle*, 18 November 1923, p. 2B.

———. "The American Scene." *Brooklyn Daily Eagle*, 20 February 1927, p. 6E.

———. "Edward Hopper." *Parnassus*, 5 (November 1933), pp. 8–10.

———. "Racial Quality of Hopper Pictures at Modern Museum Agrees with Nationalistic Mood." *Brooklyn Daily Eagle*, 5 November 1933, pp. 12B-C.

———. *Robert Henri and Five of his Pupils: George Bellows, Eugene Speicher, Guy Pène du Bois, Rockwell Kent, Edward Hopper* (exhibition catalogue). New York: Century Association, 1946.

Read, Lolan C., Jr. "The New York School of Art," *The Sketch Book*, 3 (April 1904), p. 219.

Reece, Childe. "Edward Hopper's Etchings." *Magazine of Art*, 31 (April 1938), pp. 226–28.

Richardson, E. P. "Three American Painters: Sheeler—Hopper—Burchfield." *Perspectives U.S.A.*, 16 (1956), pp. 111–19.

Rodman, Selden. *Conversations with Artists*. New York: Devin-Adair, 1957.

Rose, Barbara. "Edward Hopper—'Greatest American Realist of the 20th Century.'" *Vogue*, 158 (1 September 1971), p. 284.

Seitz, William C. *Edward Hopper in São Paulo 9*. Washington, D.C.: Smithsonian Press, 1967.

Soby, James Thrall. *Contemporary Painters*. New York: The Museum of Modern Art, 1948.

———. "Arrested Time by Edward Hopper." *Saturday Review*, 33 (4 March 1950), pp. 42–43.

Tittle, Walter. "The Pursuit of Happiness" (unpublished

autobiography). Wittenberg University Library, Springfield, Ohio.

Tyler, Parker. "Edward Hopper: Alienation by Light." *Magazine of Art,* 41 (December 1948), pp. 290–95.

"Walkowitz and Hopper." *Arts and Decoration,* 6 (February 1916), pp. 190–91.

Watson, Forbes. "A Note on Edward Hopper." *Vanity Fair,* 31 (February 1929), pp. 64, 98, 107.

———. "The Rise of Edward Hopper." *Brooklyn Daily Eagle,* 5 November 1933, p. 13.

Winsten, Archer. "Washington Square North Boasts Strangers Worth Talking To." *New York Post,* 26 November 1935.

Zigrosser, Carl. "The Etchings of Edward Hopper." In *Prints,* edited by Carl Zigrosser. New York: Holt, Rinehart, and Winston, 1962.

———. "The Prints of Edward Hopper." *American Artist,* 27 (November 1963), pp. 38–43.

INDEX OF PICTURES

Brackets indicate descriptive titles given by the author to previously untitled works. The idiosyncrasies of Hopper's spelling and French titles have been preserved.

PHOTOGRAPHIC CREDITS

Photographs of the works of art reproduced have been supplied, in the majority of cases, by the owners or custodians of the works, as cited in the captions. The following list applies to photographs for which an additional acknowledgment is due.

Daniel Abadie, Fig. 27
Armen, Pl. 344
Peter Balestero, Pl. 241
E. Irving Blomstrann, Pls. 217, 221, 406
Lee Boltin, Pl. 187
Lee Brian, Pls. 35, 36, Fig. 51
Will Brown, Pl. 304
Geoffrey Clements, Pls. 1, 4–8, 11–14, 17, 18, 20–23, 25–28,
 30–34, 37–50, 53–78, 80–124, 126, 127, 129–141, 143–157,
 162, 165–168, 170, 171, 173, 174, 181, 182, 188, 190, 195,
 196, 204–206, 211–214, 216, 219, 222, 225, 226, 229, 230,
 232, 234, 235, 239, 246, 249, 250, 252, 253, 255–257, 259,
 260, 261, 263, 270, 273, 274, 276, 277, 279, 280, 282, 284–
 287, 289, 291–293, 295, 296, 298, 299, 301, 303, 306, 307,
 309, 311, 312, 314, 316, 317, 320–322, 324, 325, 331–337,
 341–343, 345, 346, 348, 349, 351, 377–379, 382, 383, 388,
 390–392, 395–397, 401–403, 408–412, 419, 422, 423,
 Figs. 2, 3, 8, 9, 11, 15, 19, 22, 23, 28, 29, 30, 36, 38, 39, 41,
 43, 44, 49, 50, 52, 55
Bill Finney, Pl. 175
William McKillon, Pl. 245

Vincent Miraglia, Pls. 16, 210
Eric E. Mitchell, Philadelphia Museum of Art, Pls. 5, 42
Carole Palladino, Fig. 17
Eric Pollitzer, Pls. 177, 186, 198, 200, 231, 236, 288, 305
Bill Pugh, Delaware Art Museum, Pl. 166
Nathan Rabin, Pl. 387
Sandak, Inc., Pls. 161, 185, 247, 318, 340, 350, 394, 399, 418,
 429
Elton Schnellbacher, Pls. 125, 417
Schlopplein Studio, Pl. 421
Joseph Szasfai, Yale University Art Gallery, Pls. 290, 302, 330,
 414, 424
Tadder/Baltimore, Pls. 339, 347, 404
John Tennant, Pls. 172, 297, 393
Malcolm Varon, Pl. 425
John Waggaman, Pls. 128, 142, 164, 179, 231, 368, 427
Robert Wallace, Pls. 268, 283
Richard D. Warner, William A. Farnsworth Library and Art
 Museum, Pl. 215
Courtesy Städtische Kunsthalle, Düsseldorf, Pl. 160
Courtesy Kunsthaus Zurich, Pls. 327, 384

PLATES

Brackets indicate descriptive titles given by the author to previously untitled works. The idiosyncrasies of Hopper's spelling and French titles have been preserved. Some of Hopper's works are known by both French and English titles. Where variants exist, the caption follows the form used in the artist's ledgers.

During Hopper's formative years he painted, sketched, and etched his self-portrait repeatedly, a process of self-analysis that reflected his introspective nature. "Great art," he wrote, "is the outward expression of an inner life in the artist. . . ."

Pl. 1. [*Self-Portrait*], June 5, 1900. Conté on paper, 14 × 12 inches. Collection of Mr. and Mrs. Joel Harnett.

Pl. 2. [*Self-Portrait*], 1900. Pencil on paper, 5¼ × 3¾ inches. Kennedy Galleries, Inc., New York.

Pl. 3. [*Self-Portrait*], c. 1900. Pencil on paper, 10¼ × 8¼ inches. Collection of Mr. and Mrs. Peter R. Blum.

Pl. 4. [*Self-Portrait and Hand Studies*], c. 1900. Pen and ink on paper, 8¹⁵⁄₁₆ × 5⅝ inches. Whitney Museum of American Art, New York; Bequest of Josephine N. Hopper. 70.1559.21

Pl. 5. [*Self-Portrait and Hand Studies*], c. 1900. Pen and ink on paper, 7⅞ × 5 inches. Whitney Museum of American Art, New York; Bequest of Josephine N. Hopper. 70.1559.28

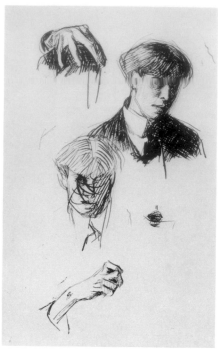

Pl. 6. [*Self-Portrait with Hand Studies*], c. 1900. Pen and ink on paper, 7¹⁵⁄₁₆ × 4¹⁵⁄₁₆ inches. Whitney Museum of American Art, New York; Bequest of Josephine N. Hopper. 70.1559.24

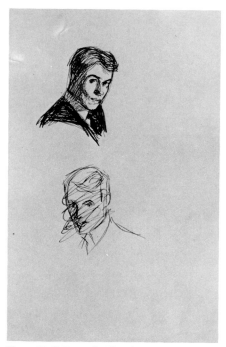

Pl. 7. [*Self-Portrait Sketches*], c. 1900. Pen and ink on paper, 8¹⁵⁄₁₆ × 5⅝ inches. Whitney Museum of American Art, New York; Bequest of Josephine N. Hopper. 70.1561.115

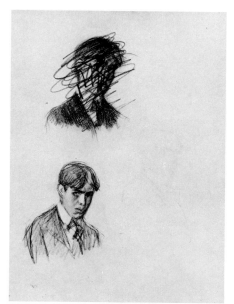

Pl. 8. [*Self-Portrait*], c. 1900. Conté on paper, 15 × 11¼ inches. Whitney Museum of American Art, New York; Bequest of Josephine N. Hopper. 70.1560.81

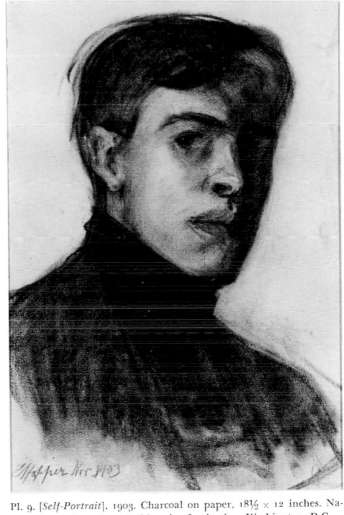

Pl. 9. [*Self-Portrait*], 1903. Charcoal on paper, 18½ × 12 inches. National Portrait Gallery, Smithsonian Institution, Washington, D.C.

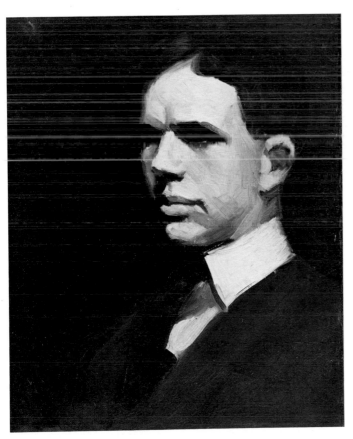

Pl. 10 [*Self-Portrait*], c. 1903. Oil on canvas, 20¼ × 16 inches. Museum of Fine Arts, Boston; The Charles Hayden Fund.

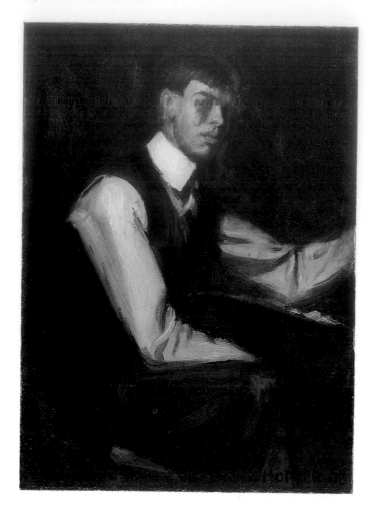

Pl. 11. [*Self-Portrait*], 1903. Oil on canvas, 14 × 10 inches. Whitney Museum of American Art, New York; Bequest of Josephine N. Hopper. 70.1650

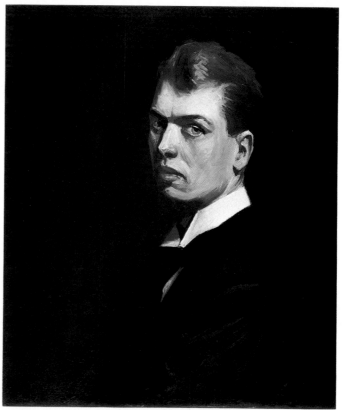

Pl. 12. [*Self-Portrait*], c. 1904–6. Oil on canvas, 26 × 22 inches. Whitney Museum of American Art, New York; Bequest of Josephine N. Hopper. 70.1253

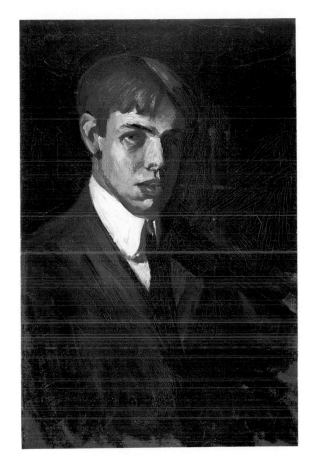

Pl. 13. [*Self-Portrait*], c. 1904–6. Oil on canvas, 28 × 17$\frac{15}{16}$ inches. Whitney Museum of American Art, New York; Bequest of Josephine N. Hopper. 70.1254

Pl. 14. [*Self-Portrait*], c. 1904–6. Oil on board, 16$\frac{15}{16}$ × 12$\frac{5}{16}$ inches. Whitney Museum of American Art, New York; Bequest of Josephine N. Hopper. 70.1410

Pl. 15. [*Self-Portrait*], c. 1904–6. Oil on canvas, 20 × 16 inches. Thyssen-Bornemisza Collection.

Pl. 17. [*Self-Portrait with Nude and Portrait*], c. 1918. Etching plate, 7¾ × 7 inches. Exists only in posthumous print. Whitney Museum of American Art, New York; Bequest of Josephine N. Hopper.

Pl. 18. [*Self-Portrait with Hat*], c. 1918. Etching plate, 4⅞ × 4 inches. Exists only in posthumous print. Whitney Museum of American Art, New York; Bequest of Josephine N. Hopper.

Pl. 19. *Self-Portrait*, 1919–23. Drypoint on zinc, 6 × 4 inches. Philadelphia Museum of Art; Purchased, The Harrison Fund.

Pl. 16. [*Self-Portrait*], 1910. Watercolor on paper, 18¼ × 12¼ inches. Private collection.

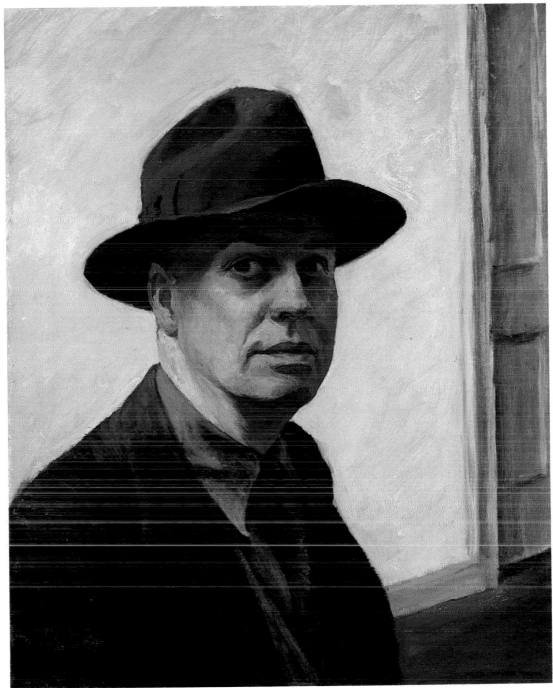

Pl. 20. [*Self-Portrait*], 1925–30. Oil on canvas, 25⅟₁₆ × 20⅜ inches. Whitney Museum of American Art, New York; Bequest of Josephine N. Hopper. 70.1165

Pl. 21. [*Self-Portrait*], 1945. Conté on paper, 22⅛ × 15 inches. Whitney Museum of American Art, New York; Bequest of Josephine N. Hopper. 70.336

Pl. 22. [*Self-Portrait*], 1945. Conté on paper, 22 × 15 inches. Whitney Museum of American Art, New York; Bequest of Josephine N. Hopper. 70.287

As a young man, Hopper often depicted his mother, father, and sister. Occasionally he painted portraits of his friends, among them his classmate in art school Guy Pène du Bois and his girlfriend Hettie Duryea Meade. Years later, he frequently portrayed his wife, Jo, who also modeled for all of the women in his paintings. He sometimes teased her with satirical cartoons. Hopper's surroundings, too, became subjects for his art—his studio, his bedroom, Hook Mountain, the view from the waterfront near his home, and Washington Square in New York City, where he lived for over fifty years.

Pl. 24. [*Garrett Henry Hopper, The Artist's Father*], c. 1900. Gouache, 13½ × 10¼ inches. Kennedy Galleries, Inc., New York.

Pl. 25. [*Elizabeth Griffiths Smith Hopper, The Artist's Mother*]. 1916–20. Oil on canvas, 38 × 32 inches. Whitney Museum of American Art, New York; Bequest of Josephine N. Hopper. 70.1191

Pl. 23. [*Garrett Henry Hopper, The Artist's Father*], 1900–1906. Conté on paper, 24¼ × 18¾ inches. Whitney Museum of American Art, New York; Bequest of Josephine N. Hopper. 70.1549 recto

Pl. 26. *My Mother*, c. 1920. Sanguine on paper, 21 × 15¾ inches. Whitney Museum of American Art, New York; Bequest of Josephine N. Hopper. 70.298

Pl. 28. [*Hook Mountain, Nyack*], c. 1899. Watercolor on paper, 5 × 7 inches. Whitney Museum of American Art, New York; Bequest of Josephine N. Hopper. 70.1558.55

Pl. 27. [*Marion Hopper, The Artist's Sister*], 1899. Pen, ink, and pencil on paper, 14⁷⁄₁₆ × 11⅝ inches. Whitney Museum of American Art, New York; Bequest of Josephine N. Hopper. 70.1566.36

Pl. 29. *Camp Nyack*, 1900. Pen and ink on paper, 10 × 14½ inches. Collection of Dr. and Mrs. Theodore Leshner.

Pl. 30. [*Artist's Bedroom, Nyack*], c. 1903–6. Oil on board, 15 1/16 × 11 1/16 inches. Whitney Museum of American Art, New York; Bequest of Josephine N. Hopper. 70.1412

Pl. 31. *Hettie Duryea Meade,* c. 1905. Oil on canvas, 22 × 18 inches. Joseph H. Hirshhorn Foundation, Inc., New York.

Pl. 32. *Guy Pène du Bois,* c. 1903. Pen and ink on paper, 9 × 5⅝ inches. Whitney Museum of American Art, New York; Bequest of Josephine N. Hopper. 70.1561.105

Pl. 33. *Guy Pène du Bois,* c. 1905. Oil on canvas, 24 × 17 inches. Collection of Yvonne Pène du Bois and William Pène du Bois.

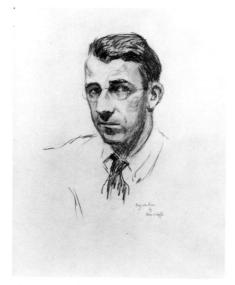

Pl. 34. *Guy Pène du Bois,* 1919. Sanguine on paper, 21 × 16 inches. Whitney Museum of American Art, New York; Bequest of Josephine N. Hopper. 70.907

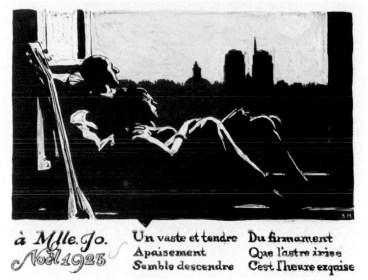

à Mlle. Jo.
Noël 1923

Un vaste et tendre Du firmament
Apaisement Que l'astre irise
Semble descendre C'est l'heure exquise

Pl. 35. *A Mlle. Jo Noel*, 1923. Gouache on paper, 7 × 8⅝ inches. Private collection.

Le rêve de Josie

Pl. 36. *Le Rêve de Josie*, c. 1924–30. Pencil on paper, 11 × 8½ inches. Private collection.

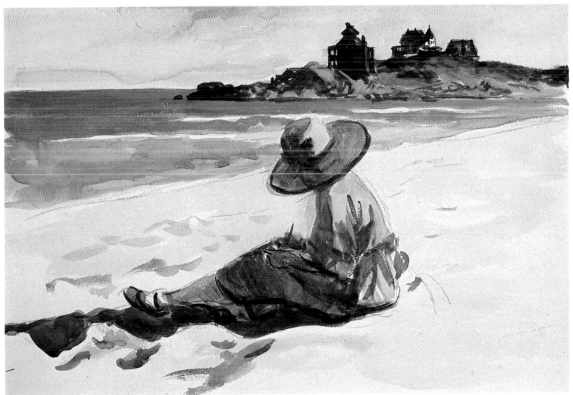

Pl. 37. [*Jo Sketching at the Beach*], 1925–28. Watercolor on paper, 13⅞ × 20 inches. Whitney Museum of American Art, New York; Bequest of Josephine N. Hopper. 70.1129

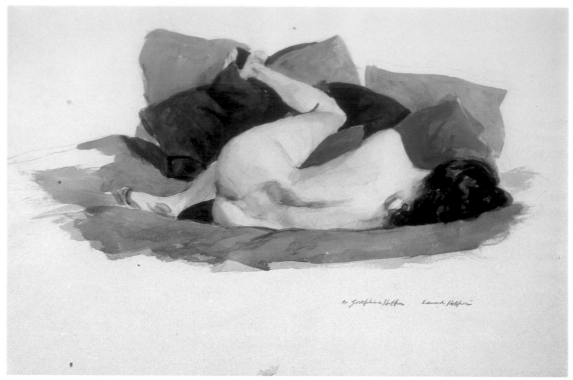

Pl. 38. [*Reclining Nude*], c. 1925–30. Watercolor on paper, 13⅞ × 19⅞ inches. Whitney Museum of American Art, New York; Bequest of Josephine N. Hopper. 70.1089

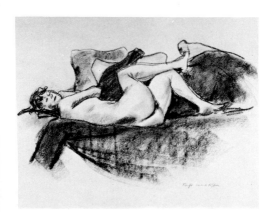

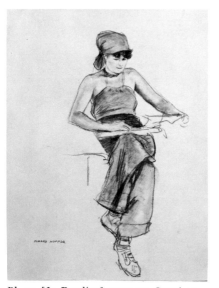

Pl. 39. [*Reclining Nude on a Couch*], 1925–30. Charcoal on paper, 15⅝ × 18 inches. Whitney Museum of American Art, New York; Bequest of Josephine N. Hopper. 70.296

Pl. 40. [*Jo Hopper*], 1934–40. Conté on paper, 15 × 19 inches. Whitney Museum of American Art, New York; Bequest of Josephine N. Hopper. 70.289

Pl. 41. [*Jo Reading*], 1934–35. Conté on paper, 15¹⁄₁₆ × 12¹⁄₁₆ inches. Whitney Museum of American Art, New York; Bequest of Josephine N. Hopper. 70.909

Pl. 42. [*Jo Sketching in the Truro House*], 1934–40. Watercolor on paper, 13¹⁵⁄₁₆ × 20 inches. Whitney Museum of American Art, New York; Bequest of Josephine N. Hopper. 70.1106

Pl. 43. [*Jo Hopper*], c. 1935–40. Conté on paper, 15⅛ × 22⅛ inches. Whitney Museum of American Art, New York; Bequest of Josephine N. Hopper. 70.293

Pl. 44. *Jo Painting*, 1936. Oil on canvas, 18 × 16 inches. Whitney Museum of American Art, New York; Bequest of Josephine N. Hopper. 70.1171

Pl. 45. [*Jo Sleeping*], c. 1940–45. Watercolor and pencil on illustration board. 11^{11}⁄$_{16}$ × 18 inches. Whitney Museum of American Art, New York; Bequest of Josephine N. Hopper. 70.1113

Pl. 46: *Jo in Wyoming*, July 1946. Watercolor on paper, 13^{15}⁄$_{16}$ × 20 inches. Whitney Museum of American Art, New York; Bequest of Josephine N. Hopper. 70.1159

Pl. 48. [*Jo Hopper*], 1945–50. Charcoal on paper, 18 × 15½ inches. Whitney Museum of American Art, New York; Bequest of Josephine N. Hopper. 70.288

Pl. 47. [*Jo Sleeping*], 1940–45. Conté on paper, 15 × 22⅛ inches. Whitney Museum of American Art, New York; Bequest of Josephine N. Hopper. 70.292

Pl. 50. [*Fireplace at Hopper's New York Apartment*], c. 1925–30. Pen and ink on paper, 12³⁄₁₆ × 7 inches. Whitney Museum of American Art, New York; Bequest of Josephine N. Hopper. 70.811

Pl. 49. *Perkins Youngboy Dos Passos*, 1941. Conté on paper, 15 × 22 inches. Whitney Museum of American Art, New York; Bequest of Josephine N. Hopper. 70.659

Pl. 51. *November, Washington Square,* 1932 and 1959. Oil on canvas, 34 × 50 inches. Santa Barbara Museum of Art, California.

Pl. 52. *City Roofs,* 1932. Oil on canvas, 29 × 36 inches. Private collection.

Pl. 54. *Josie lisant un journal*, 1925–35. Pencil on paper, 5⅞ × 8½ inches. Private collection.

Pl. 53. *This is a comic picture you must laugh*, c. 1899. Pen and ink on paper, 8 × 5 inches. Whitney Museum of American Art, New York; Bequest of Josephine N. Hopper. 70.1553.74

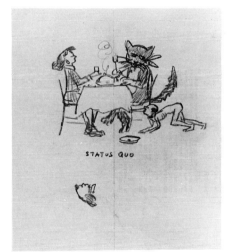

Pl. 55. *Status Quo*, 1932. Pencil on paper, 11 × 8½ inches. Private collection.

Pl. 56. *The sacrament of sex (female version)*, c. 1935–40. Conté on paper, 8½ × 11 inches. Private collection.

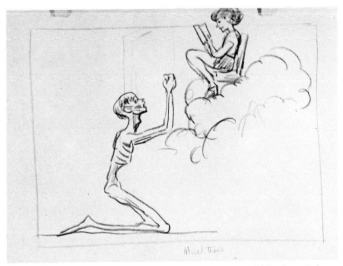

Pl. 57. *Meal time*, c. 1935–40. Conté on paper, 8 × 9⅜ inches. Private collection.

Hopper studied painting at the New York School of Art with William Merritt Chase, Kenneth Hayes Miller, and Robert Henri, whom he considered his most influential teacher: "Few teachers of art have gotten as much out of their pupils, or given them so great an initial impetus." This was a period of much experimentation for Hopper, in which he tried many different techniques, styles, and subjects.

Pl. 58. *Phil May*, 1899. Pen and ink on illustration board, 12¼ × 5⅝ inches. Whitney Museum of American Art, New York; Bequest of Josephine N. Hopper. 70.1553.104

Pl. 59. [*Artist's Studio*], c. 1900. Pen, ink, and pencil on paper, 14½ × 11⅜ inches. Whitney Museum of American Art, New York; Bequest of Josephine N. Hopper. 70.1566.147

Pl. 60. [*Woman Seated on Table*], 1900. Pencil on paper, 14 × 10 inches. Whitney Museum of American Art, New York; Bequest of Josephine N. Hopper. 70.1555.4

Pl. 61. *Venus—Thorvaldsen*, c. 1901. Pencil on paper, 8⅛ × 5⅞ inches. Whitney Museum of American Art, New York; Bequest of Josephine N. Hopper. 70.1560.117

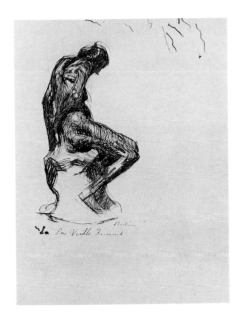

Pl. 62. Sketch after Rodin's *La Vieille Femme*, 1901. Pen and ink on paper, 8⅞ × 5⅝ inches. Whitney Museum of American Art, New York; Bequest of Josephine N. Hopper. 70.1561.106

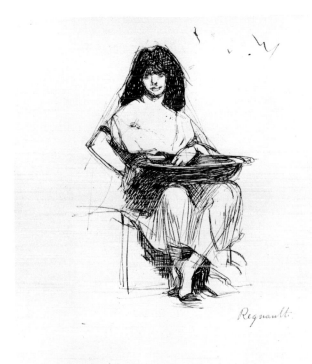

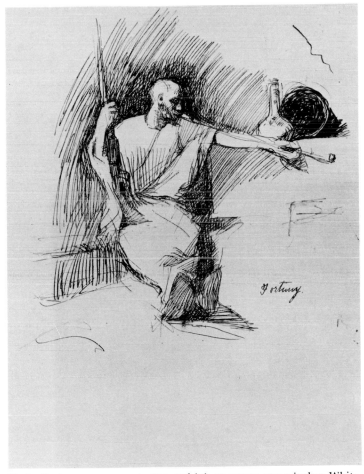

Pl. 63. Sketch after Regnault's *Salomé*, c. 1900–1907. Pen and ink on paper, 10 × 7 inches. Whitney Museum of American Art, New York; Bequest of Josephine N. Hopper. 70.1560.98

Pl. 64. *Fortuny*, c. 1900–1907. Pen and ink on paper, 10 × 7 inches. Whitney Museum of American Art, New York; Bequest of Josephine N. Hopper. 70.1560.97

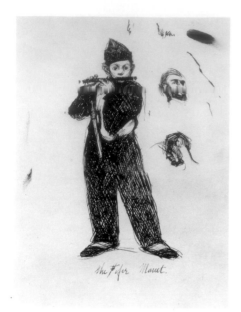

Pl. 65. Sketch after Manet's *The Fifer,* 1900–1907. Pen and ink on paper, 10 × 7 inches. Whitney Museum of American Art, New York; Bequest of Josephine N. Hopper. 70.1560.96

Pl. 66. Sketch after Manet's *Olympia,* 1900–1907. Pen and ink on paper, 8⅞ × 5½ inches. Whitney Museum of American Art, New York; Bequest of Josephine N. Hopper. 70.1561.133

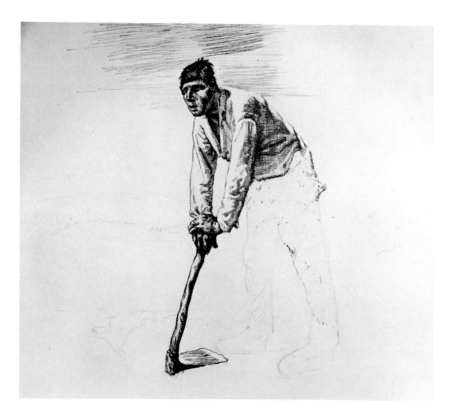

Pl. 67. Sketch after Millet's *Man With a Hoe,* c. 1900–1907. Pen and ink on paper, 10¾ × 11¹⁵⁄₁₆ inches. Whitney Museum of American Art, New York; Bequest of Josephine N. Hopper. 70.1565.64

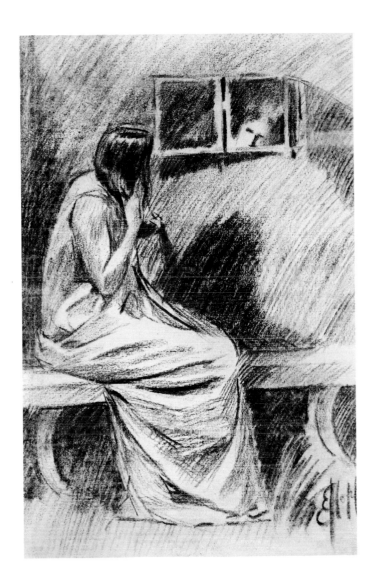

Pl. 68. [*Seated Woman*], c. 1900. Charcoal on paper, 16½ × 10¼ inches. Whitney Museum of American Art, New York; Bequest of Josephine N. Hopper. 70.1560.168

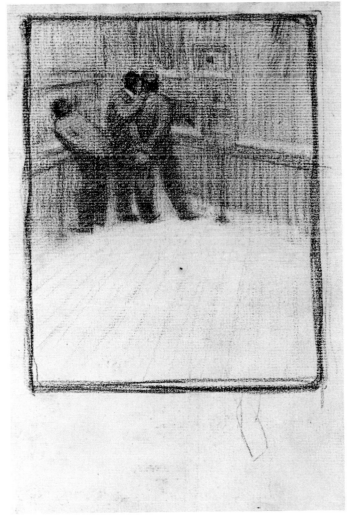

Pl. 69. [*Three Men at an Art Exhibition*], 1900–1903. Conté on paper, 9⅜ × 6¹⁄₁₆ inches. Whitney Museum of American Art, New York; Bequest of Josephine N. Hopper. 70.1560.51

Pl. 70. [*Nude Female Model in Studio*], c. 1900–1903. Charcoal on paper, 12⅛ × 9½ inches. Whitney Museum of American Art, New York; Bequest of Josephine N. Hopper. 70.1560.90

Pl. 71. [*Nude Female Model on Platform*], c. 1900–1903. Charcoal on paper, 18⅞ × 12⅛ inches. Whitney Museum of American Art, New York; Bequest of Josephine N. Hopper. 70.1566.118

Pl. 72. [*Model Jimmy Corsi Dressed as Fisherman*], 1901. Pencil on paper, 14¹⁵⁄₁₆ × 11 inches. Whitney Museum of American Art, New York; Bequest of Josephine N. Hopper. 70.1566.7

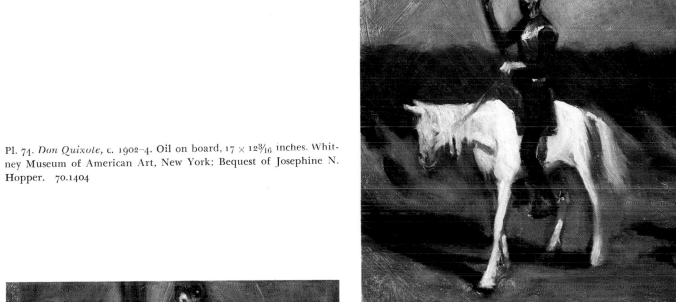

Pl. 74. *Don Quixote*, c. 1902–4. Oil on board, 17 × 12¾₁₆ inches. Whitney Museum of American Art, New York; Bequest of Josephine N. Hopper. 70.1404

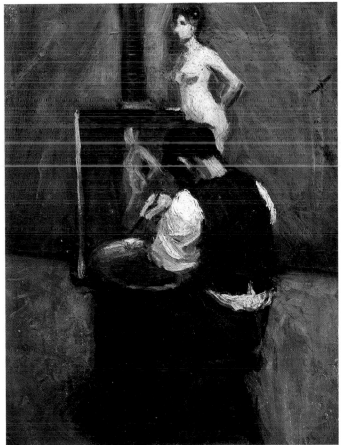

Pl. 73. [*Painter and Model*], c. 1902–4. Oil on board, 10¼ × 8¹⁄₁₆ inches. Whitney Museum of American Art, New York; Bequest of Josephine N. Hopper. 70.1420

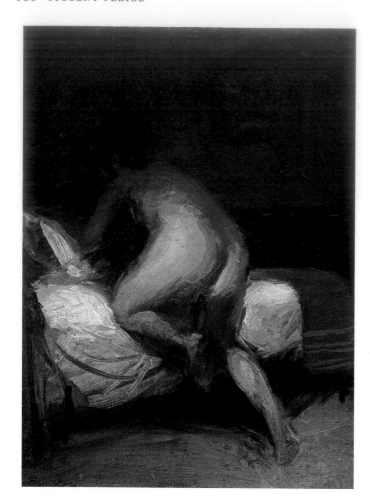

Pl. 75. [*Nude Crawling into Bed*], 1903–5. Oil on board, 12¼ × 9⅛ inches. Whitney Museum of American Art, New York; Bequest of Josephine N. Hopper. 70.1294

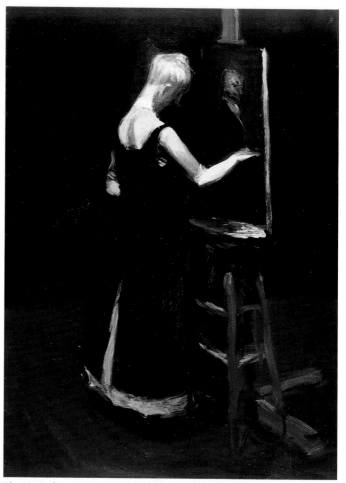

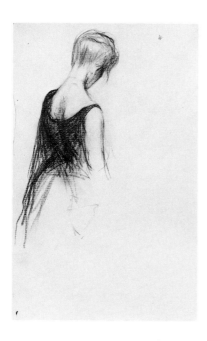

Pl. 77. Study for painting, [*Blond Woman Before an Easel*], 1903–6. Conté on paper, 7⅞ × 5¹⁵⁄₁₆ inches. Whitney Museum of American Art, New York; Bequest of Josephine N. Hopper. 70.1559.22

Pl. 76. [*Blond Woman Before an Easel*], c. 1903–6. Oil on board, 16¹⁵⁄₁₆ × 12¼ inches. Whitney Museum of American Art, New York; Bequest of Josephine N. Hopper. 70.1417

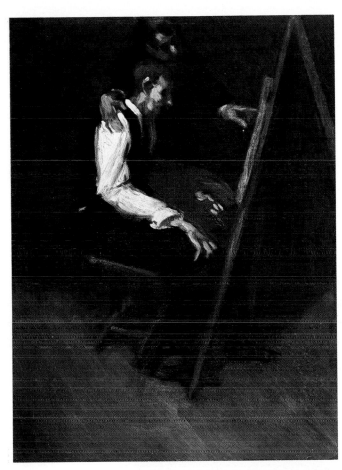

Pl. 78. [*Student and Teacher at the Easel*], c. 1903–6. Oil on board, 12½ × 9⅜ inches. Whitney Museum of American Art, New York, Bequest of Josephine N. Hopper. 70.1303

Pl. 79. [*Girl in White*], c. 1903–6. Oil on canvas, 22 × 17¾ inches. Kennedy Galleries, Inc., New York.

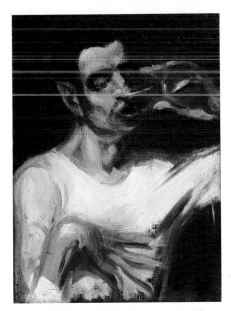

Pl. 80. [*Man Drinking*], c. 1905–6. Oil on canvas, 14⅛ × 9¹⁵⁄₁₆ inches. Whitney Museum of American Art, New York; Bequest of Josephine N. Hopper. 70.1648

PARIS

Paris enthralled Hopper, from his first visit (October 1906–June 1907) to the brief trips he made there in 1909 and 1910. In Paris, Hopper spent his time painting out-of-doors and visiting art exhibitions.

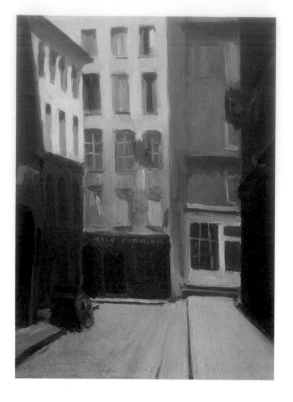

Pl. 81. [*Paris Street*], 1906. Oil on wood, 13 × 10 inches. Whitney Museum of American Art, New York; Bequest of Josephine N. Hopper. 70.1296

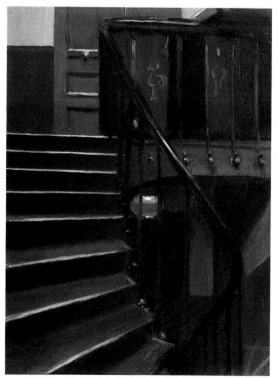

Pl. 82. [*Stairway at 48 rue de Lille, Paris*], 1906. Oil on wood, 13 × 9¼ inches. Whitney Museum of American Art, New York; Bequest of Josephine N. Hopper. 70.1295

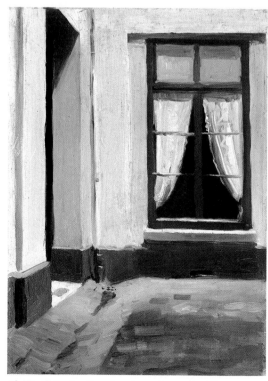

Pl. 83. [*Interior Courtyard at 48 rue de Lille, Paris*], 1906. Oil on wood, 13 × 9⅝ inches. Whitney Museum of American Art, New York; Bequest of Josephine N. Hopper. 70.1304

Pl. 84. [*Bridge in Paris*], 1906. Oil on wood, 9⅝ × 13 inches. Whitney Museum of American Art, New York; Bequest of Josephine N. Hopper. 70.1305

Pl. 85. [*River and Buildings*], 1906–7. Oil on wood, 9¼ × 13 inches. Whitney Museum of American Art, New York; Bequest of Josephine N. Hopper. 70.1301

Pl. 86. *Street in Paris,* 1906–7. Pencil and charcoal with touches of white paint on paper, 13¼ × 16 inches. Private collection.

Pl. 87. *Dome,* 1906–7 or 1909. Conté, wash, charcoal, and pencil on paper, 21⅜ × 9⅞ inches. Whitney Museum of American Art, New York; Bequest of Josephine N. Hopper. 70.1434

Pl. 88. *Cab, Horse and Crowd*, 1906–7 or 1909. Conté, charcoal, and wash with touches of white on paper, 18¼ × 14⅞ inches. Whitney Museum of American Art, New York; Bequest of Josephine N. Hopper. 70.1436

Pl. 89. *The Railroad*, 1906–7 or 1909. Conté, charcoal, and wash with touches of white on paper, 17¾ × 14⅛ inches. Whitney Museum of American Art, New York; Bequest of Josephine N. Hopper. 70.1437

Pl. 90. [*Figures Under a Bridge in Paris*], 1906–7 or 1909. Conté and wash on illustration board, 22⅛ × 15⅛ inches. Whitney Museum of American Art, New York; Bequest of Josephine N. Hopper. 70.1339

Pl. 91. [*Seated Old Man*], 1906–7 or 1909. Watercolor and pencil on composition board, 15 × 10½ inches. Whitney Museum of American Art, New York; Bequest of Josephine N. Hopper. 70.1329

Pl. 92. [*Parisian Workman*], 1906–7 or 1909. Watercolor and pencil on composition board, 15⅛ × 10¹¹⁄₁₆ inches. Whitney Museum of American Art, New York; Bequest of Josephine N. Hopper. 70.1333

Pl. 93. [*Parisian Woman*], 1906–7 or 1909. Watercolor on composition board, 11¹³⁄₁₆ × 9⁷⁄₁₆ inches. Whitney Museum of American Art, New York; Bequest of Josephine N. Hopper. 70.1324

Pl. 94. [*Parisian Woman Walking*], 1906–7 or 1909. Watercolor on composition board, 11¹³⁄₁₆ × 9¼ inches. Whitney Museum of American Art, New York; Bequest of Josephine N. Hopper. 70.1323

Pl. 95. [*Cunard Sailor*], 1906–7 or 1909. Watercolor on composition board, 14¹³⁄₁₆ × 10⅝ inches. Whitney Museum of American Art, New York; Bequest of Josephine N. Hopper. 70.1335

Pl. 96. [*French Woman with Basket*], 1906–7 or 1909. Watercolor and pencil on illustration board, 15 × 10½ inches. Whitney Museum of American Art, New York; Bequest of Josephine N. Hopper. 70.1331

Pl. 97. *Tugboat at Boulevard Saint Michel,* 1907. Oil on canvas, 23¾ × 28⅝ inches. Whitney Museum of American Art, New York; Bequest of Josephine N. Hopper. 70.1250

Pl. 98. *Boat Landing at Gare d'Orleans,* 1907. Oil on canvas, 23½ × 28¹¹⁄₁₆ inches. Whitney Museum of American Art, New York; Bequest of Josephine N. Hopper. 70.1229

Pl. 99. *Pont du Carrousel and Gare d'Orleans*, 1907. Oil on canvas, 23¾ × 28⅝ inches. Whitney Museum of American Art, New York; Bequest of Josephine N. Hopper. 70.1230

Pl. 100. *Pont du Carrousel in the Fog*, 1907. Oil on canvas, 23¼ × 28¼ inches. Whitney Museum of American Art, New York; Bequest of Josephine N. Hopper. 70.1245

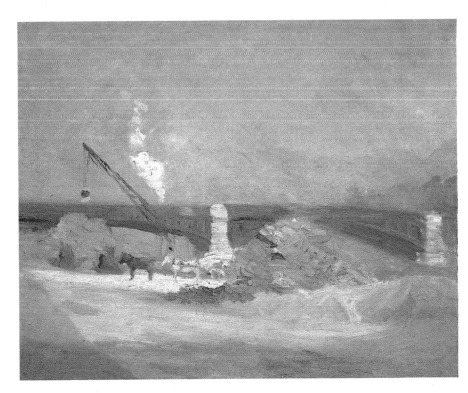

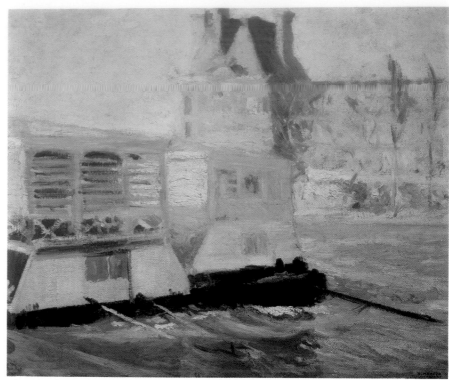

Pl. 101. *Le Louvre et la Seine,* 1907. Oil on canvas, 23½ × 28½ inches. Whitney Museum of American Art, New York; Bequest of Josephine N. Hopper. 70.1186

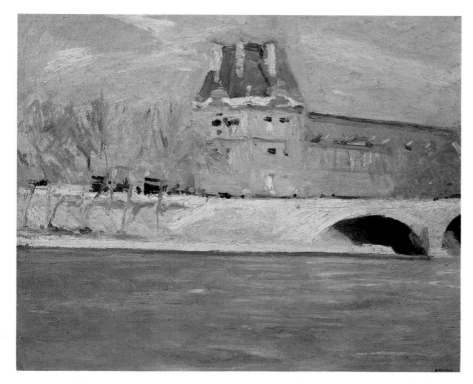

Pl. 102. *Après midi de Juin* or *L'après midi de Printemps,* 1907. Oil on canvas, 23½ × 28½ inches. Whitney Museum of American Art, New York; Bequest of Josephine N. Hopper. 70.1172

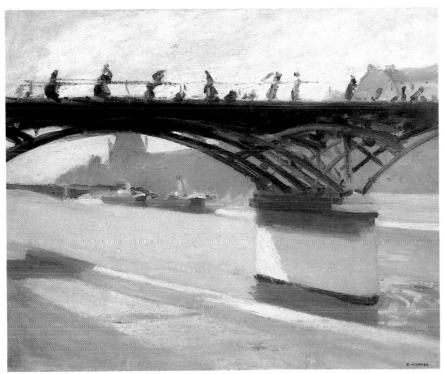

Pl. 103. *Le Pont des Arts*, 1907. Oil on canvas, 23⅟₁₆ × 28⅟₁₆ inches. Whitney Museum of American Art, New York; Bequest of Josephine N. Hopper. 70.1181

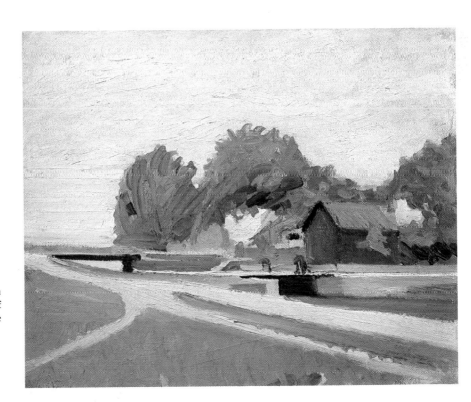

Pl. 104. *Canal Lock at Charenton*, 1907. Oil on canvas, 23¼ × 28⅜ inches. Whitney Museum of American Art, New York; Bequest of Josephine N. Hopper. 70.1227

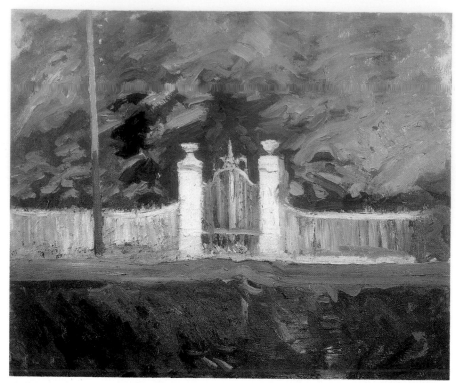

Pl. 105. *Gateway and Fence, Saint Cloud,* 1907. Oil on canvas, 23 × 28 inches. Whitney Museum of American Art, New York; Bequest of Josephine N. Hopper. 70.1231

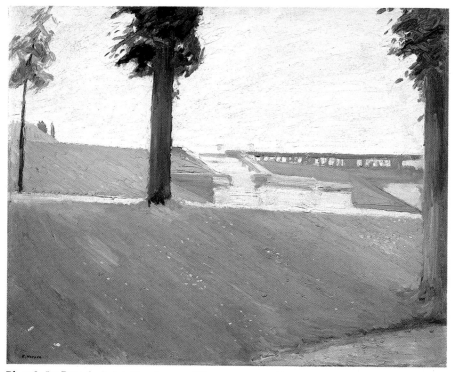

Pl. 106. *Le Parc du Saint Cloud,* 1907. Oil on canvas, 23½ × 28½ inches. Whitney Museum of American Art, New York; Bequest of Josephine N. Hopper. 70.1180

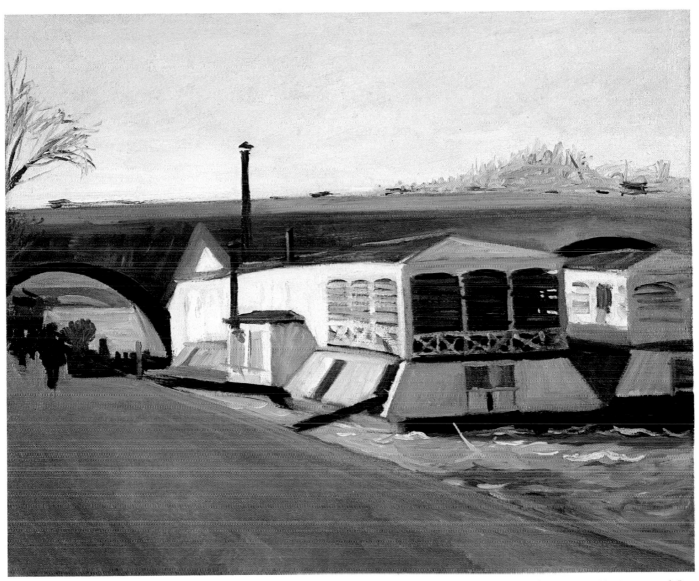

Pl. 107. *Les Lavoirs à Pont Royal*, 1907. Oil on canvas, 23¼ × 28½ inches. Whitney Museum of American Art, New York; Bequest of Josephine N. Hopper. 70.1247

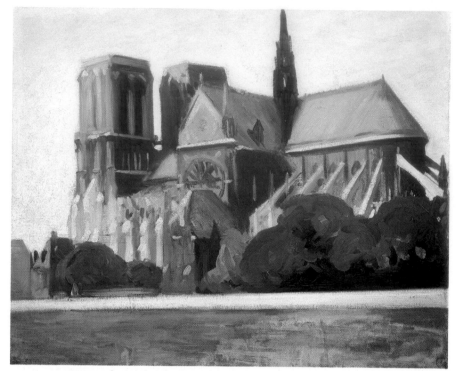

Pl. 108. *Notre Dame de Paris,* 1907. Oil on canvas, 23½ × 28½ inches. Whitney Museum of American Art, New York; Bequest of Josephine N. Hopper. 70.1179

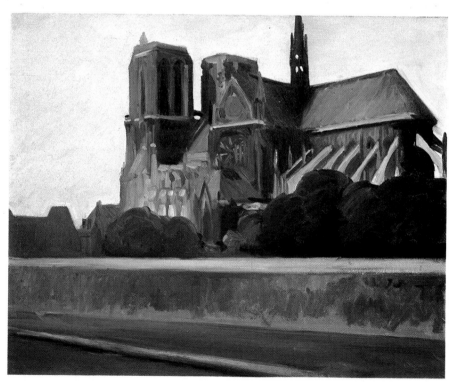

Pl. 109. *Notre Dame, No.* 2, 1907 or 1909. Oil on canvas, 23 × 28½ inches. Whitney Museum of American Art, New York; Bequest of Josephine N. Hopper. 70.1222

Pl. 110. *Louvre and Boat Landing*, 1907 or 1909. Oil on canvas, 23 × 28¼ inches. Whitney Museum of American Art, New York; Bequest of Josephine N. Hopper. 70.1249

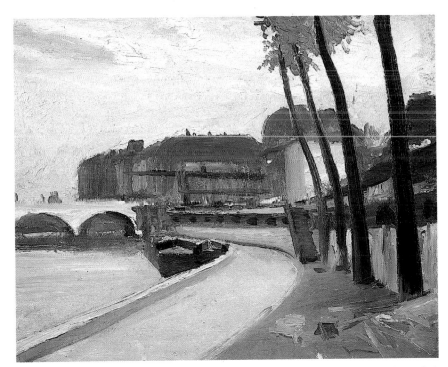

Pl. 111. *Le Quai des Grands Augustins with Trees*, 1907. Oil on canvas, 23¾ × 28¾ inches. Whitney Museum of American Art, New York; Bequest of Josephine N. Hopper. 70.1226

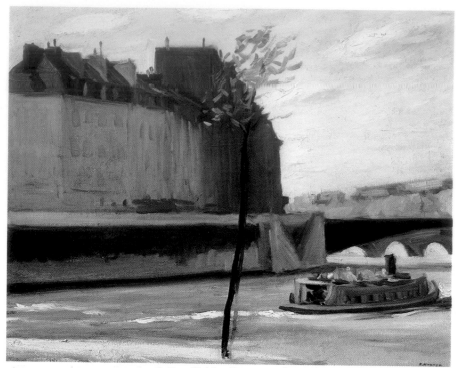

Pl. 112. *Ile Saint Louis* or *La Cité*, 1909. Oil on canvas, 23¾ × 28½ inches. Whitney Museum of American Art, New York; Bequest of Josephine N. Hopper. 70.1177

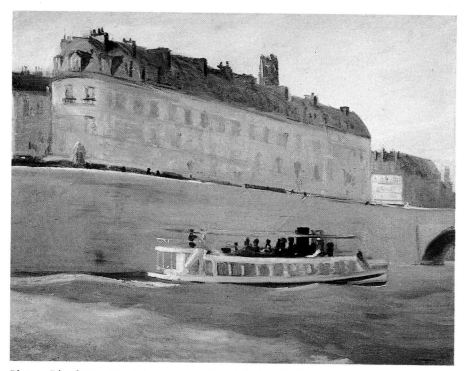

Pl. 113. *Riverboat*, 1909. Oil on canvas, 28 × 48 inches. Whitney Museum of American Art, New York; Bequest of Josephine N. Hopper. 70.1190

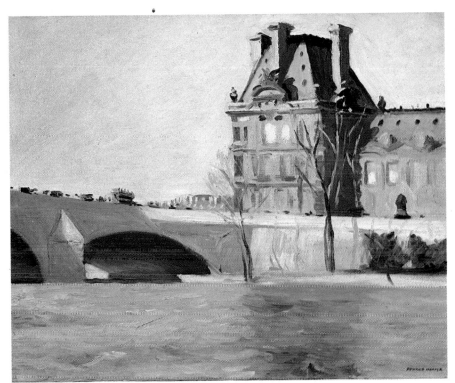

Pl. 114. *Le Pont Royal*, 1909. Oil on canvas, 23¼ × 28½ inches. Whitney Museum of American Art, New York; Bequest of Josephine N. Hopper. 70.1175

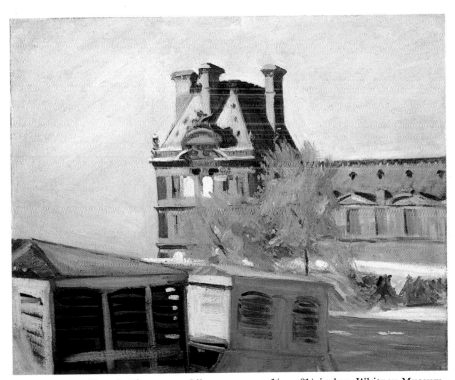

Pl. 115. *Le Pavillon de Flore*, 1909. Oil on canvas, 23½ × 28½ inches. Whitney Museum of American Art, New York; Bequest of Josephine N. Hopper. 70.1174

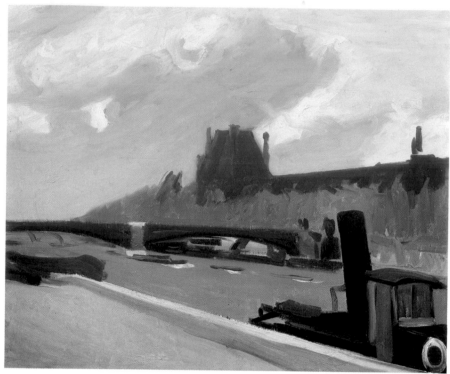

Pl. 116. *The Louvre in a Thunder Storm*, 1909. Oil on canvas, 23 × 28¾ inches. Whitney Museum of American Art, New York; Bequest of Josephine N. Hopper. 70.1223

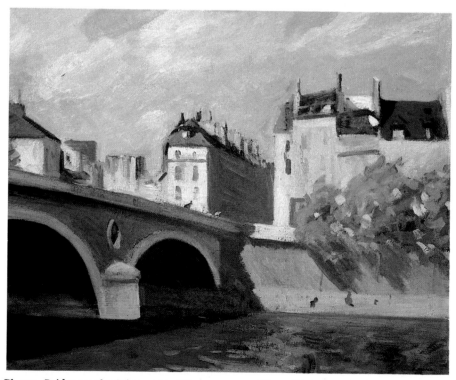

Pl. 117. *Bridge on the Seine*, 1909. Oil on canvas, 23½ × 28½ inches. Whitney Museum of American Art, New York; Bequest of Josephine N. Hopper. 70.1176

Pl. 118. *Le Pont Neuf* or *Ecluse de la Monnaie*, 1909. Oil on canvas, 23¼ × 28 inches. Whitney Museum of American Art, New York, Bequest of Josephine N. Hopper. 70.1178

Pl. 119. *Le Quai des Grands Augustins*, 1909. Oil on canvas, 23½ × 28½ inches. Whitney Museum of American Art, New York; Bequest of Josephine N. Hopper. 70.1173

In the period after his return from Paris in 1907, Hopper painted restaurants, interiors, cityscapes, and nautical scenes, all themes that would preoccupy him during his mature years. With these works, Hopper tried to free himself of French subject matter and style. "It seemed awfully crude and raw here when I got back. It took me ten years to get over Europe."

Pl. 120. *Valley of the Seine,* 1908. Oil on canvas, 26 × 38 inches. Whitney Museum of American Art, New York; Bequest of Josephine N. Hopper. 70.1183

Pl. 121. *Tug Boat with Black Smokestack,* c. 1908. Oil on canvas, 20 × 29 inches. Whitney Museum of American Art, New York; Bequest of Josephine N. Hopper. 70.1192

Pl. 122. *Le Bistro* or *The Wine Shop*, 1909. Oil on canvas, 23⅜ × 28½ inches. Whitney Museum of American Art, New York; Bequest of Josephine N. Hopper. 70.1187

Pl. 123. *Summer Interior*, 1909. Oil on canvas, 24 × 29 inches. Whitney Museum of American Art, New York; Bequest of Josephine N. Hopper. 70.1197

Pl. 124. *Blackwell's Island,* 1911. Oil on canvas, 24 × 29 inches. Whitney Museum of American Art, New York; Bequest of Josephine N. Hopper. 70.1188

Pl. 125. *Sailing,* 1911. Oil on canvas, 24 × 29 inches. Museum of Art, Carnegie Institute, Pittsburgh, Pennsylvania; Gift of Mr. and Mrs. James H. Beal in Honor of the Sarah M. Scaife Gallery.

Pl. 126. *Gloucester Harbor*, 1912. Oil on canvas, 26 × 38 inches. Whitney Museum of American Art, New York; Bequest of Josephine N. Hopper. 70.1204

Pl. 127. *Tall Masts, Gloucester*, 1912. Oil on canvas, 24 × 29 inches. Whitney Museum of American Art, New York; Bequest of Josephine N. Hopper. 70.1198

Pl. 128. *Squam Light,* 1912. Oil on canvas, 24 × 29 inches. Private collection.

Pl. 129. *Briar Neck,* 1912. Oil on canvas, 24 × 29 inches. Whitney Museum of American Art, New York; Bequest of Josephine N. Hopper. 70.1193

Pl. 130. *American Village*, 1912. Oil on canvas, 26 × 38 inches. Whitney Museum of American Art, New York; Bequest of Josephine N. Hopper. 70.1185

Pl. 131. *Road in Maine,* 1914. Oil on canvas, 24 × 29 inches. Whitney Museum of American Art, New York; Bequest of Josephine N. Hopper. 70.1201

Pl. 132. *Rocks and Houses, Ogunquit,* 1914. Oil on canvas, 23¾ × 28¾ inches. Whitney Museum of American Art, New York; Bequest of Josephine N. Hopper. 70.1202

Pl. 133. *The Dories, Ogunquit,* 1914. Oil on canvas. 24 × 29 inches. Whitney Museum of American Art, New York; Bequest of Josephine N. Hopper. 70.1196

Pl. 134. *Cove at Ogunquit,* 1914. Oil on canvas, 24 × 29 inches. Whitney Museum of American Art, New York; Bequest of Josephine N. Hopper. 70.1199

Pl. 135. *Sea at Ogunquit,* 1914. Oil on canvas, 24¼ × 29⅛ inches. Whitney Museum of American Art, New York; Bequest of Josephine N. Hopper. 70.1195

Pl. 136. [*Two Dories*], c. 1915–18. Oil on board, 9½ × 12¹⁵⁄₁₆ inches. Whitney Museum of American Art, New York; Bequest of Josephine N. Hopper. 70.1314

Pl. 137. [*Trees and Bench*], 1916–19. Oil on wood, 9½ × 13 inches. Whitney Museum of American Art, New York; Bequest of Josephine N. Hopper. 70.1316

Pl. 138. [*Landscape with Fence and Trees*], c. 1916–19. Oil on canvas, 9⁷⁄₁₆ × 12¾ inches. Whitney Museum of American Art, New York; Bequest of Josephine N. Hopper. 70.1667

In the summer of 1916, Hopper went to Monhegan Island, Maine. Completely captivated by its rocky shores and towering headlands, he worked out-of-doors, painting many views of the island's dramatic shoreline. He liked Monhegan so much that he returned for the next few summers and used the landscape there as a point of departure for the exploration of form and light.

Pl. 139. *Blackhead, Monhegan,* c. 1916–19. Sanguine on paper, 12¼ × 16 inches. Whitney Museum of American Art, New York; Bequest of Josephine N. Hopper. 70.367

Pl. 140. *Blackhead, Monhegan,* 1916–19. Oil on wood, 9½ × 13 inches. Whitney Museum of American Art, New York; Bequest of Josephine N. Hopper. 70.1317

Pl. 141. *Blackhead, Monhegan,* 1916–19. Oil on wood, 11¾ × 16 inches. Whitney Museum of American Art, New York; Bequest of Josephine N. Hopper. 70.1291

Pl. 142. *Blackhead, Monhegan,* 1916–19. Oil on wood, 11¾ × 16 inches. Private collection.

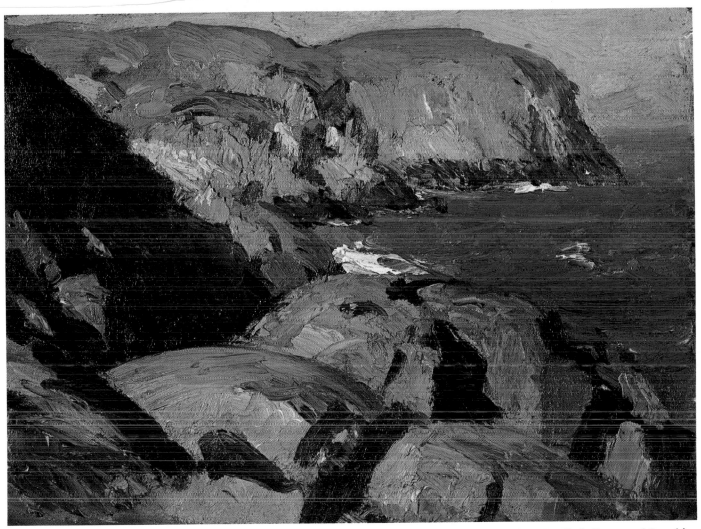

Pl. 143. *Blackhead, Monhegan,* 1916–19. Oil on wood, 9⅜ × 13 inches. Whitney Museum of American Art, New York; Bequest of Josephine N. Hopper. 70.1668

Pl. 144. *Little Cove, Monhegan*, 1916–19. Oil on board, 9⁷⁄₁₆ × 13 inches. Whitney Museum of American Art, New York; Bequest of Josephine N. Hopper. 70.1669

Pl. 145. [*Rocky Shoreline*], 1916–19. Oil on board, 9½ × 12⁷⁄₈ inches. Whitney Museum of American Art, New York; Bequest of Josephine N. Hopper. 70.1672

Pl. 146. [*Rocky Shore*], 1916–19. Oil on wood, 9½ × 13 inches. Whitney Museum of American Art, New York; Bequest of Josephine N. Hopper. 70.1309

Pl. 147. [*Bluff*], 1916–19. Oil on board, 9½ × 12 inches. Whitney Museum of American Art, New York; Bequest of Josephine N. Hopper. 70.1319

Pl. 148. [*Rocks and Sea*], 1916–19. Oil on wood, 11¾ × 16 inches. Whitney Museum of American Art. New York; Bequest of Josephine N. Hopper. 70.1292

Pl. 149. [*Rocky Shore and Sea*], 1916–19. Oil on wood, 11¾ × 15⅝ inches. Whitney Museum of American Art, New York; Bequest of Josephine N. Hopper. 70.1267

Pl. 150. [*Rocky Seashore*], 1916–19. Oil on canvas, 9½ × 12¹⁵⁄₁₆ inches. Whitney Museum of American Art, New York; Bequest of Josephine N. Hopper. 70.1666

Pl. 151. [*Rocky Shore and Sea*], 1916–19. Oil on wood, 11⅞ × 16 inches. Whitney Museum of American Art, New York; Bequest of Josephine N. Hopper. 70.1290

Pl. 152. [*Rocky Projection at the Sea*], 1916–19. Oil on board, 9 ×12⅞ inches. Whitney Museum of American Art, New York: Bequest of Josephine N. Hopper. 70.1310

Pl. 159. [*Rocky Cliffs by the Sea*], 1916–19. Oil on canvas, 9⅜ × 12¾ inches. Whitney Museum of American Art, New York; Bequest of Josephine N. Hopper. 70.1675

Pl. 154. [*Waves and Rocky Shore*], 1916–19. Oil on wood, 11¾ × 16 inches. Whitney Museum of American Art, New York; Bequest of Josephine N. Hopper. 70.1288

FIRST RECOGNITION

After years of struggle, Hopper began to receive recognition when he won his first award since art school in a wartime poster competition conducted by the United States Shipping Board, in which there were fourteen hundred entries. For his poster Smash the Hun, *he received the first prize of three hundred dollars. In January 1920, Hopper had his first one-man exhibition at the Whitney Studio Club, located on West Fourth Street. During the early 1920s, he frequently attended the evening classes held at the club, where a model posed and artists paid a fee of twenty-five cents.*

Pl. 155. Study for poster, *Smash the Hun*, 1918. Gouache on illustration board, 9½ × 6⅜ inches. The Charles Rand Penney Collection.

Pl. 156. [*Standing Nude*], October 26, 1923. Sanguine on paper, 19 × 11¹⁵⁄₁₆ inches. Whitney Museum of American Art, New York; Bequest of Josephine N. Hopper. 70.661

Pl. 157. [*Seated Nude*], c. 1923. Charcoal on paper, 19 × 12⅛ inches. Whitney Museum of American Art, New York; Bequest of Josephine N. Hopper. 70.401

From his early maturity through the end of his career, Hopper was interested in the solitary figure lost in thought. Even when other figures are visible, the central figure is often psychologically remote, existing in a private space.

Pl. 158. [*Girl at Sewing Machine*], c. 1921. Oil on canvas, 19 × 18 inches. Thyssen-Bornemisza Collection.

Pl. 159. *Apartment Houses,* 1923. Oil on canvas, 25½ × 31½ inches. Courtesy of the Pennsylvania Academy of the Fine Arts, Philadelphia; Lambert Fund Purchase.

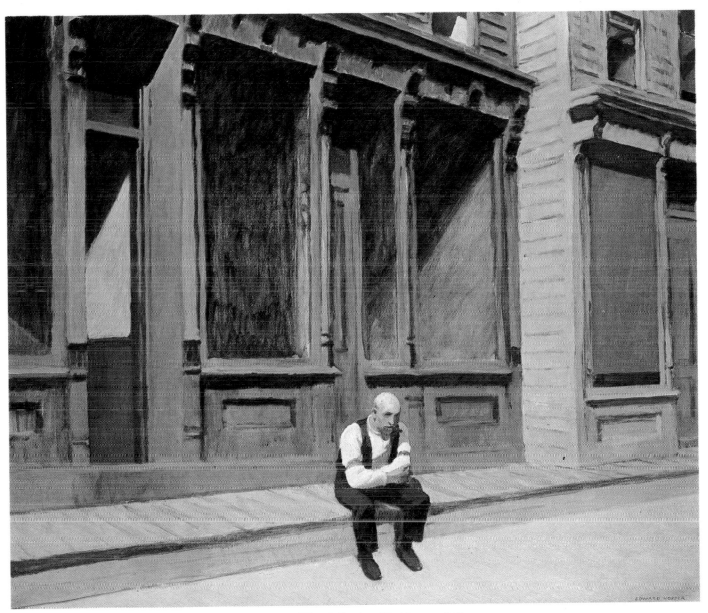

Pl. 160. *Sunday,* 1926. Oil on canvas, 29 × 34 inches. The Phillips Collection, Washington, D.C.

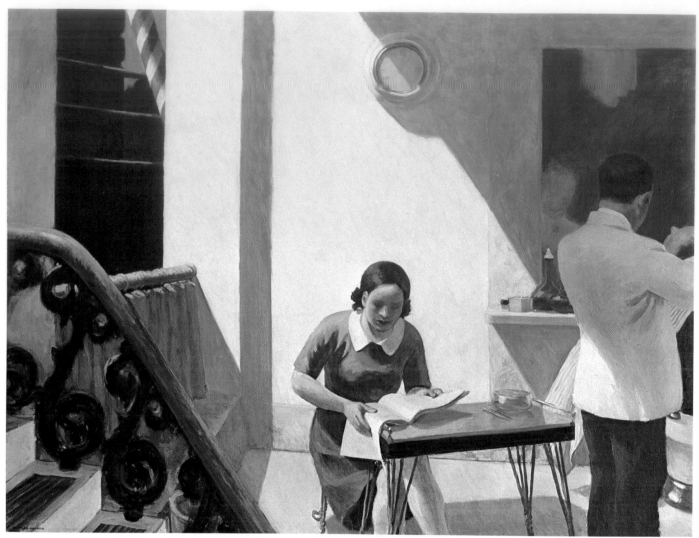

Pl. 161. *The Barber Shop,* 1931. Oil on canvas, 60 × 78 inches. Neuberger Museum, State University of New York at Purchase.

Pl. 162. Drawing for painting, *The Barber Shop,* 1931. Conté and charcoal on paper, 12½ × 17⅝ inches. Whitney Museum of American Art, New York; Bequest of Josephine N. Hopper. 70.853

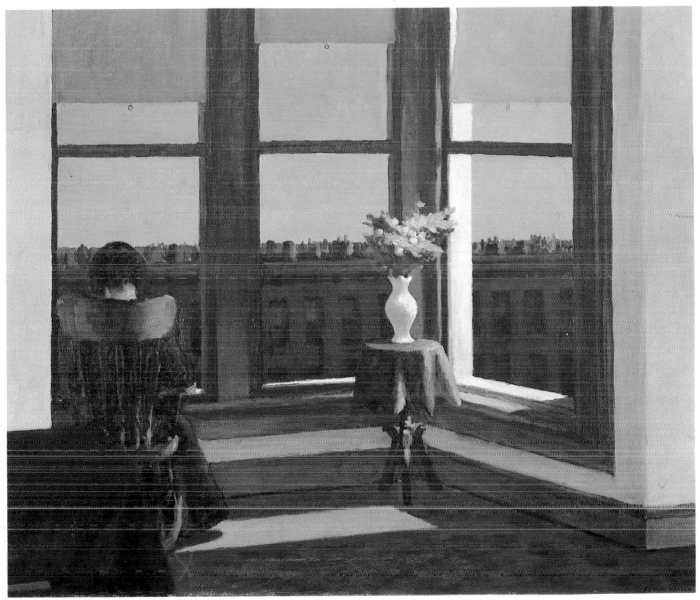

Pl. 163. *Room in Brooklyn*, 1932. Oil on canvas, 29 × 34 inches. Courtesy of the Museum of Fine Arts, Boston; Charles Henry Hayden Fund.

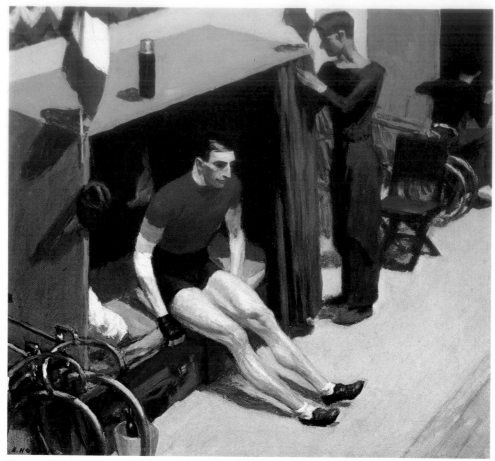

Pl. 164. *French Six-Day Bicycle Rider*, 1937. Oil on canvas, 17 × 19 inches. Collection of Mr. and Mrs. Albert Hackett.

Pl. 165. Drawing for painting, *French Six-Day Bicycle Rider*, 1937. Conté on paper, 7¾ × 8½ inches. Whitney Museum of American Art, New York; Bequest of Josephine N. Hopper. 70.451

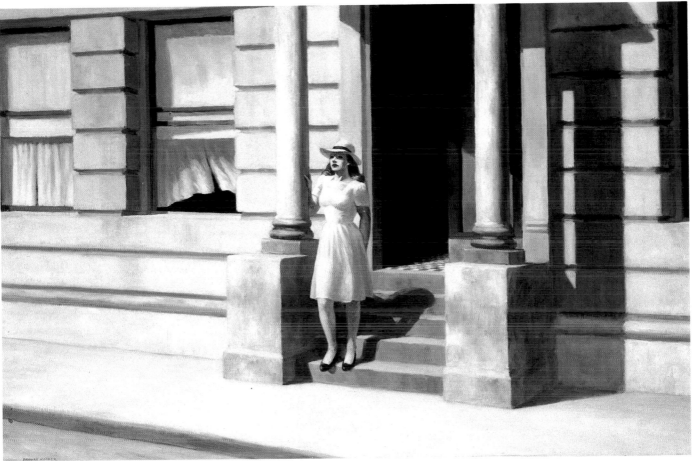

Pl. 166. *Summertime,* 1943. Oil on canvas, 29⅛ × 44 inches. Delaware Art Museum, Wilmington; Gift of Dora Sexton Brown.

Pl. 167. Drawing for painting, *Summertime,* 1943. Conté on paper, 8⅞ × 11⅞ inches. Whitney Museum of American Art, New York; Bequest of Josephine N. Hopper. 70.460

Pl. 168. Drawing for painting, *Summertime,* 1943. Conté on paper, 8½ × 11 inches. Whitney Museum of American Art, New York; Bequest of Josephine N. Hopper. 70.458

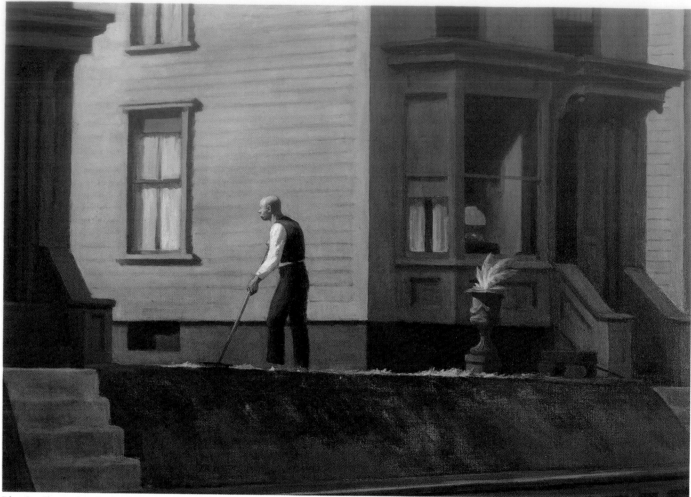

Pl. 169. *Pennsylvania Coal Town*, 1947. Oil on canvas, 28 × 40 inches. The Butler Institute of American Art, Youngstown, Ohio.

Pl. 170. Drawing for painting, *Pennsylvania Coal Town*, 1947. Conté and pencil on paper, 11⅛ × 15 inches. Whitney Museum of American Art, New York; Bequest of Josephine N. Hopper. 70.229

NAUTICAL

Hopper's interest in boats began with his childhood in Nyack, New York, then a prosperous Hudson River port with a thriving shipyard. At the age of fifteen, he built himself a catboat and later he considered a career as a naval architect. His enthusiasm for nautical subjects continued throughout his life, although he eventually gave up sailing because his wife insisted he was too good a man to lose that way.

Pl. 171. [*Sailing*], c. 1900. Ink on paper, 5⅝ × 8⅞ inches. Whitney Museum of American Art, New York, Bequest of Josephine N. Hopper. 70.1553.77

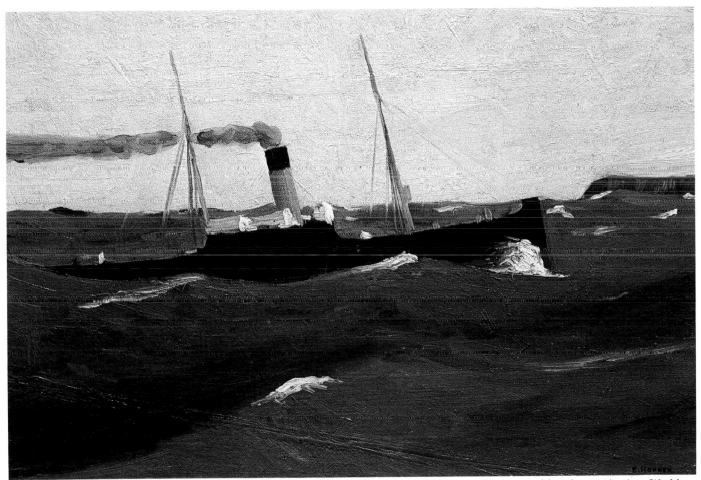

Pl. 172. *Tramp Steamer*, 1908. Oil on canvas, 20 × 29 inches. Hirshhorn Museum and Sculpture Garden, Smithsonian Institution, Washington, D.C.

Pl. 173. *Bow of Beam Trawler,* 1923. Watercolor on paper, 14 × 20 inches. Collection of Mr. and Mrs. Malcolm Chace.

Pl. 174. [*Two Trawlers*], 1923–24. Watercolor on paper, 13⅞ × 19⅞ inches. Whitney Museum of American Art, New York; Bequest of Josephine N. Hopper. 70.1091

Pl. 175. *The Bootleggers*, 1925. Oil on canvas, 30 × 38 inches. The Currier Gallery of Art, Manchester, New Hampshire.

Pl. 176. *Beam Trawler Teale,* 1926. Watercolor on paper, 14 × 20 inches. Munson-Williams-Proctor Institute, Museum of Art, Utica, New York; Gift of Mr. Fred L. Palmer.

Pl. 177. *Beam Trawler Osprey,* c. 1926. Watercolor on paper, 14 × 20 inches. Private collection.

Pl. 178. *Trawler and Telegraph Pole,* 1926. Watercolor on paper, 14 × 19⅞ inches. The Art Museum, Princeton University; The Laura P. Hall Memorial Collection.

Pl. 179. *Gloucester Harbor*, 1926. Watercolor on paper, 19½ × 14 inches. Munson-Williams-Proctor Institute, Museum of Art, Utica, New York; Property of John B. Root.

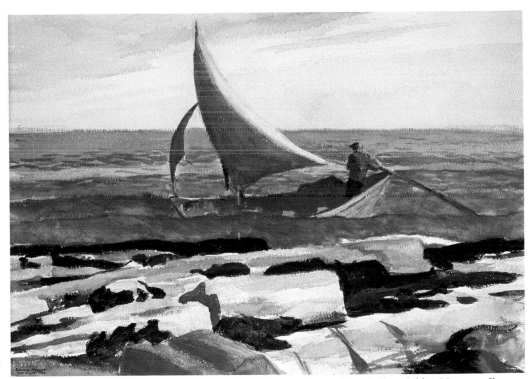

Pl. 180. *The Dory*, 1929. Watercolor on paper, 14 × 20 inches. Nelson Gallery-Atkins Museum, Kansas City, Missouri; Gift of Mrs. Louis Sosland.

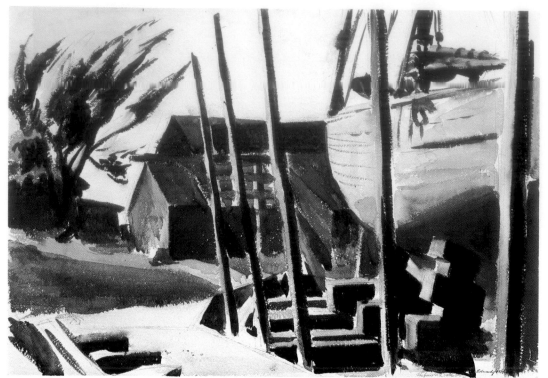

Pl. 181. [*Boatyard*], 1934–38. Watercolor on paper, 13⅞ × 20 inches. Whitney Museum of American Art, New York; Bequest of Josephine N. Hopper. 70.1111

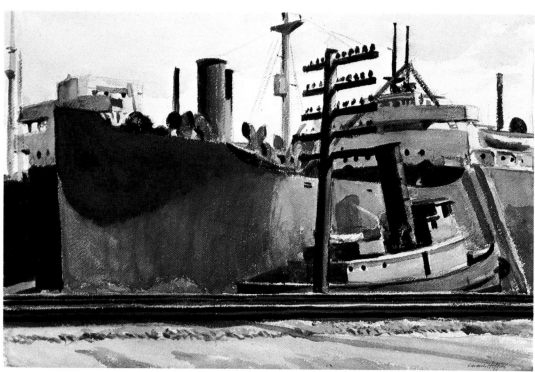

Pl. 182. [*Docked Freighter and Tugboat*], 1934–38. Watercolor on paper, 13¹⁵⁄₁₆ × 20 inches. Whitney Museum of American Art, New York; Bequest of Josephine N. Hopper. 70.1095

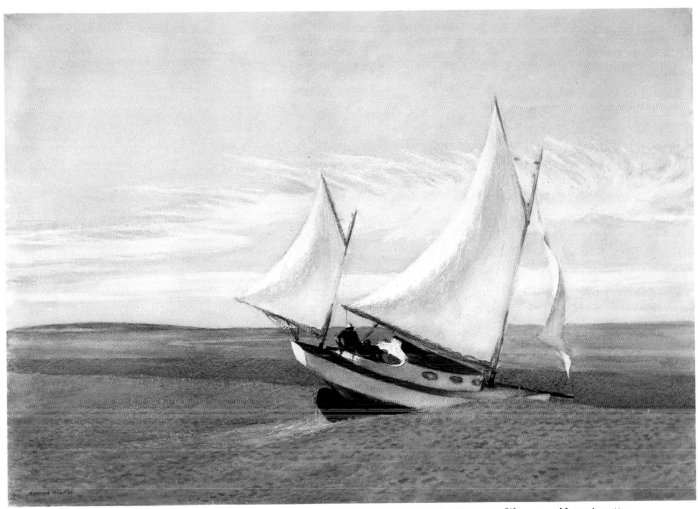

Pl. 183. *Yawl Riding a Swell*, 1935. Watercolor on paper, 20$\frac{1}{16}$ × 28$\frac{1}{4}$ inches. Worcester Art Museum, Worcester, Massachusetts.

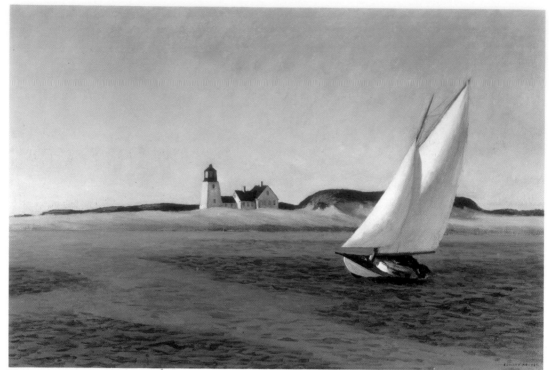

Pl. 184. *The Long Leg*, 1935. Oil on canvas, 20 × 30 inches. Virginia Steele Scott Foundation, Pasadena, California.

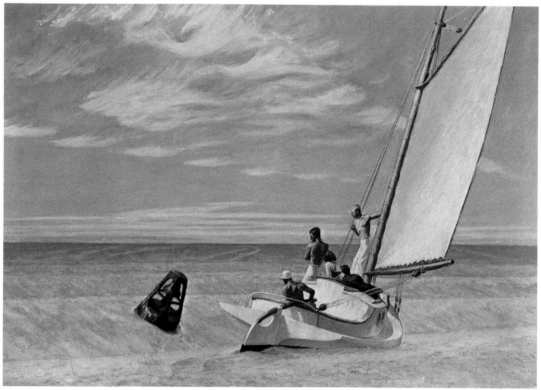

Pl. 185. *Ground Swell*, 1939. Oil on canvas, 36 × 50 inches. Corcoran Gallery of Art, Washington, D.C.; The William A. Clark Fund.

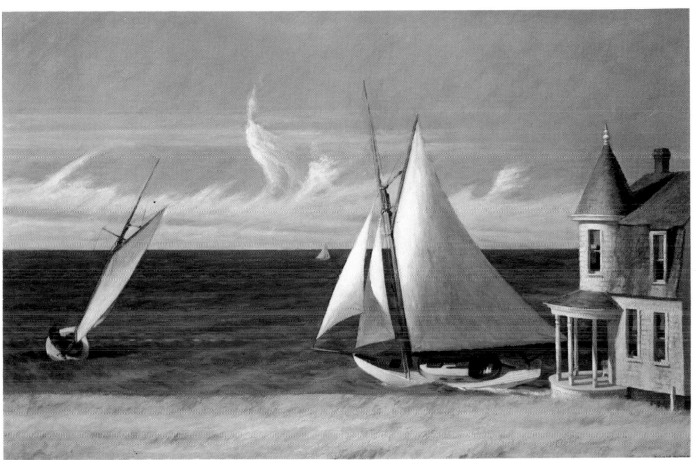

Pl. 186. *The Lee Shore,* 1941. Oil on canvas, 28¼ × 43 inches. Private collection.

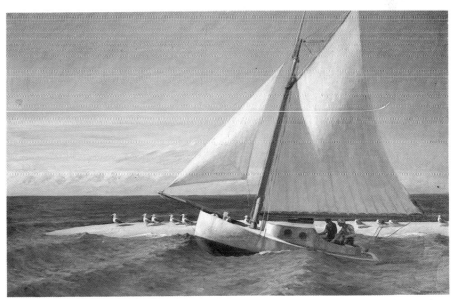

Pl. 187. *The Martha McKean of Wellfleet,* 1944. Oil on canvas, 32 × 50 inches. Private collection.

LIGHTHOUSES

As early as his student period, Hopper's love of the sea drew him to the dramatically stark architecture of lighthouses. His paintings from Cape Ann and Monhegan Island include lighthouses, but his best paintings of this subject were done in Cape Elizabeth, Maine, during the late 1920s.

Pl. 188. [*Lighthouse*], c. 1900. Pen and ink on paper, 4½ × 6 inches. Whitney Museum of American Art, New York; Bequest of Josephine N. Hopper. 70.1561.31

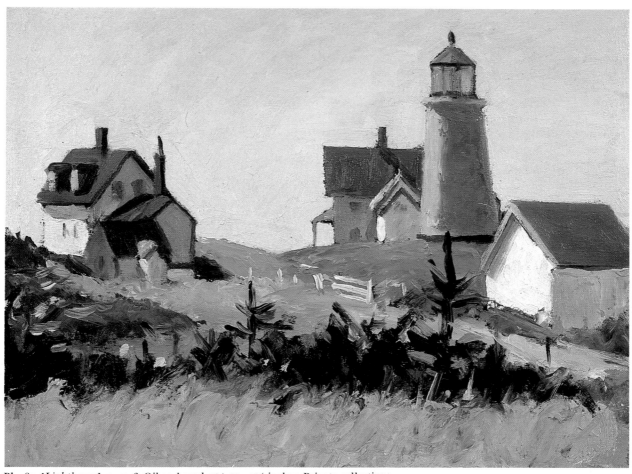

Pl. 189. [*Lighthouse*], c. 1916. Oil on board, 9½ × 12¾ inches. Private collection.

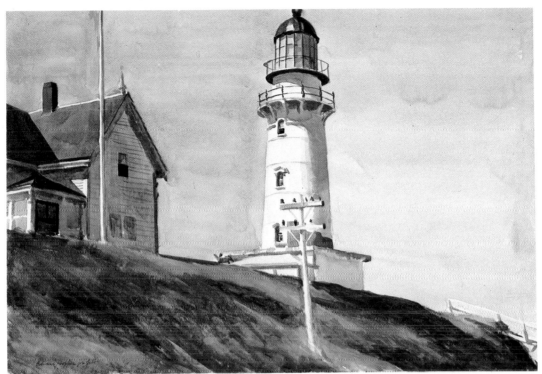

Pl. 190. *Light at Two Lights*, c. 1927. Watercolor on paper, 13¹⁵⁄₁₆ × 20 inches. Whitney Museum of American Art, New York; Bequest of Josephine N. Hopper. 70.1094

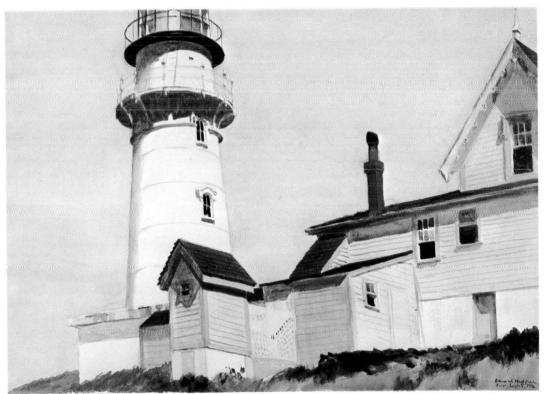

Pl. 191. *Light at Two Lights*, 1927. Watercolor on paper, 14 × 20 inches. Collection of Blount, Inc., Montgomery, Alabama.

Pl. 192. *Light at Two Lights,* 1927. Conté and charcoal on paper, 15 × 22¹⁄₁₆ inches. Whitney Museum of American Art, New York; Bequest of Josephine N. Hopper. 70.683

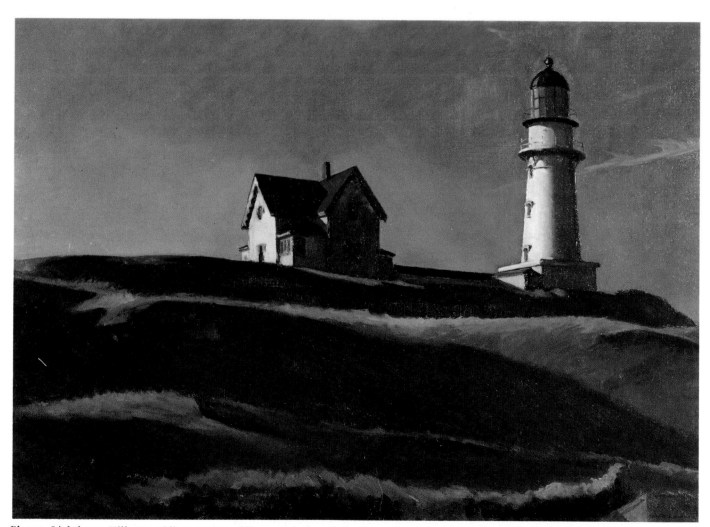

Pl. 193. *Lighthouse Hill,* 1927. Oil on canvas, 28¼ × 39½ inches. Dallas Museum of Fine Arts; Gift of Mr. and Mrs. Maurice Purnell.

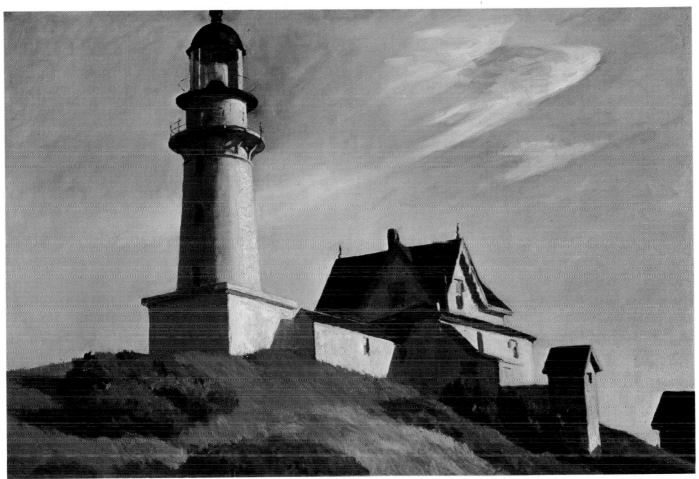

Pl. 191. *The Lighthouse at Two Lights*, 1929. Oil on canvas, 29½ × 43¼ inches. The Metropolitan Museum of Art, New York; Hugo Kastor Fund, 1962.

Pl. 195. *Light at Two Lights,* 1927. Watercolor on paper, 13¹⁵⁄₁₆ × 19¹⁵⁄₁₆ inches. Whitney Museum of American Art, New York; Bequest of Josephine N. Hopper. 70.1143

Hopper spent the summer of 1912 in Gloucester, Massachusetts, a quaint New England coastal village which appealed to many artists. It was also in Gloucester, during the summer of 1923, that he first made the watercolors which initially won him recognition as a painter. He and Jo returned there in 1924 for their honeymoon. In 1928 they again summered there, and Hopper painted Prospect Street, *one of the few watercolors that he ever used as a study for an oil.*

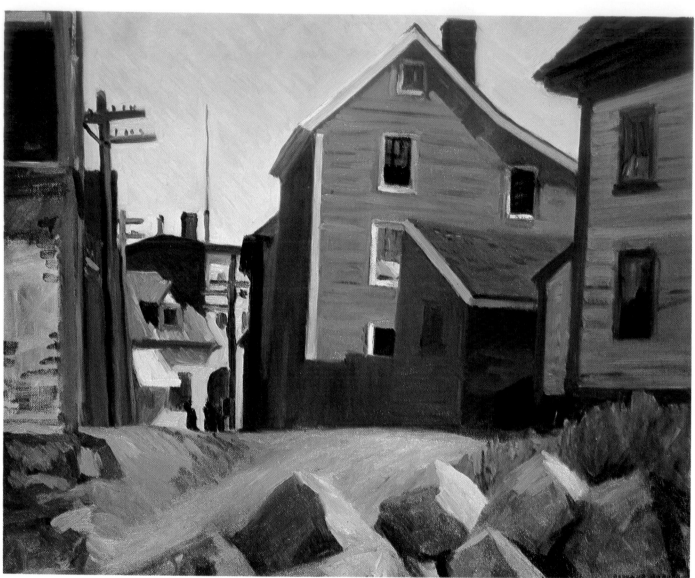

Pl. 196. *Italian Quarter, Gloucester,* 1912. Oil on canvas, 23¾ × 28½ inches. Whitney Museum of American Art, New York; Bequest of Josephine N. Hopper. 70.1214

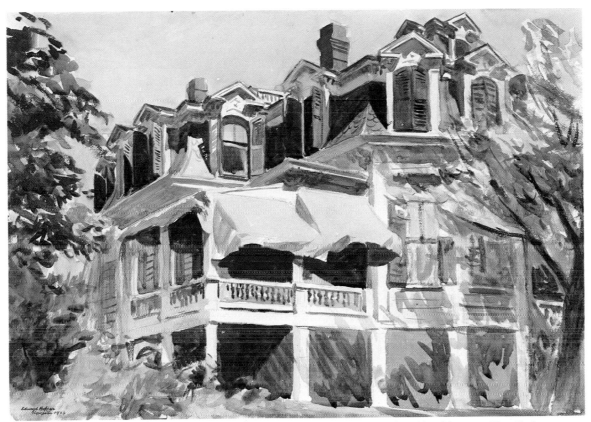

Pl. 197. *The Mansard Roof*, 1923. Watercolor on paper, 13¾ × 19 inches. The Brooklyn Museum, New York.

Pl. 198. *Dead Trees, Gloucester,* 1923. Watercolor on paper, 13 × 19 inches. Private collection.

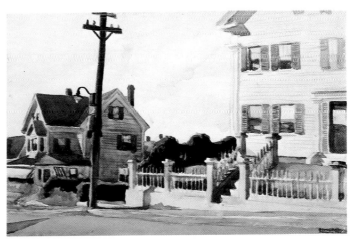

Pl. 199. *House with Fence,* 1923. Watercolor on paper, 11¾ × 18 inches. Collection of George M. Irwin.

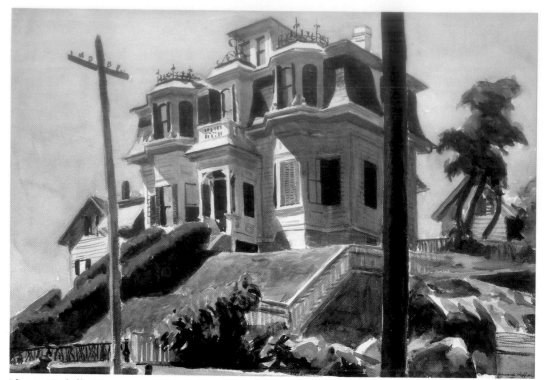

Pl. 200. *Haskell's House,* 1924. Watercolor on paper, 14 × 20 inches. Private collection.

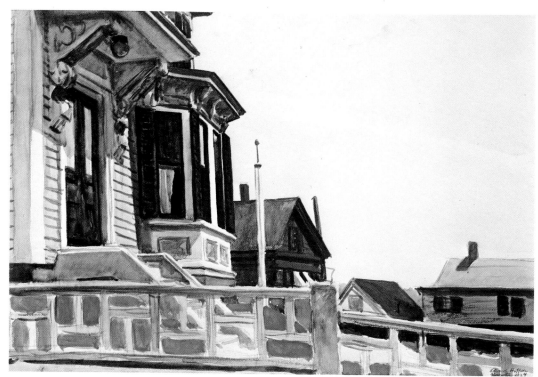

Pl. 201. *Parkhurst House (Captain's House),* 1924. Watercolor on paper, 13½ × 19 inches. Private collection.

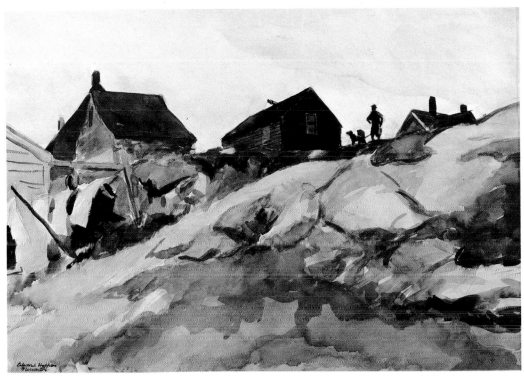

Pl. 202. *Rocks at the Fort, Gloucester*, 1924. Watercolor on paper, 13¾ × 19¾ inches. Collection of Mr. and Mrs. Alvin L. Snowiss.

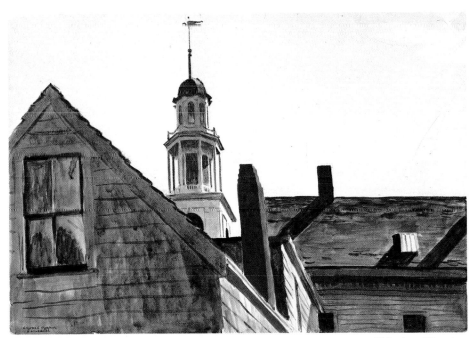

Pl. 203. *Universalist Church, Gloucester*, 1926. Watercolor on paper, 14 × 19⅞ inches. The Art Museum, Princeton University; The Laura P. Hall Memorial Collection.

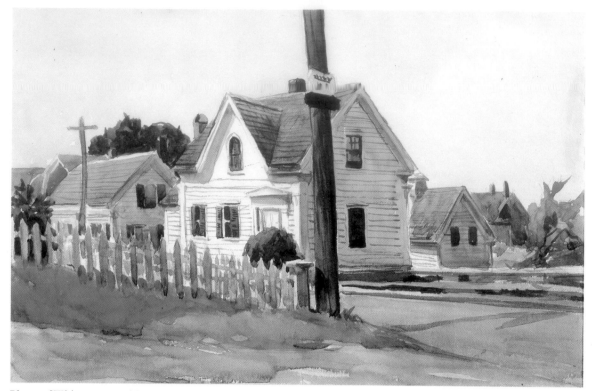

Pl. 204. [*White House with Dormer Window*], c. 1926–28. Watercolor on paper, 11¾ × 18 inches. Whitney Museum of American Art, New York; Bequest of Josephine N. Hopper. 70.1154

Pl. 205. [*Cars and Rocks*], c. 1927. Watercolor on paper, 13⅞ × 20 inches. Whitney Museum of American Art, New York; Bequest of Josephine N. Hopper. 70.1104

Pl. 206. [*Rocky Cove II*], c. 1927. Watercolor on paper, 13¹⁵⁄₁₆ × 20 inches. Whitney Museum of American Art, New York; Bequest of Josephine N. Hopper. 70.1139

Pl. 207. *Gloucester Houses,* 1928. Watercolor on paper, 16 × 22 inches. Private collection.

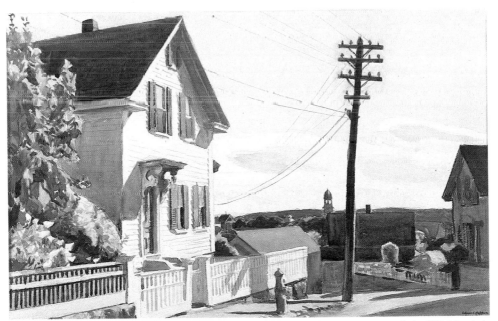

Pl. 208. *Adam's House,* 1928. Watercolor on paper, 16 × 25 inches. Courtesy of the Wichita Art Museum, Kansas; The Roland P. Murdock Collection.

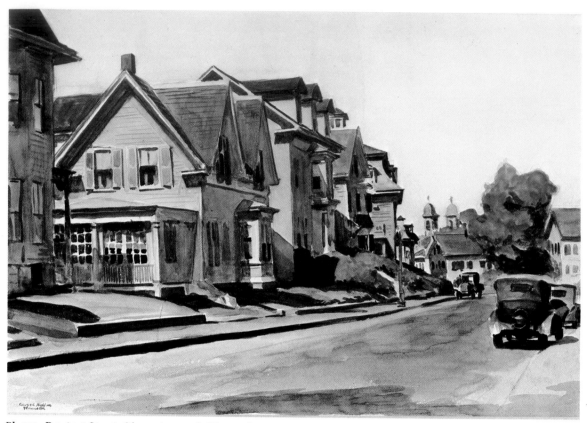

Pl. 209. *Prospect Street, Gloucester*, 1928. Watercolor on paper, 14 × 20 inches. Private collection.

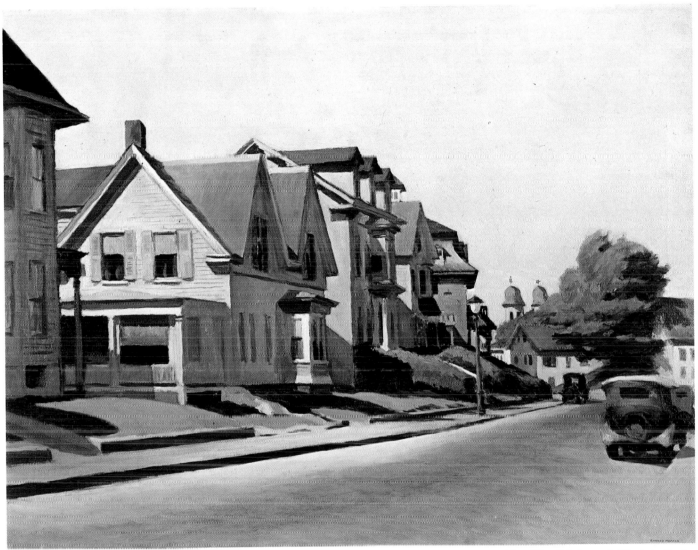

Pl. 210. *Sun on Prospect Street*, 1934. Oil on canvas, 28 × 36 inches. The Cincinnati Art Museum, Ohio; The Edwin and Virginia Irwin Memorial.

In 1935, Hopper commented on his early work as a commercial illustrator, "I was always interested in architecture, but the editors wanted people waving their arms." He painted and sketched buildings throughout his life, often preferring them over other subject matter.

Pl. 211. Drawing for painting, [*Stairway*], c. 1925. Conté on paper, 19¼ × 12⅛ inches. Whitney Museum of American Art, New York; Bequest of Josephine N. Hopper. 70.849

Pl. 212. [*Stairway*], c. 1925. Oil on wood, 16 × 11⅞ inches. Whitney Museum of American Art, New York; Bequest of Josephine N. Hopper. 70.1265

Pl. 213. *House with Bay Window*, 1925. Watercolor on paper, 15 × 20 inches. Private collection.

Pl. 214. [*Victorian House*], 1925–27. Watercolor on paper, 13⅞ × 19⅞ inches. Whitney Museum of American Art, New York; Bequest of Josephine N. Hopper. 70.1432

Pl. 215. *Haunted House,* 1926. Watercolor on paper, 14 × 20 inches. William A. Farnsworth Library and Art Museum, Rockland, Maine.

Pl. 216. [*Small Town Street*], c. 1926–28. Watercolor on paper, 13⅞ × 20 inches. Whitney Museum of American Art, New York; Bequest of Josephine N. Hopper. 70.1125

Pl. 217. *Custom House, Portland,* 1927. Watercolor on paper, 13¾ × 19½ inches. Wadsworth Atheneum, Hartford, Connecticut.

Pl. 218. *Hodgkin's House, Cape Ann, Massachusetts*, 1928. Oil on canvas, 28 × 36 inches. Private collection, Courtesy of Andrew Crispo Gallery, New York.

Pl. 220. *Coast Guard Station*, 1929. Oil on canvas, 29 × 43 inches. the Montclair Art Museum, Montclair, New Jersey.

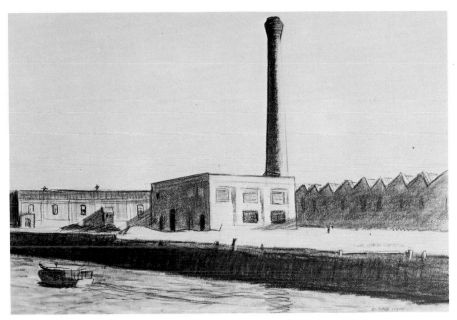

Pl. 219. *Salem*, 1929. Conté on paper, 15 × 22⅟₁₆ inches. Whitney Museum of American Art, New York; Bequest of Josephine N. Hopper. 70.307

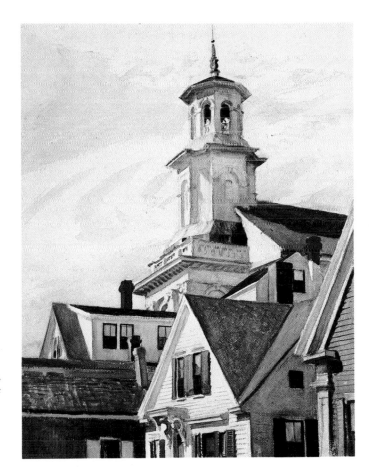

Pl. 221. *Methodist Church, Provincetown*, 1930. Watercolor on paper, 25 × 20 inches. Wadsworth Atheneum, Hartford, Connecticut; The Ella Gallup Sumner and Mary Catlin Sumner Collection.

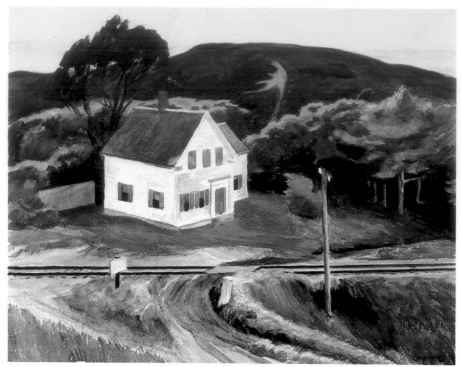

Pl. 222. *Captain Kelly's House,* 1931. Watercolor on paper, 20 × 24⅞ inches. Whitney Museum of American Art, New York; Bequest of Josephine N. Hopper. 70.1160

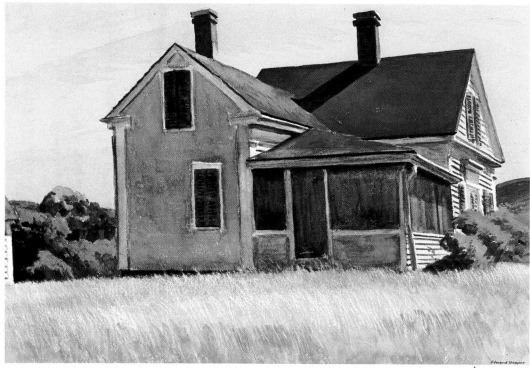

Pl. 223. *Marshall's House,* 1932. Watercolor on paper, 14 × 20 inches. Wadsworth Atheneum, Hartford, Connecticut.

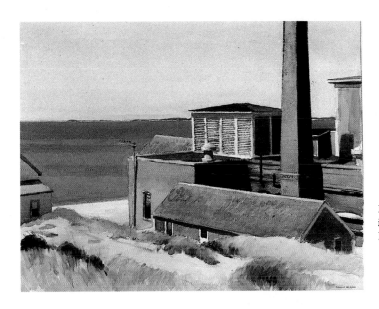

Pl. 224. *Cold Storage Plant,* 1933. Watercolor on paper, 20 × 25 inches. The Fogg Museum of Art, Harvard University, Cambridge, Massachusetts.

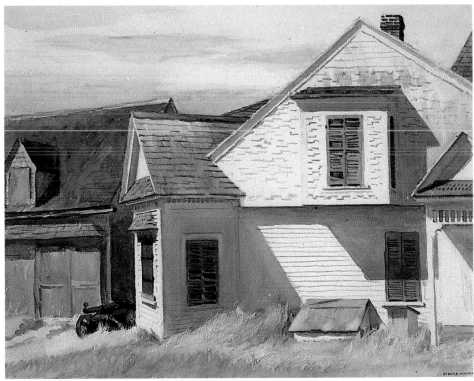

Pl. 225. *House on Pamet River,* 1934. Watercolor on paper, 20 × 25 inches. Whitney Museum of American Art, New York. 36.20

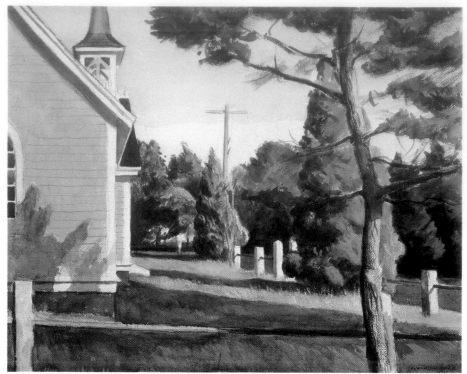

Pl. 226. [*Village Church*], c. 1934–35. Watercolor on paper, 19½ × 25 inches. Whitney Museum of American Art, New York; Bequest of Josephine N. Hopper. 70.1086

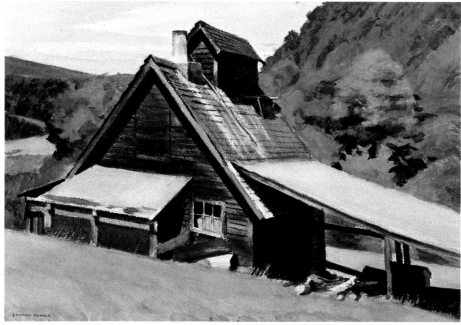

Pl. 227. *Vermont Sugar House,* 1938. Watercolor on paper, 13½ × 19½ inches. Collection of Harrison Investments.

Pl. 228. *Pretty Penny*, 1939. Oil on canvas, 29 × 40 inches. Smith College Museum of Art, Northampton, Massachusetts.

Pl. 229. Drawing for painting, *Pretty Penny*, 1939. Conté on paper, 10½ × 16 inches. Whitney Museum of American Art, New York; Bequest of Josephine N. Hopper. 70.983

Pl. 230. Drawing for painting, *Pretty Penny*, 1939. Conté on paper, 10½ × 16 inches. Whitney Museum of American Art, New York; Bequest of Josephine N. Hopper. 70.681

Pl. 231. *Two Puritans,* 1945. Oil on canvas, 30 × 40 inches. Private collection.

CITYSCAPES

Hopper was fascinated with cities, from Paris—which he once described as "graceful"—to "the raw disorder of New York." For most of the year New York was his home, the environment which inspired him. In the city, he found the settings and moods for some of his most poignant paintings.

Pl. 232. *Queensborough Bridge,* 1913. Oil on canvas, 25½ × 37½ inches. Whitney Museum of American Art, New York; Bequest of Josephine N. Hopper. 70.1184

Pl. 233. *New York Corner* or *Corner Saloon,* 1913. Oil on canvas, 24 × 29 inches. The Museum of Modern Art, New York; Abby Aldrich Rockefeller Fund.

Pl. 234. *Yonkers* or *Summer Street,* 1916. Oil on canvas, 24 × 29 inches. Whitney Museum of American Art, New York; Bequest of Josephine N. Hopper. 70.1215

Pl. 235. *Park Entrance,* c. 1918–20. Oil on canvas, 24 × 29 inches. Whitney Museum of American Art, New York; Bequest of Josephine N. Hopper. 70.1194

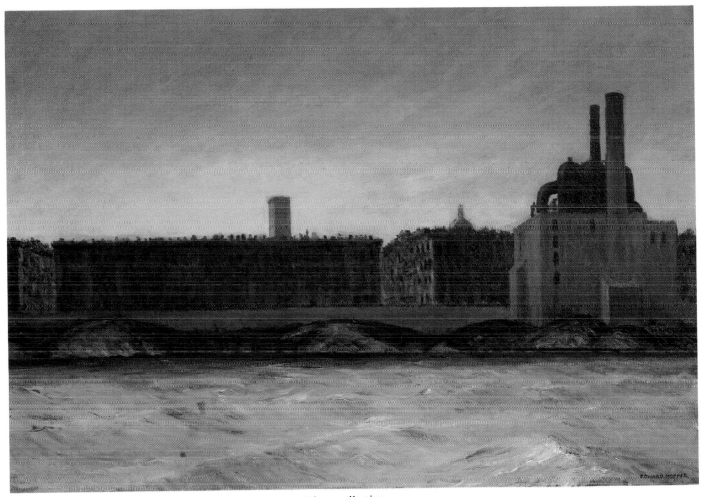

Pl. 236. *East River*, c. 1920–23. Oil on canvas, 32 × 46 inches. Private collection.

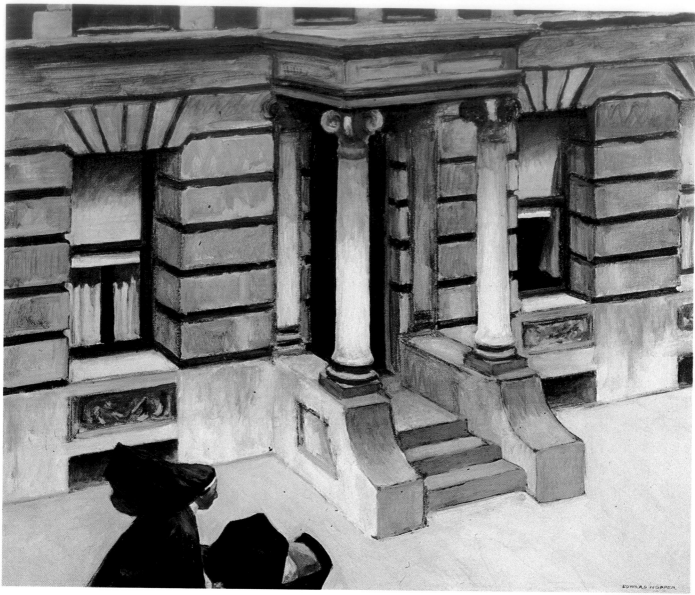

Pl. 237. *New York Pavements,* 1924. Oil on canvas, 24 × 29 inches. Chrysler Museum at Norfolk, Virginia; on loan from the collection of Walter P. Chrysler, Jr.

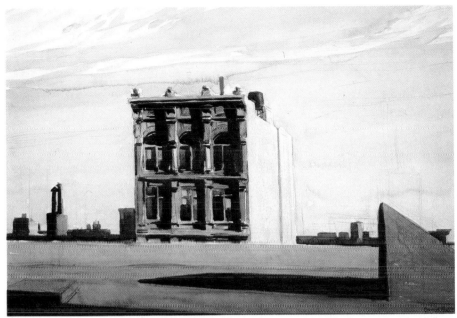

Pl. 238. *Skyline, Near Washington Square*, 1925. Watercolor on paper, 15¹⁄₁₆ × 21³⁄₁₆ inches. Munson-Williams-Proctor Institute, Museum of Art, Utica, New York; Edward W. Root Bequest.

Pl. 239. [*Rooftops*], c. 1926. Watercolor on paper, 13¹¹⁄₁₆ × 20 inches. Whitney Museum of American Art, New York; Bequest of Josephine N. Hopper. 70.1114

Pl. 240. *Manhattan Bridge and Lily Apartments*, 1926. Watercolor on paper, 13½ × 19½ inches. Collection of Mr. and Mrs. Joel Harnett.

Pl. 241. *The City*, 1927. Oil on canvas, 28 × 36 inches. University of Arizona, Museum of Art, Tucson, Arizona.

Pl. 242. *Drug Store*, 1927. Oil on canvas, 29 × 40 inches. Courtesy of the Museum of Fine Arts, Boston; Bequest of John T. Spaulding.

Pl. 243. *From Williamsburg Bridge,* 1928. Oil on canvas, 29 × 43 inches. The Metropolitan Museum of Art, New York; George A. Hearn Fund.

Pl. 244. Drawing for painting, *From Williamsburg Bridge,* 1928. Conté on paper, 8½ × 11 1/16 inches. Whitney Museum of American Art, New York; Bequest of Josephine N. Hopper. 70.457

Pl. 245. *Blackwell's Island,* 1928. Oil on canvas, 35 × 60 inches. Private collection.

Pl. 246. Drawing for painting, *Blackwell's Island,* 1928. Conté on paper, 10 1/16 × 14 inches. Whitney Museum of American Art, New York; Bequest of Josephine N. Hopper. 70.454

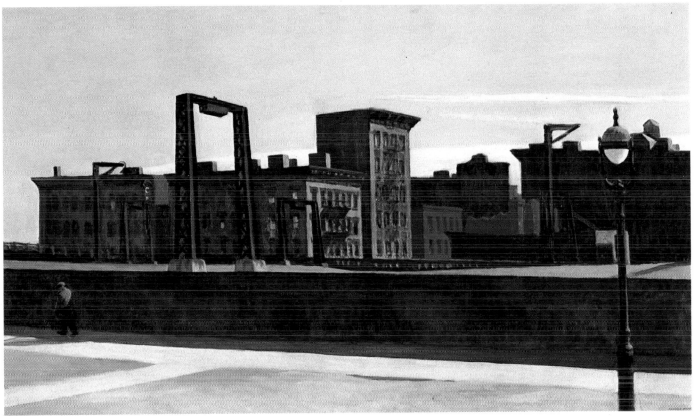

Pl. 247. *Manhattan Bridge Loop*, 1928. Oil on canvas, 35 × 60 inches. Addison Gallery of American Art, Phillips Academy, Andover, Massachusetts; Gift of Mr. Stephen C. Clark.

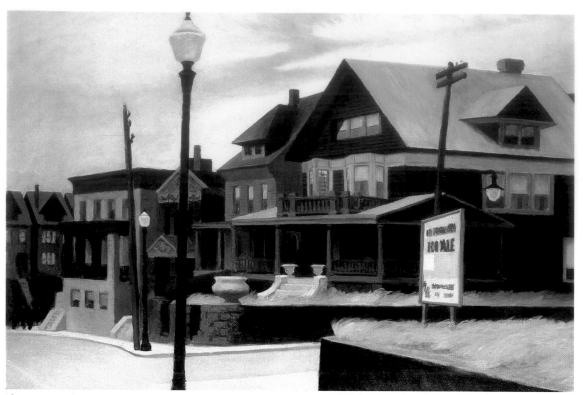

Pl. 248. *East Wind Over Weehawken*, 1934. Oil on canvas, 24¼ × 50¼ inches. Courtesy of the Pennsylvania Academy of the Fine Arts, Philadelphia; Collections Fund Purchase.

Pl. 249. Drawing for painting, *East Wind Over Weehawken*, 1934. Conté on paper, 10 × 14 inches. Whitney Museum of American Art, New York; Bequest of Josephine N. Hopper. 70.252

Pl. 250. Drawing for painting, *East Wind Over Weehawken*, 1934. Conté and pencil on paper, 10 × 14 inches. Whitney Museum of American Art, New York; Bequest of Josephine N. Hopper. 70.250

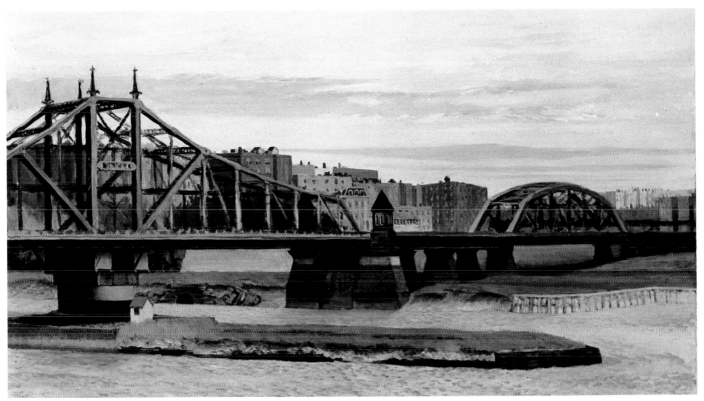

Pl. 251. *Macomb's Dam Bridge*, 1935. Oil on canvas, 35 × 60 inches. The Brooklyn Museum, New York.

Pl. 252. Drawing for painting, *Macomb's Dam Bridge*, 1935. Conté on paper, 8⅛ × 23½ inches. Whitney Museum of American Art, New York; Bequest of Josephine N. Hopper. 70.440

Pl. 253. Drawing for painting, *Macomb's Dam Bridge*, 1935. Pencil on paper, 9¼ × 18¼ inches. Whitney Museum of American Art, New York; Bequest of Josephine N. Hopper. 70.990

Pl. 254. *Bridle Path,* 1939. Oil on canvas, 28 × 42 inches. San Francisco Museum of Modern Art; Anonymous Gift.

Pl. 256. Drawing for painting, *Bridle Path,* 1939. Conté on paper, 8⅞ × 11⅞ inches. Whitney Museum of American Art, New York; Bequest of Josephine N. Hopper. 70.463

Pl. 255. Drawing for painting, *Bridle Path,* 1939. Conté on paper, 8⅞ × 11⅞ inches. Whitney Museum of American Art, New York; Bequest of Josephine N. Hopper. 70.219

Pl. 257. Drawing for painting, *Bridle Path,* 1939. Conté on paper, 22¹⁄₁₆ × 15 inches. Whitney Museum of American Art, New York; Bequest of Josephine N. Hopper. 70.857

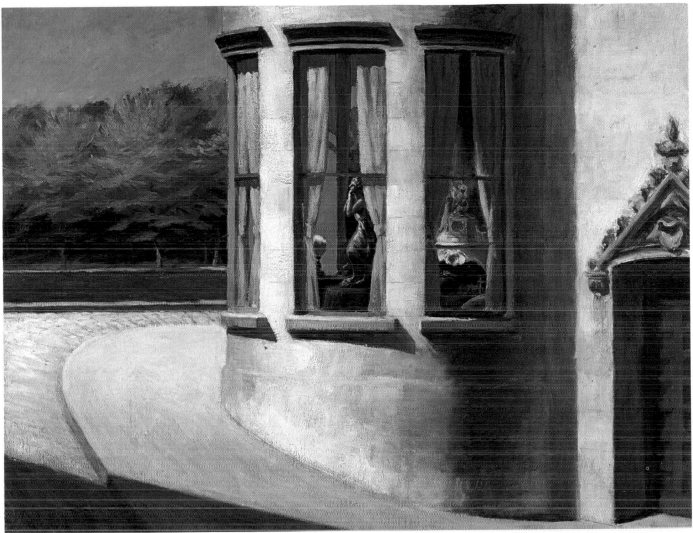

Pl. 258. *August in the City*, 1945. Oil on canvas, 23 × 30 inches. Norton Gallery and School of Art, West Palm Beach, Florida.

Pl. 259. Drawing for painting, *August in the City*, 1945. Conté on paper, 8½ × 11 inches. Whitney Museum of American Art, New York; Bequest of Josephine N. Hopper. 70.456

Hopper frequently traveled in America and Mexico, seeking inspiration. In so doing, he became interested in the psychology and environment of travelers—in hotels, motels, trains, highways, and filling stations. These became the haunting themes of many of his paintings.

Pl. 260. [*Steam Engine; Railroad of New Jersey*], c. 1896. Pencil on paper, 8 × 10 inches. Whitney Museum of American Art, New York; Bequest of Josephine N. Hopper. 70.1553.11

Pl. 261. *The El Station,* 1908. Oil on canvas, 20 × 29 inches. Whitney Museum of American Art, New York; Bequest of Josephine N. Hopper. 70.1182

Pl. 262. *Railroad Train*, 1908. Oil on canvas, 24 × 29 inches. Addison Gallery of American Art, Phillips Academy, Andover, Massachusetts; Gift of Dr. Fred T. Murphy.

Pl. 263. *Railroad Crossing*, c. 1922–23. Oil on canvas, 29 × 39¾ inches. Whitney Museum of American Art, New York; Bequest of Josephine N. Hopper. 70.1189

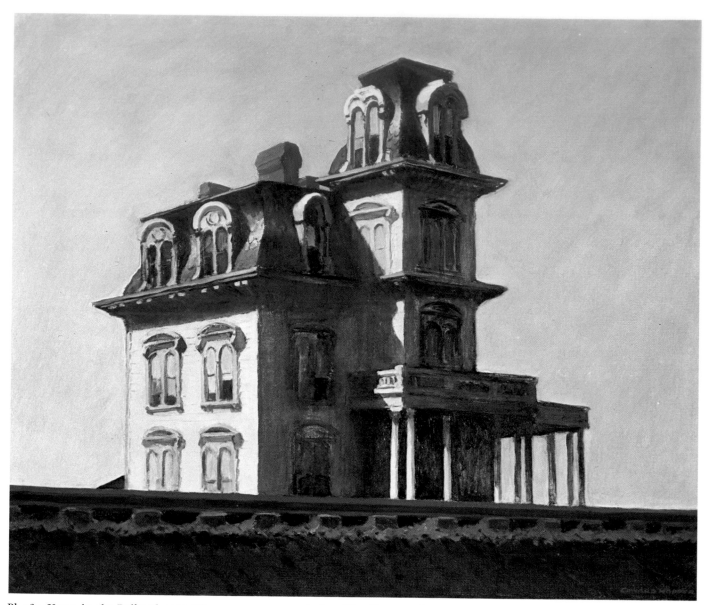

Pl. 264. *House by the Railroad*, 1925. Oil on canvas, 24 × 29 inches. The Museum of Modern Art, New York.

Pl. 265. *Lime Rock Railroad, Rockland, Maine*, 1926. Watercolor on paper, 14 × 19⅞ inches. The Art Museum, Princeton University; The Laura P. Hall Memorial Collection.

Pl. 266. *Railroad Crossing*, 1926. Watercolor on paper, 13½ × 19½ inches. Private collection.

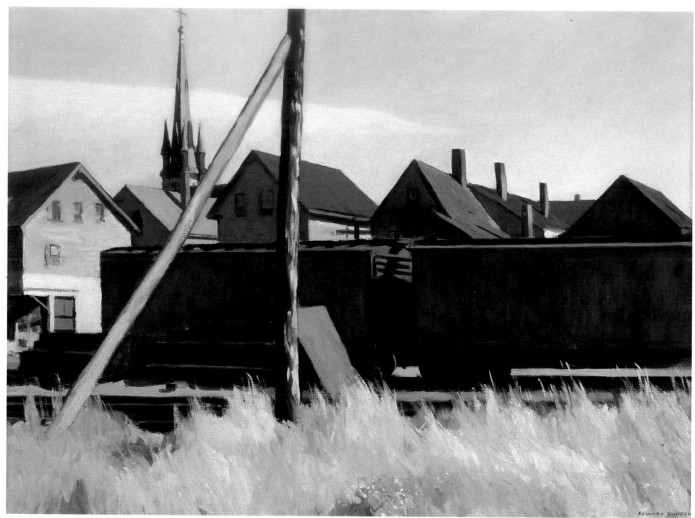

Pl. 267. *Freight Cars, Gloucester,* 1928. Oil on canvas, 29 × 40 inches. Addison Gallery of American Art, Phillips Academy, Andover, Massachusetts; Gift of Edward W. Root.

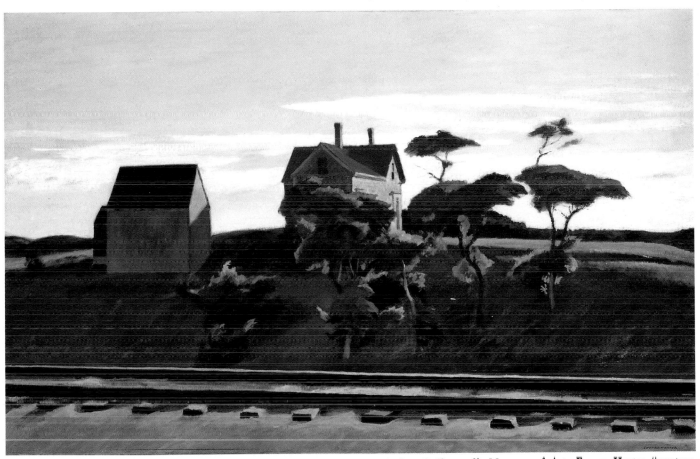

Pl. 268. *New York, New Haven, and Hartford,* 1931. Oil on canvas, 32 × 50 inches. Indianapolis Museum of Art; Emma Harter Sweetser Fund.

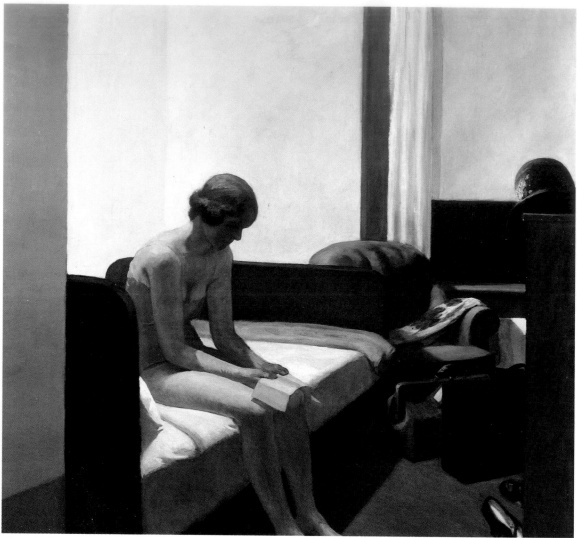

Pl. 269. *Hotel Room,* 1931. Oil on canvas, 60 × 65 inches. Thyssen-Bornemisza Collection.

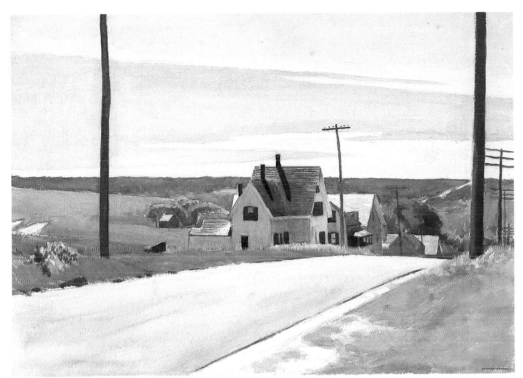

Pl. 270. *High Road*, 1931. Watercolor on paper, 20 × 28 inches. Whitney Museum of American Art, New York; Bequest of Josephine N. Hopper. 70.1163

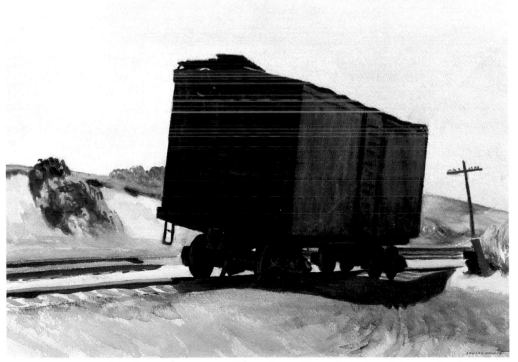

Pl. 271. *Box Car, Freight Car at Truro*, 1931. Watercolor, 13¾ × 19¾ inches. Private collection.

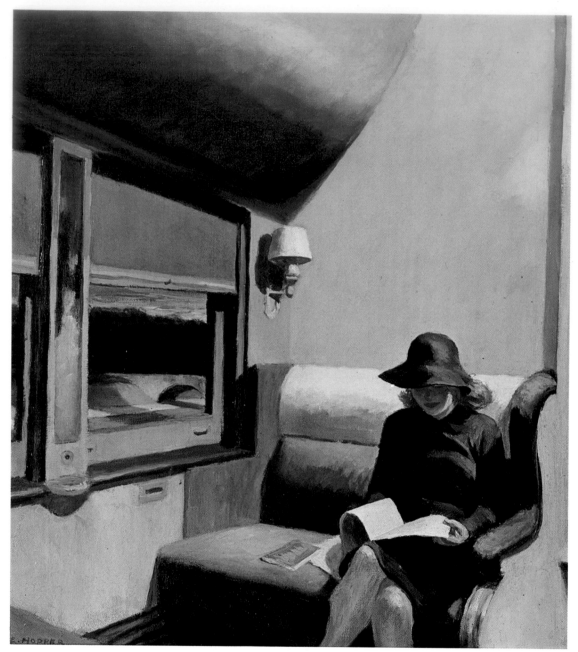

Pl. 272. *Compartment C, Car 293*, 1938. Oil on canvas, 20 × 18 inches. IBM Corporation, Armonk, New York.

Pl. 273. Drawing for painting, *Compartment C, Car 293*, 1938. Conté on paper, 8 × 10½ inches. Whitney Museum of American Art, New York; Bequest of Josephine N. Hopper. 70.431

Pl. 274. Drawing for painting, *Compartment C, Car 293*, 1938. Conté on paper, 15¹⁄₁₆ × 22 inches. Whitney Museum of American Art, New York; Bequest of Josephine N. Hopper. 70.430

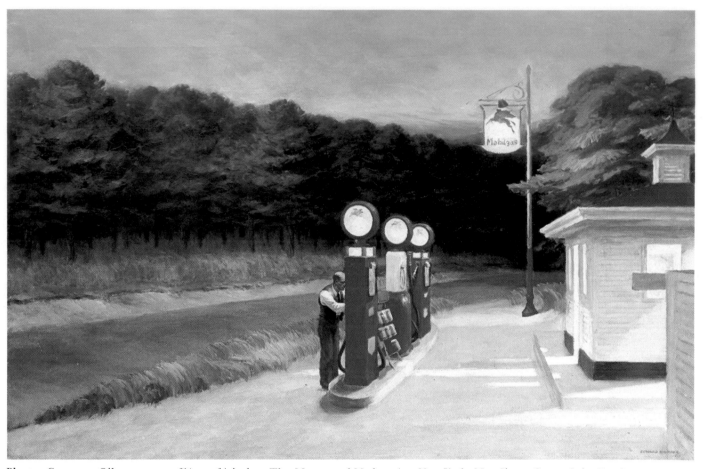

Pl. 275. *Gas*, 1940. Oil on canvas, 26¼ × 40¼ inches. The Museum of Modern Art, New York; Mrs. Simon Guggenheim Fund.

Pl. 276. Drawing for painting, *Gas*, 1940. Conté on paper, 8⅞ × 11⅞ inches. Whitney Museum of American Art, New York; Bequest of Josephine N. Hopper. 70.225

Pl. 277. Drawing for painting, *Gas*, 1940. Conté and charcoal with touches of white paint on paper, 15 × 22⅛ inches. Whitney Museum of American Art, New York; Bequest of Josephine N. Hopper. 70.349

Pl. 278. *Route 6, Eastham,* 1941. Oil on canvas, 27 × 38 inches. Sheldon Swope Art Gallery, Terre Haute, Indiana.

Pl. 279. Drawing for painting, *Route 6, Eastham,* 1941. Conté on paper, 10½ × 16 inches. Whitney Museum of American Art, New York; Bequest of Josephine N. Hopper. 70.445

Pl. 280. Drawing for painting, *Route 6, Eastham,* 1941. Conté on paper, 10½ × 16 inches. Whitney Museum of American Art, New York; Bequest of Josephine N. Hopper. 70.330

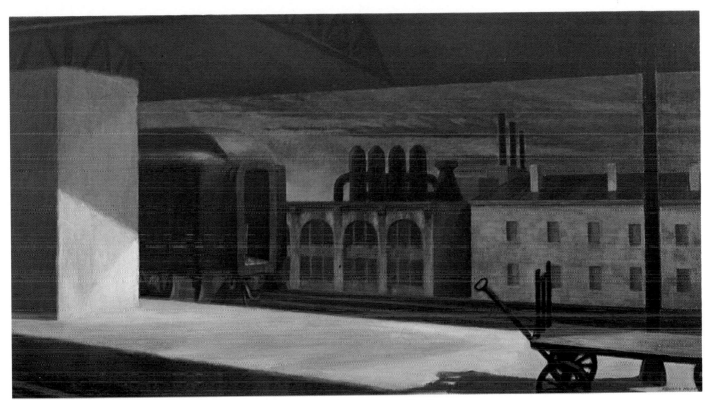

Pl. 281. *Dawn in Pennsylvania*, 1942. Oil on canvas, 24½ × 44½ inches. Private collection.

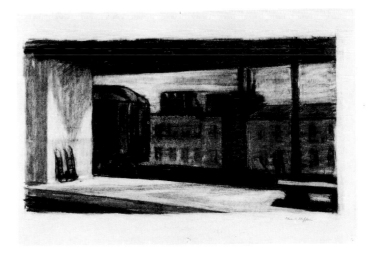

Pl. 282. Drawing for painting, *Dawn in Pennsylvania*, 1942. Conté on paper, 15 × 22⅛ inches. Whitney Museum of American Art, New York; Bequest of Josephine N. Hopper. 70.850

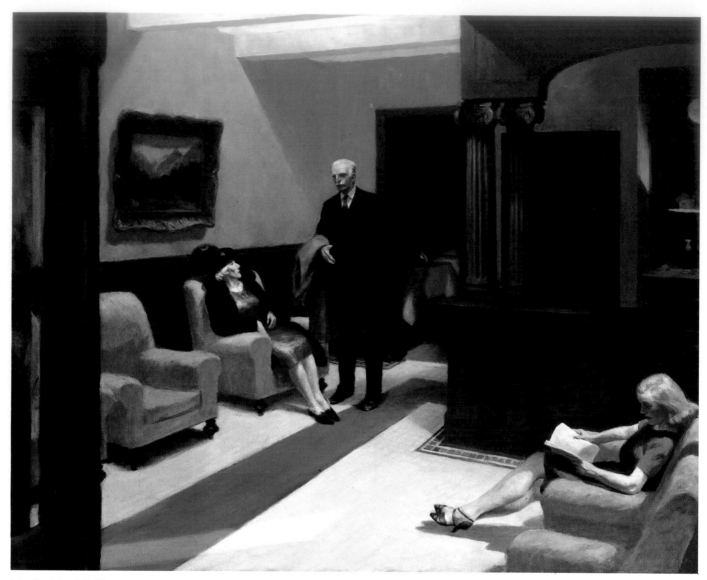

Pl. 283. *Hotel Lobby*, 1943. Oil on canvas, 32½ × 40¾ inches. Indianapolis Museum of Art; William Ray Adams Memorial Collection.

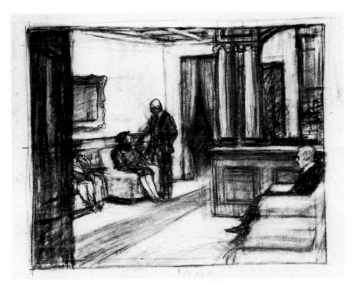

Pl. 284. Drawing for painting, *Hotel Lobby*, 1943. Conté on paper, 8½ × 11 inches. Whitney Museum of American Art, New York; Bequest of Josephine N. Hopper. 70.117

Pl. 285. Drawing for painting, *Hotel Lobby*, 1943. Conté and pencil on paper, 8½ × 11 inches. Whitney Museum of American Art, New York; Bequest of Josephine N. Hopper 70.116

Pl. 287. Drawing for painting, *Hotel Lobby*, 1943. Conté on paper, 15 × 22 inches. Whitney Museum of American Art, New York; Bequest of Josephine N. Hopper. 70.839

Pl. 286. Drawing for painting, *Hotel Lobby*, 1943. Conté on paper, 15 × 22⅛ inches. Whitney Museum of American Art, New York; Bequest of Josephine N. Hopper. 70.996

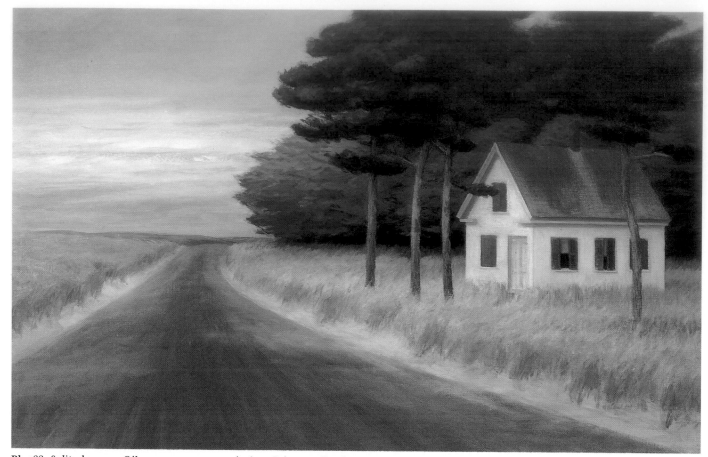

Pl. 288. *Solitude*, 1944. Oil on canvas, 32 × 50 inches. Private collection.

Pl. 289. Drawing for painting, *Solitude*, 1944. Conté on paper, 15⅟₁₆ × 22⅛ inches. Whitney Museum of American Art, New York; Bequest of Josephine N. Hopper. 70.855

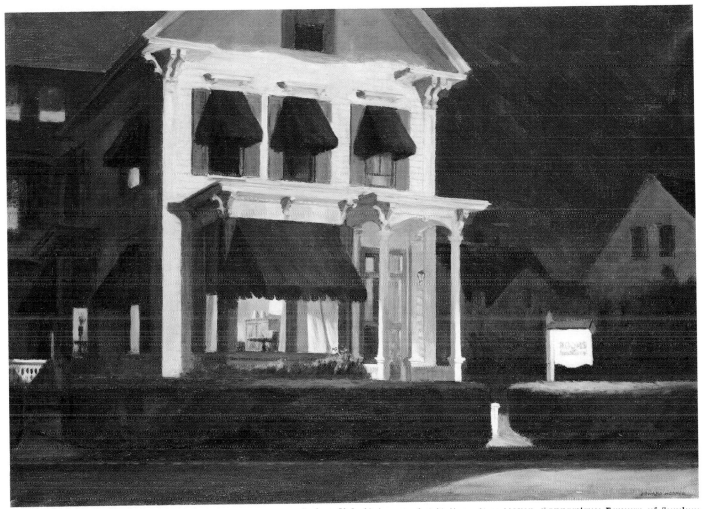

Pl. 290. *Rooms for Tourists*, 1945. Oil on canvas, 30 × 40 inches. Yale University Art Gallery, New Haven, Connecticut; Bequest of Stephen Carlton Clark, B.A., 1903.

Pl. 291. Drawing for painting, *Rooms for Tourists*, 1945. Conté and charcoal on paper, 10⅜ × 16 inches. Whitney Museum of American Art, New York; Bequest of Josephine N. Hopper. 70.438

Pl. 292. Drawing for painting, *Rooms for Tourists*, 1945. Conté on paper, 15 × 22¼ inches. Whitney Museum of American Art, New York; Bequest of Josephine N. Hopper. 70.848

Pl. 293. Drawing for painting, *Rooms for Tourists*, 1945. Conté on paper, 10⅜ × 16 inches. Whitney Museum of American Art, New York; Bequest of Josephine N. Hopper. 70.221

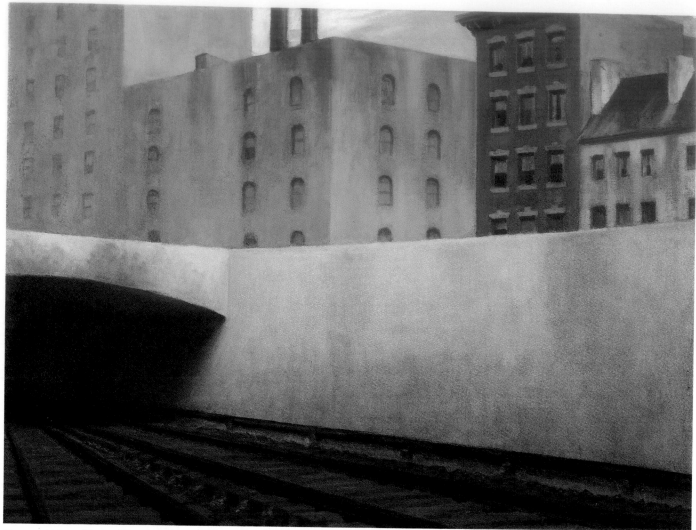

Pl. 294. *Approaching a City*, 1946. Oil on canvas, 27 × 36 inches. The Phillips Collection, Washington, D.C.

Pl. 295. Drawing for painting, *Approaching a City*, 1946. Conté on paper, 15¹⁄₁₆ × 22⅛ inches. Whitney Museum of American Art, New York; Bequest of Josephine N. Hopper. 70.869

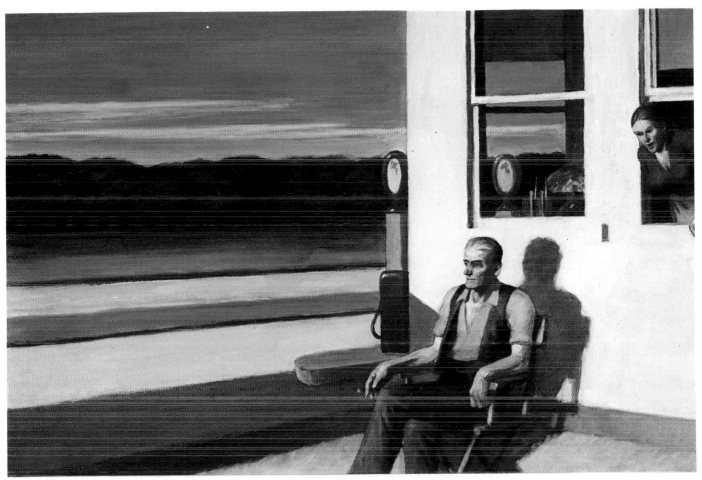

Pl. 296. *Four Lane Road*, 1956. Oil on canvas, 27½ × 41½ inches. Private collection.

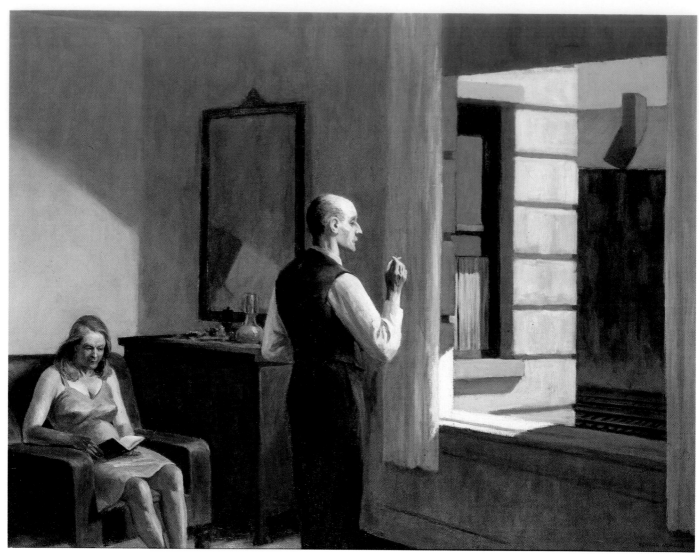

Pl. 297. *Hotel by a Railroad,* 1952. Oil on canvas, 31 × 40 inches. Hirshhorn Museum and Sculpture Garden, Smithsonian Institution, Washington, D.C.

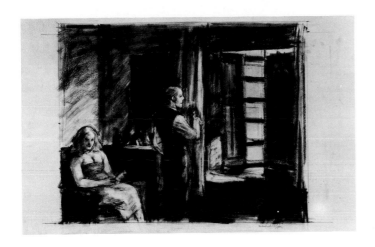

Pl. 298. Drawing for painting, *Hotel by a Railroad*, 1952. Conté on paper, 12 × 19 inches. Whitney Museum of American Art, New York; Bequest of Josephine N. Hopper. 70.427

Pl. 299. Drawing for painting, *Hotel by a Railroad*, 1952. Conté on paper, 19 × 11¹⁵⁄₁₆ inches. Whitney Museum of American Art, New York; Bequest of Josephine N. Hopper. 70.874

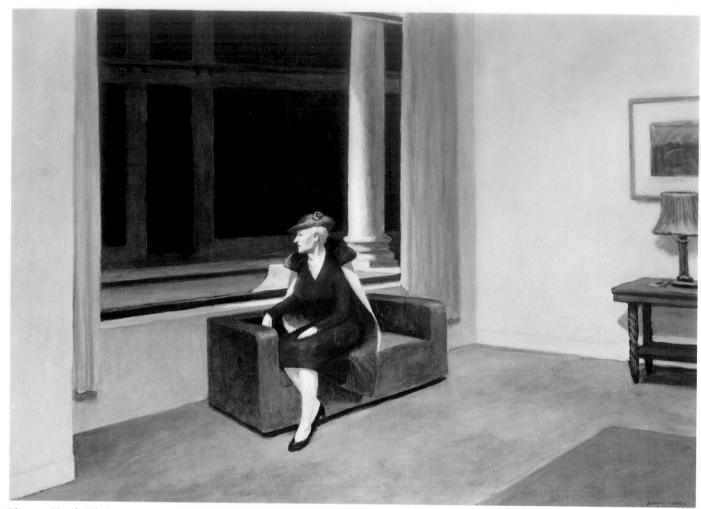

Pl. 300. *Hotel Window,* 1956. Oil on canvas, 40 × 55 inches. Thyssen-Bornemisza Collection.

Pl. 301. Drawing for painting, *Hotel Window,* 1956. Conté and pencil on paper, 8½ × 11 inches. Whitney Museum of American Art, New York; Bequest of Josephine N. Hopper. 70.161

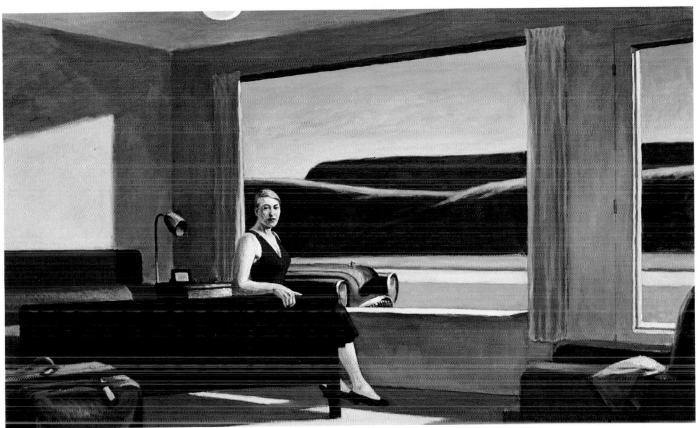

Pl. 302. *Western Motel*, 1957. Oil on canvas, 30¼ x 50⅛ inches. Yale University Art Gallery, New Haven, Connecticut; Bequest of Stephen Carlton Clarke, B.A., 1903.

Pl. 303. *Canal at Charenton,* 1907. Oil on canvas, 23¼ × 28¼ inches. Whitney Museum of American Art, New York; Bequest of Josephine N. Hopper. 70.1246

Pl. 304. *Road and Trees,* 1962. Oil on canvas, 34 × 60 inches. Collection of Mr. and Mrs. Daniel W. Dietrich II.

PI. 305. *Chair Car*, 1965. Oil on canvas, 40 × 50 inches. Private collection.

LOCAL COLOR

Although he rarely painted oils on his travels, Hopper produced many watercolors which recorded specific locales. Often choosing unusual subject matter rather than the sights that might appeal to the average tourist, he conveyed a sense of place with an individual vision.

Pl. 306. [*St. Michael's College, Santa Fe*], 1925. Watercolor on paper, 13⅞ × 19¹⁵⁄₁₆ inches. Whitney Museum of American Art, New York; Bequest of Josephine N. Hopper. 70.1158

Pl. 307. [*Adobes and Shed, New Mexico*], 1925. Watercolor on paper, 13⅞ × 19¹⁵⁄₁₆ inches. Whitney Museum of American Art, New York; Bequest of Josephine N. Hopper. 70.1121

Pl. 308. *Adobe Houses,* 1925. Watercolor on paper, 13⅝ × 19⅝ inches. Private collection.

Pl. 309. [*Railroad Trestle in the Desert*], 1925. Watercolor on paper, 13¹⁵⁄₁₆ × 9⅞ inches. Whitney Museum of American Art, New York; Bequest of Josephine N. Hopper. 70.1099

Pl. 310. *St. Francis Tower, Santa Fe,* 1925. Watercolor on paper, 13½ × 19½ inches. The Phillips Collection, Washington, D.C.

Pl. 311. [*Cabin, Charleston, S.C.*], 1929. Watercolor on paper, 13^{15}/$_{16}$ × 19^{15}/$_{16}$ inches. Whitney Museum of American Art. New York; Bequest of Josephine N. Hopper. 70.1147

Pl. 312. Drawing for watercolor, [*Cabin, Charleston, S.C.*], 1929. Conté on paper, 15 × 22^{1}/$_{16}$ inches. Whitney Museum of American Art, New York; Bequest of Josephine N. Hopper. 70.670

Pl. 313. *Baptistry of Saint John's,* 1929. Watercolor on paper, 13⅝ × 19⅝ inches. Private collection.

Pl. 314. Drawing for painting, *Baptistry of Saint John's,* 1929. Conté on paper, 22⅛ × 15 inches. Whitney Museum of American Art, New York; Bequest of Josephine N. Hopper. 70.302

Pl. 315. *Charleston Doorway*, 1929. Watercolor on paper, 14 × 20 inches. Private collection.

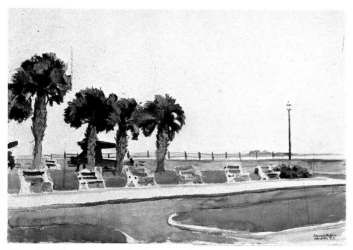

Pl. 316. [*The Battery, Charleston, S.C.*], 1929. Watercolor on paper, 13⅞ × 19¹⁵⁄₁₆ inches. Whitney Museum of American Art, New York; Bequest of Josephine N. Hopper. 70.1145

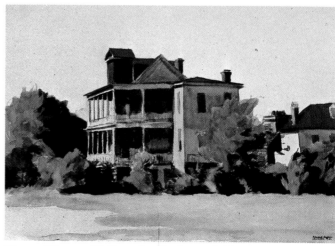

Pl. 317. [*House with Veranda, Charleston, S.C.*], 1929. Watercolor on paper, 13⅞ × 20 inches. Whitney Museum of American Art, New York; Bequest of Josephine N. Hopper. 70.1146

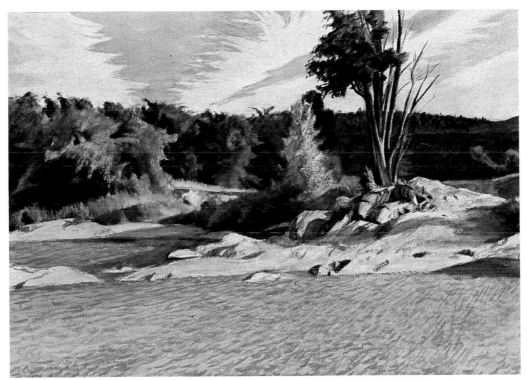

Pl. 318. *White River at Sharon*, 1937. Watercolor on paper, 19⅜ × 27½ inches. The Sara Roby Foundation, New York.

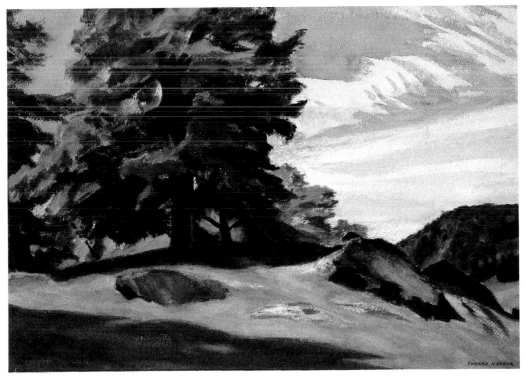

Pl. 319. *Sugar Maple*, 1938. Watercolor on paper, 14 × 20 inches. Private collection.

Pl. 320. [*Roofs, Saltillo, Mexico*], 1946. Watercolor on paper, 21 × 29 inches. Whitney Museum of American Art, New York; Bequest of Josephine N. Hopper. 70.1162

Pl. 321. *El Palacio*, 1946. Watercolor on paper, 20¾ × 28⅝ inches. Whitney Museum of American Art, New York. 50.2

Pl. 322. *Carolina Morning*, 1955. Oil on canvas, 30 × 40 inches. Whitney Museum of American Art, New York; Given in memory of Otto L. Spaeth by his family. 67.13

Pl. 323. *California Hills,* 1957. Watercolor on paper, 21½ × 29¼ inches. Hallmark Collection, Hallmark Cards, Inc., Kansas City, Missouri.

From childhood, Hopper was fascinated with the interaction of people in restaurants. He later developed this theme, achieving a diversity of moods through light, composition, and the figures he depicted.

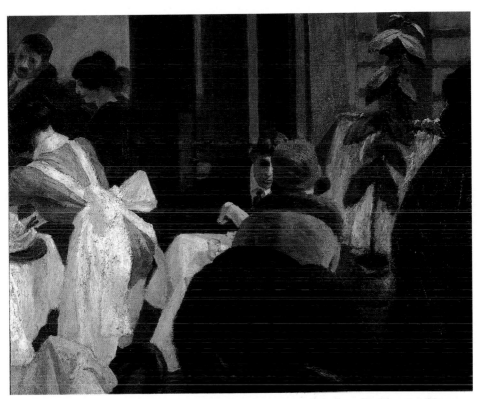

Pl. 326. *New York Restaurant*, c. 1922. Oil on canvas, 24 × 30 inches. Hackley Art Museum, Muskegon, Michigan.

Pl. 324. [*Restaurant Scene*], 1894. Pencil on paper, 5 × 8 inches. Whitney Museum of American Art, New York; Bequest of Josephine N. Hopper. 70.1561.161

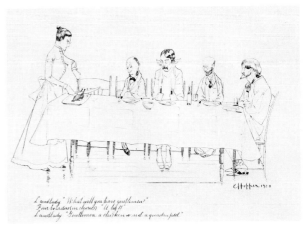

Pl. 325. [*Landlady and Boarders*], c. 1900. Pen and ink on paper, 11⅜ × 14¼ inches. Whitney Museum of American Art, New York; Bequest of Josephine N. Hopper. 70.1566.146

Pl. 327. *Automat,* 1927. Oil on canvas, 28⅛ × 36 inches. Des Moines Art Center, Iowa; James D. Edmundson Fund, 1958.

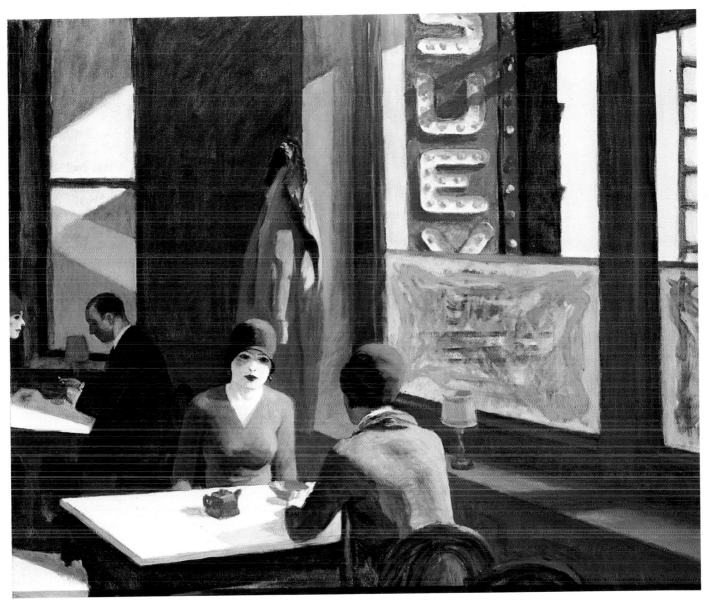

Pl. 328. *Chop Suey*, 1929. Oil on canvas, 32⅛ × 38⅛ inches. Collection of Barney A. Ebsworth.

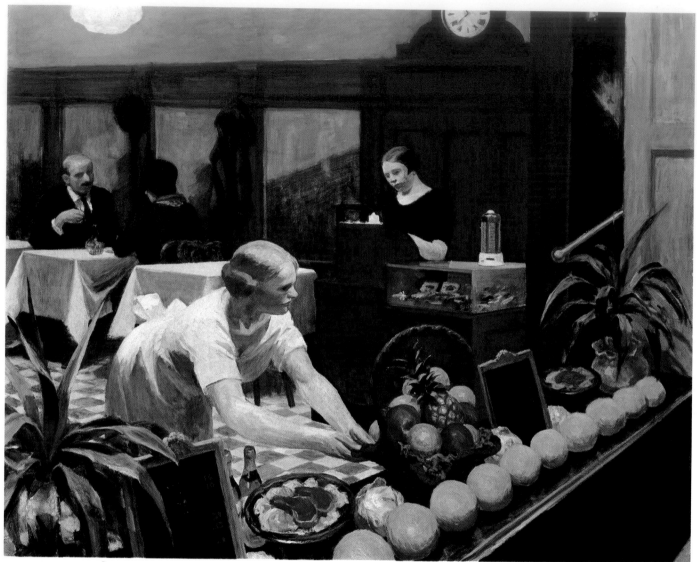

Pl. 329. *Tables for Ladies*, 1930. Oil on canvas, 48¼ × 60¼ inches. The Metropolitan Museum of Art, New York; George A. Hearn Fund, 1931.

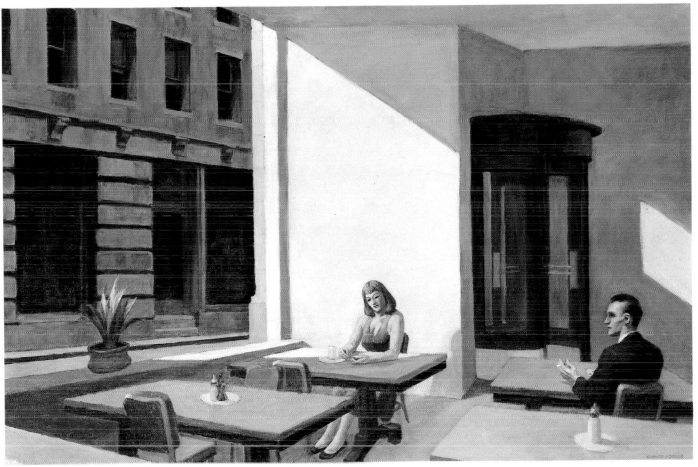

Pl. 330. *Sunlight in a Cafeteria*, 1958. Oil on canvas, 40¼ × 60⅛ inches. Yale University Art Gallery, New Haven, Connecticut.

Hopper's love of theater began in childhood—he assisted his sister in staging puppet shows and plays at home. Encouraged by his teacher Robert Henri to attend theatrical performances, Hopper later went to movies or plays as an escape, when he found himself unable to paint.

Pl. 331. *Acrobats*, c. 1898–99. Pencil on paper, 5 × 7¹⁵⁄₁₆ inches. Whitney Museum of American Art, New York; Bequest of Josephine N. Hopper. 70.1553.21

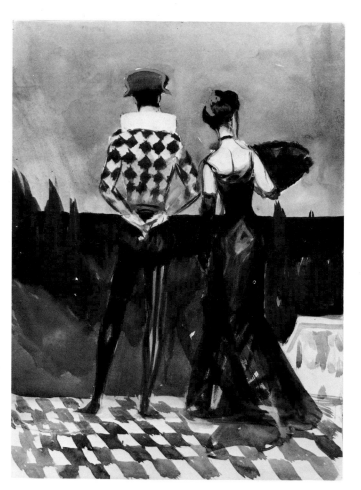

Pl. 334. *Before the Footlights*, c. 1900. Pen and ink on paper, 14¹³⁄₁₆ × 5⅝ inches. Whitney Museum of American Art, New York; Bequest of Josephine N. Hopper. 70.1558.82

Pl. 332. [*Harlequin and Lady in Evening Dress*], c. 1900. Watercolor on illustration board, 14⁹⁄₁₆ × 10⅝ inches. Whitney Museum of American Art, New York; Bequest of Josephine N. Hopper. 70.1629

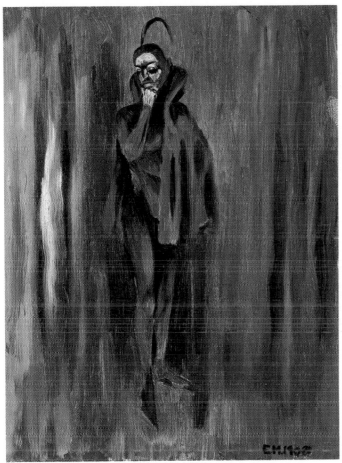

Pl. 333. [*Satan in Red*], 1900. Oil on board, 12¼ × 9¼ inches. Whitney Museum of American Art, New York; Bequest of Josephine N. Hopper. 70.1419

Pl. 335. [*Solitary Figure in a Theatre*], c. 1902–4. Oil on board, 12½ × 9³⁄₁₆ inches. Whitney Museum of American Art, New York; Bequest of Josephine N. Hopper. 70.1418

Pl. 336. *Anno Domini XIXCV*, 1905. Conté on paper, 18½ × 24 inches. Whitney Museum of American Art, New York; Bequest of Josephine N. Hopper. 70.1532

Pl. 337. [*Ibsen: At the Theatre*], 1900–1906. Pencil and wash on illustration board, 22 × 15 inches. Whitney Museum of American Art, New York; Bequest of Josephine N. Hopper. 70.1355

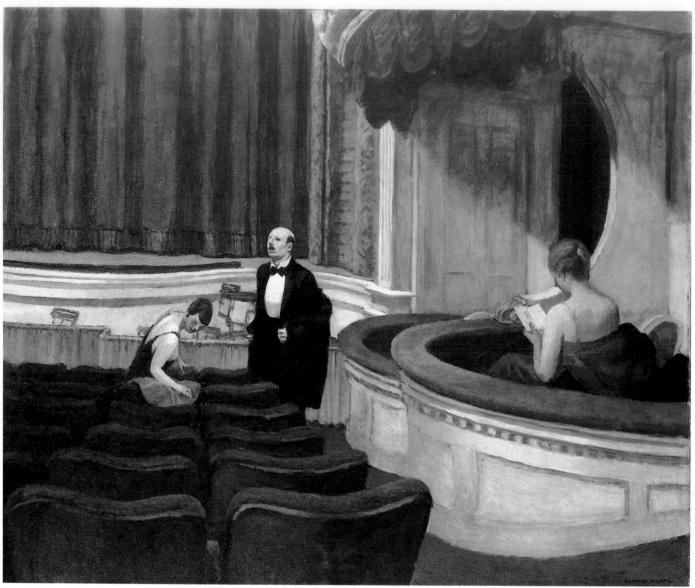

Pl. 338. *Two on the Aisle*, 1927. Oil on canvas, 40¼ × 48¼ inches. The Toledo Museum of Art; Gift of Edward Drummond Libbey.

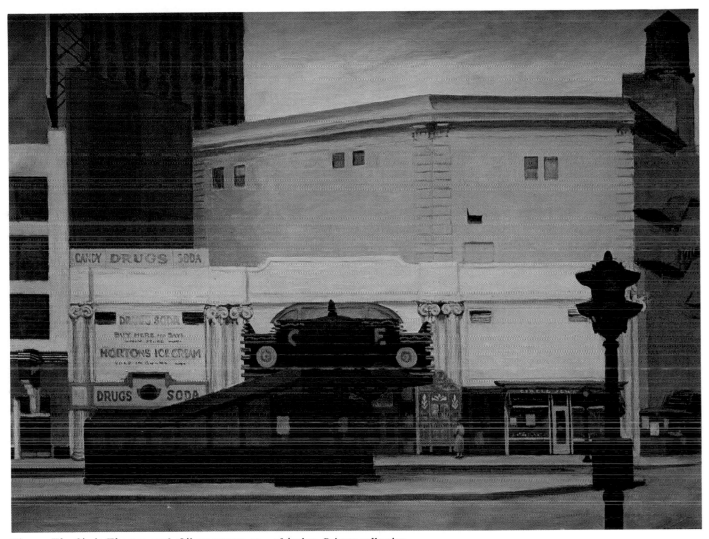

Pl. 339. *The Circle Theatre*, 1936. Oil on canvas, 27 × 96 inches. Private collection.

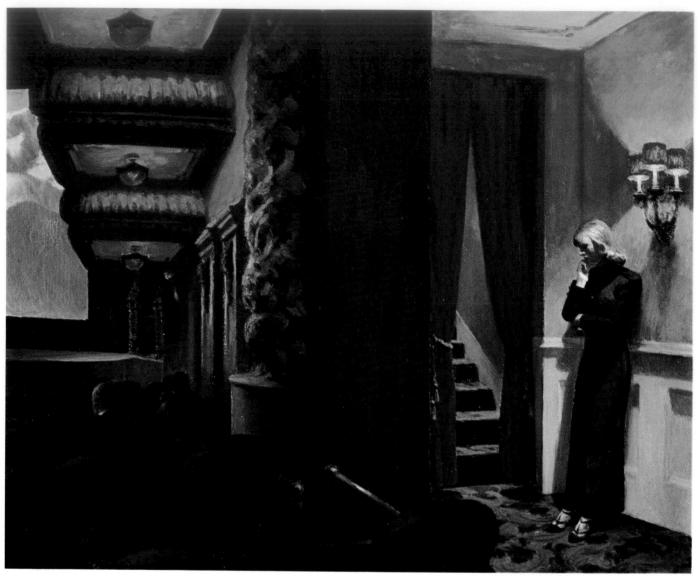

Pl. 340. *New York Movie*, 1939. Oil on canvas, 32¼ × 40⅛ inches. The Museum of Modern Art, New York.

Pl. 342. Drawing for painting, *New York Movie; Palace*, 1939. Conté on paper, 8⅞ × 11⅞ inches. Whitney Museum of American Art, New York; Bequest of Josephine N. Hopper. 70.111

Pl. 341. Drawing for painting, *New York Movie*, 1939. Conté on paper, 15⅛ × 7¾ inches. Whitney Museum of American Art, New York; Bequest of Josephine N. Hopper. 70.447

Pl. 343. Drawing for painting, *New York Movie*, 1939. Conté on paper, 11 × 15 inches. Whitney Museum of American Art, New York; Bequest of Josephine N. Hopper. 70.272

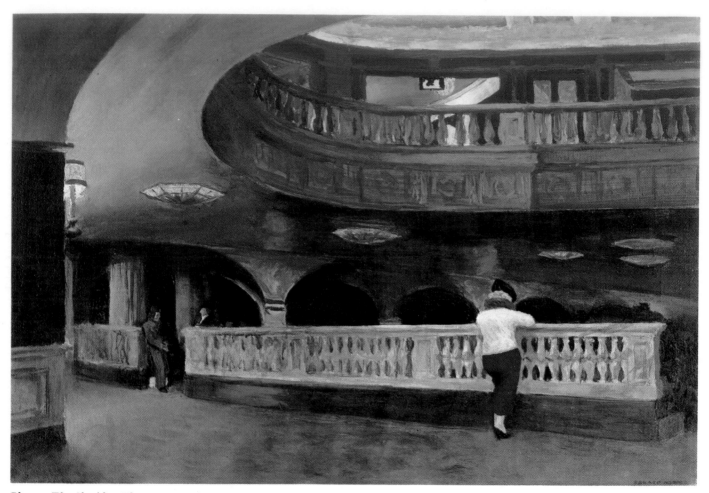

Pl. 344. *The Sheridan Theatre,* 1937. Oil on canvas, 17 × 25 inches. The Newark Museum, New Jersey; Purchase 1940, Felix Bequest Fund.

Pl. 345. Drawing for painting, *The Sheridan Theatre,* 1936–37. Conté on paper, 4½ × 7⅛ inches. Whitney Museum of American Art, New York; Bequest of Josephine N. Hopper. 70.958

Pl. 346. Drawing for painting, *The Sheridan Theatre,* 1936–37. Conté on paper, 4½ × 7⅛ inches. Whitney Museum of American Art, New York; Bequest of Josephine N. Hopper. 70.963

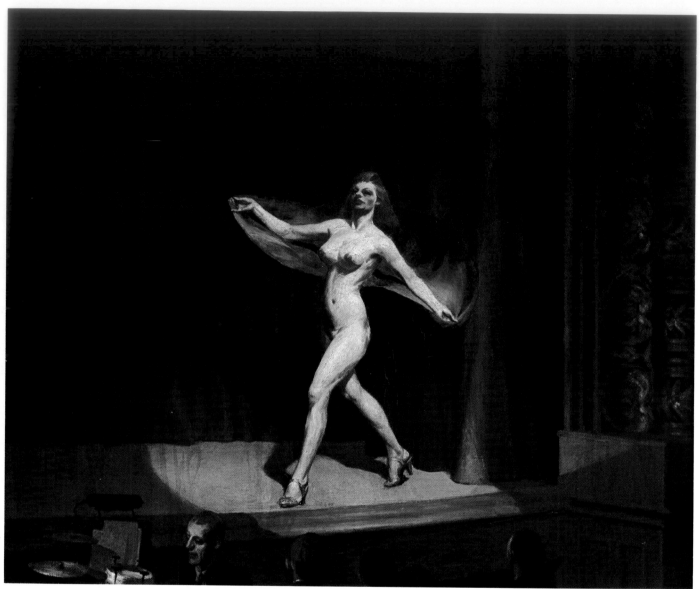

Pl. 347. *Girlie Show,* 1941. Oil on canvas, 32 × 38 inches. Private collection.

Pl. 348. Drawing for painting, *Girlie Show*, 1941. Conté on paper, 13¼ × 15 inches. Whitney Museum of American Art, New York; Bequest of Josephine N. Hopper. 70.295

Pl. 349. Drawing for painting, *Girlie Show*, 1941. Conté on paper, 22⅛ × 15¹⁄₁₆ inches. Whitney Museum of American Art, New York; Bequest of Josephine N. Hopper. 70.301

Pl. 350. *First Row Orchestra,* 1951. Oil on canvas, 31 × 40 inches. Hirshhorn Museum and Sculpture Garden, Smithsonian Institution. Washington, D.C.

Pl. 351. Drawing for painting, *First Row Orchestra,* 1951. Conté on paper, 17¹/₁₆ × 20⁷/₁₆ inches. Whitney Museum of American Art. New York; Bequest of Josephine N. Hopper. 70.841

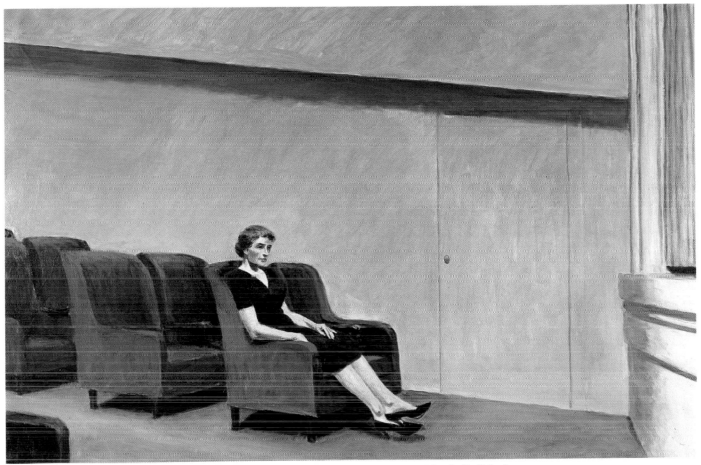

Pl. 352. *Intermission*, 1963. Oil on canvas, 40 × 60 inches. Collection of Mr. and Mrs. Morris B. Pelavin.

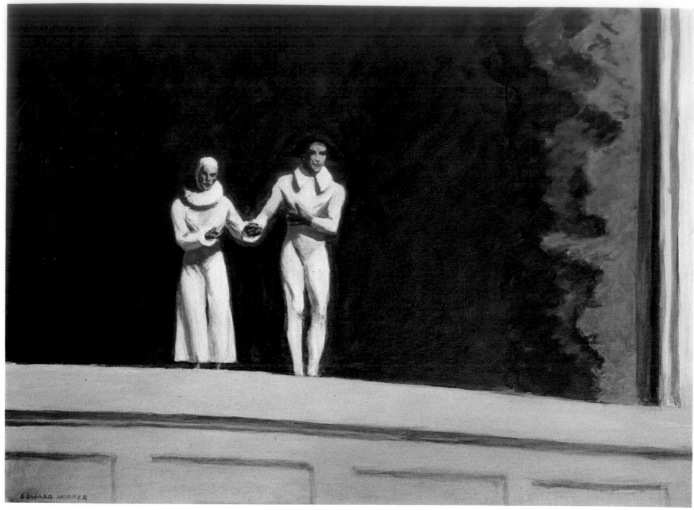

Pl. 353. *Two Comedians*, 1965. Oil on canvas, 29 × 40 inches. Private collection.

Pl. 354. Drawing for painting, *Two Comedians*, 1965. Charcoal on paper, 8½ × 11 inches. Private collection.

Pl. 355. Drawing for painting, *Two Comedians*, 1965. Charcoal on paper, 8½ × 11 inches. Private collection.

Beginning in 1912, Hopper depicted many offices as an illustrator for System *maga-zine. Later, as part of his observations of city life, he found the office an intriguing setting, although it is an unusual subject for paintings.*

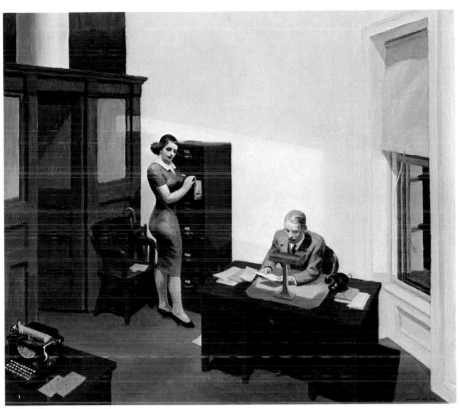

Pl. 356. *Office at Night,* 1940. Oil on canvas, 22⅛ × 25 inches. Walker Art Center, Minneapolis, Minnesota; Gift of the T. B. Walker Foundation.

Pl. 357. Drawing for painting, *Office at Night,* 1940. Conté on paper, 8½ × 11 inches. Whitney Museum of American Art, New York; Bequest of Josephine N. Hopper. 70.168

Pl. 358. Drawing for painting, *Office at Night,* 1940. Conté and charcoal with touches of white paint on paper, 15⅛ × 18⅜ inches. Whitney Museum of American Art, New York; Bequest of Josephine N. Hopper. 70.341

Pl. 359. Drawing for painting, *Office at Night,* 1940. Conté and charcoal with touches of white paint on paper, 15 × 19⅝ inches. Whitney Museum of American Art, New York; Bequest of Josephine N. Hopper. 70.340

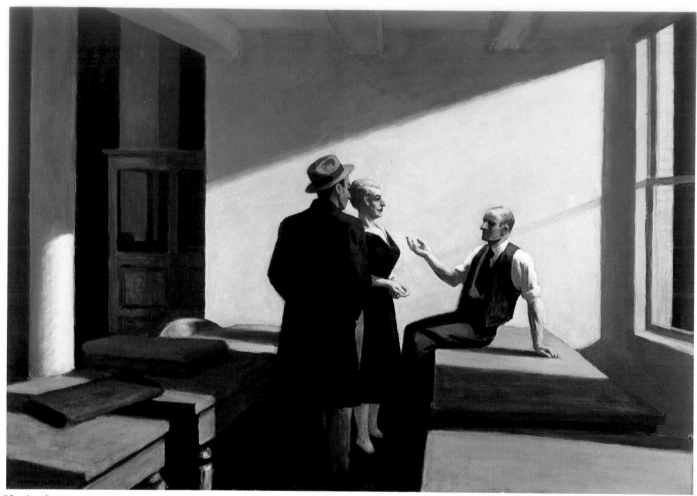

Pl. 360. *Conference at Night,* 1949. Oil on canvas, 27¾ × 40 inches. Courtesy of the Wichita Art Museum, Kansas; The Roland P. Murdock Collection.

Pl. 361. Drawing for painting, *Conference at Night,* 1949. Conté on paper, 8½ × 11 inches. Whitney Museum of American Art, New York; Bequest of Josephine N. Hopper. 70.172

Pl. 362. Drawing for painting, *Conference at Night,* 1949. Conté on paper, 15 × 22 inches. Whitney Museum of American Art, New York; Bequest of Josephine N. Hopper. 70.842

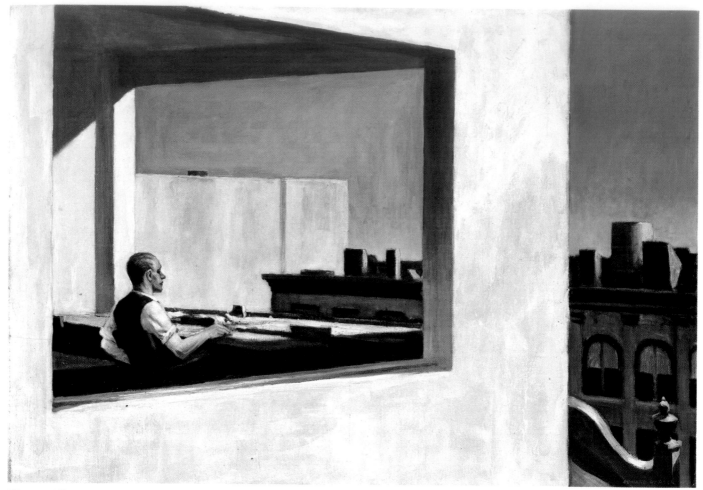

Pl. 363. *Office in a Small City,* 1953. Oil on canvas, 28 × 40 inches. The Metropolitan Museum of Art, New York; George A. Hearn Fund.

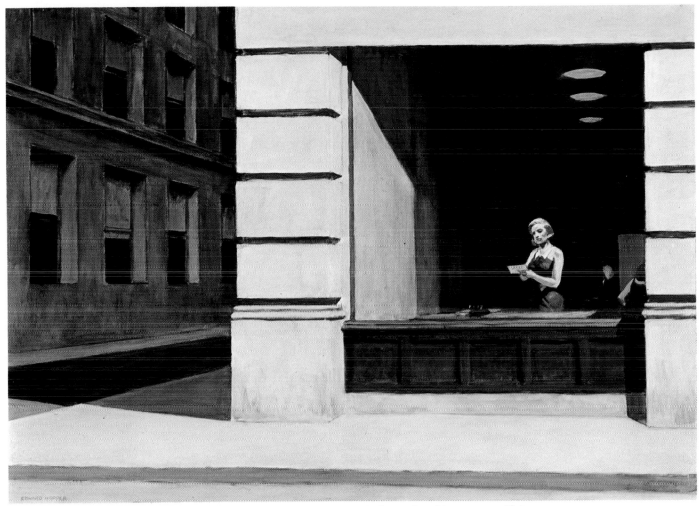

Pl. 364. *New York Office*, 1962. Oil on canvas, 40 × 55 inches. Collection of Blount, Inc., Montgomery, Alabama.

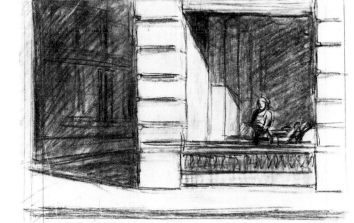

Pl. 365. Drawing for painting, *New York Office*, 1962. Pencil on paper, 8½ × 11 inches. Whitney Museum of American Art, New York; Bequest of Josephine N. Hopper. 70.822

Hopper sometimes focused on two people encountering one another, conveying effectively their anxiety or dismay. He was a romantic at heart, but at the same time a pessimist who felt that others rarely measure up to one's ideal.

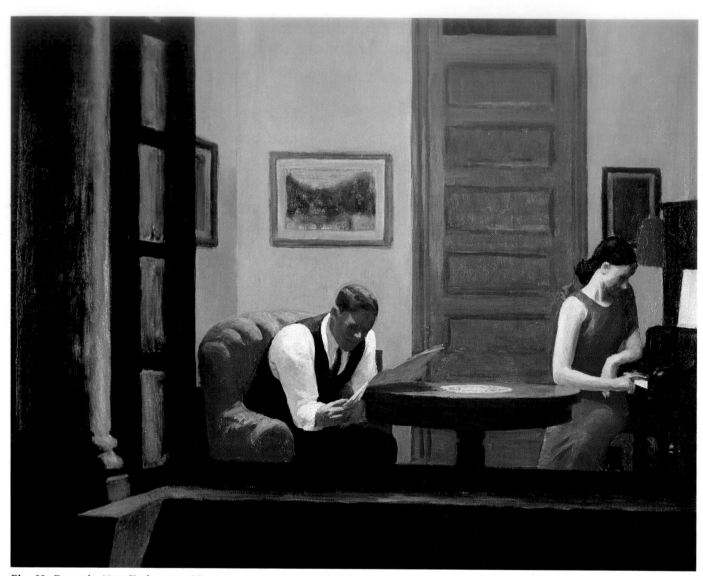

Pl. 366. *Room in New York,* 1932. Oil on canvas, 29 × 36 inches. F. M. Hall Collection; University of Nebraska Art Galleries, Lincoln.

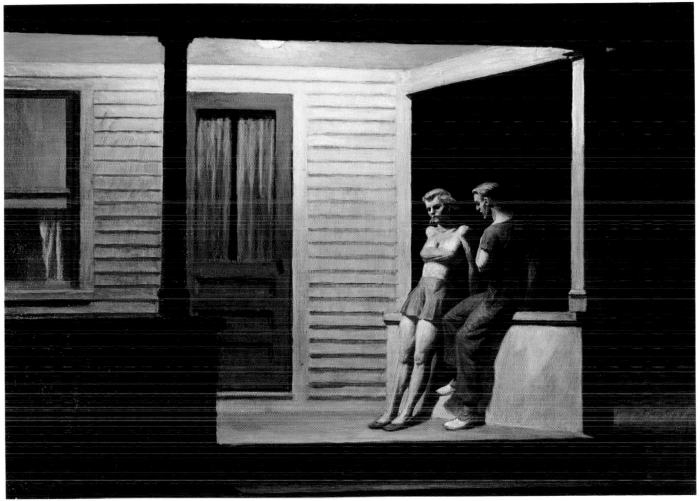

Pl. 367. *Summer Evening*, 1947. Oil on canvas, 30 × 42 inches. Collection of Mr. and Mrs. Gilbert H. Kinney.

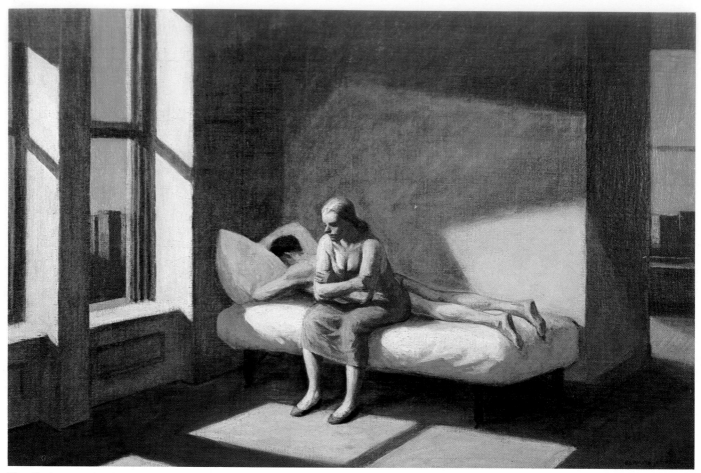

Pl. 368. *Summer in the City,* 1949. Oil on canvas, 20 × 30 inches. Berry-Hill Galleries, Inc., New York.

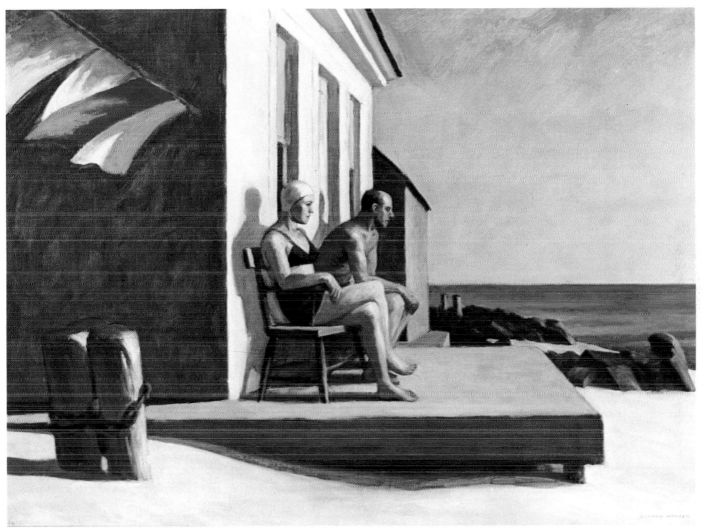

Pl. 369. *Seawatchers*, 1952. Oil on canvas, 30 × 40 inches. Private collection.

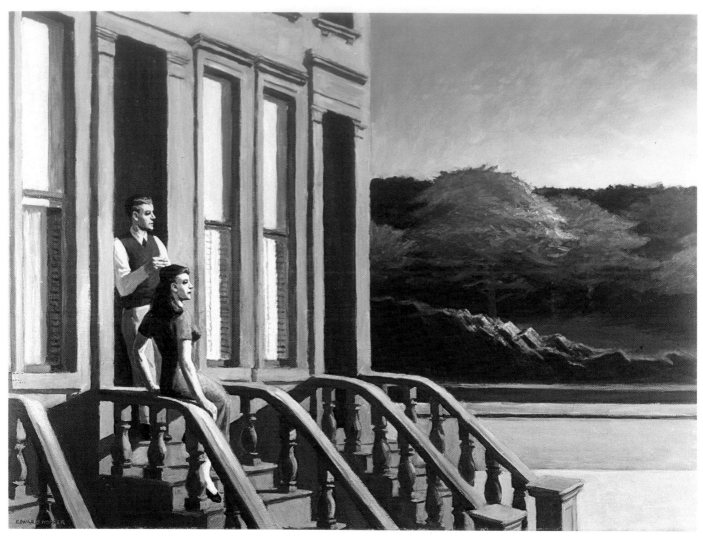

Pl. 370. *Sunlight on Brownstones*, 1956. Oil on canvas, 29¾ × 39¾ inches. Courtesy of the Wichita Art Museum, Kansas; The Roland P. Murdock Collection.

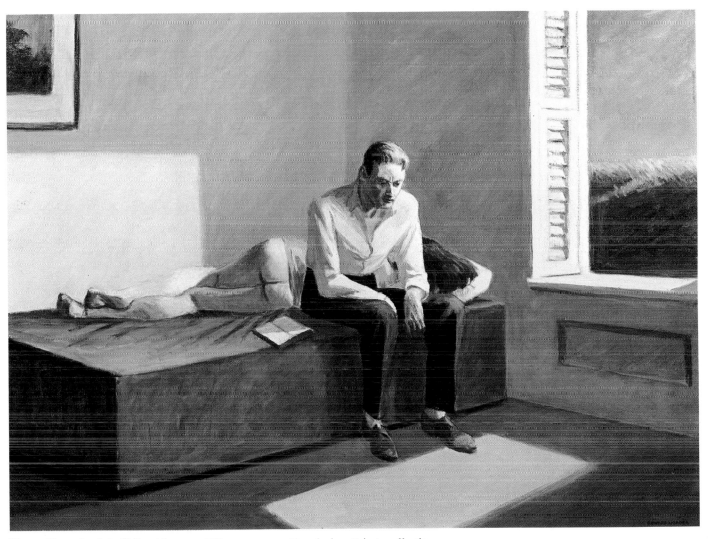

Pl. 371. *Excursion into Philosophy*, 1959. Oil on canvas, 30 × 40 inches. Private collection.

Hopper always loved military history, and as a child often made drawings and cutout figures of soldiers. As an illustrator and etcher he also depicted soldiers of several nationalities and eras. His interest later focused on the Civil War and he returned to this subject for several paintings.

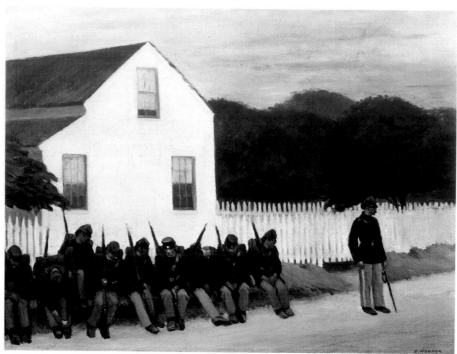

Pl. 373. *Dawn Before Gettysburg*, 1934. Oil on canvas, 15 × 20 inches. Private collection.

Pl. 372. *Soldiers in Wagon*, 1896. Pencil on paper, 7⅞ × 10 inches. Whitney Museum of American Art, New York; Bequest of Josephine N. Hopper. 70.1554.14

Pl. 374. Drawing for painting, *Dawn Before Gettysburg*, 1934. Conté on paper, 7¹¹⁄₁₆ × 11 inches. Whitney Museum of American Art, New York; Bequest of Josephine N. Hopper. 70.424

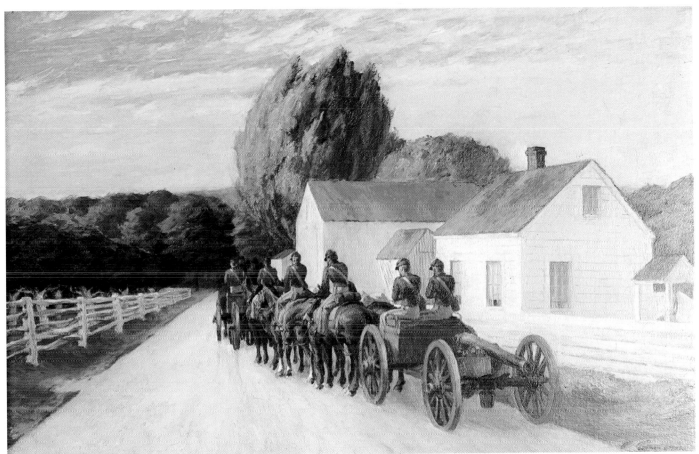

Pl. 375. *Light Battery at Gettysburg*, 1940. Oil on canvas, 18 × 27 inches. Nelson Gallery-Atkins Museum, Kansas City, Missouri; Gift of the Friends of Art.

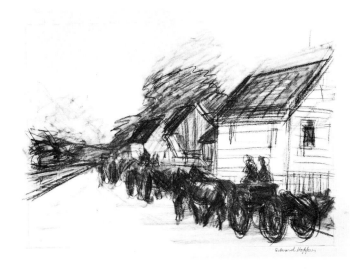

Pl. 376. Drawing for painting, *Light Battery at Gettysburg*, 1940. Conté on paper, 11¼ × 15⅛ inches. Whitney Museum of American Art, New York; Bequest of Josephine N. Hopper. 70.425

Hopper repeatedly represented different times of day, emphasizing mood through the varying effects of light. Often, he even entitled his painting with specific hours. In his use of time as an expression of mood, Hopper was probably inspired by French Symbolist literature.

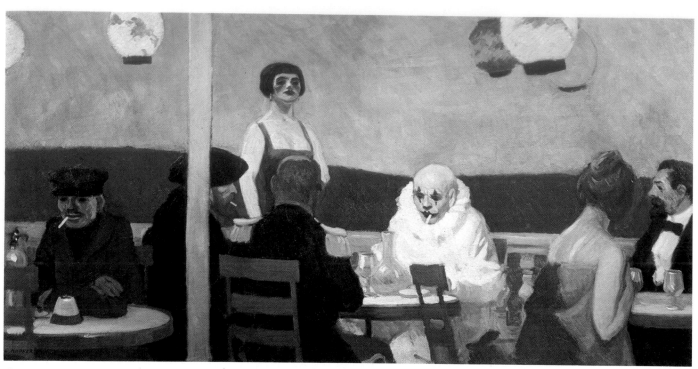

Pl. 378. *Soir Bleu*, 1914. Oil on canvas, 36 × 72 inches. Whitney Museum of American Art, New York; Bequest of Josephine N. Hopper. 70.1208

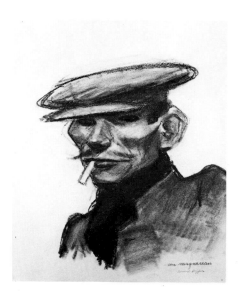

Pl. 377. [*Studies of Light on Portrait Heads*], c. 1903. Pencil on paper, 10 × 8 inches. Whitney Museum of American Art, New York; Bequest of Josephine N. Hopper. 70.1553.78

Pl. 379. *Un Maquereau* (drawing for painting, *Soir Bleu*), 1914. Conté on paper, 10 × 8⅜ inches. Whitney Museum of American Art, New York; Bequest of Josephine N. Hopper. 70.318

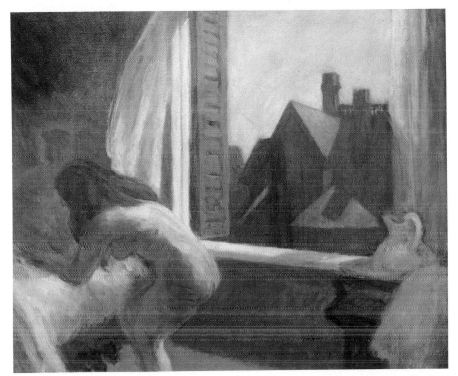

Pl. 380. *Moonlight Interior*, 1921–23. Oil on canvas, 24 × 29 inches. Private collection

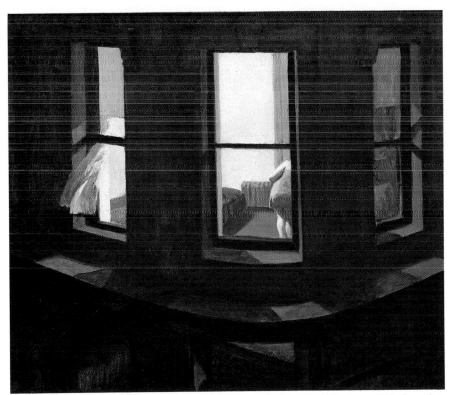

Pl. 381. *Night Windows*, 1928. Oil on canvas, 29 × 34 inches. The Museum of Modern Art, New York; Gift of John Hay Whitney.

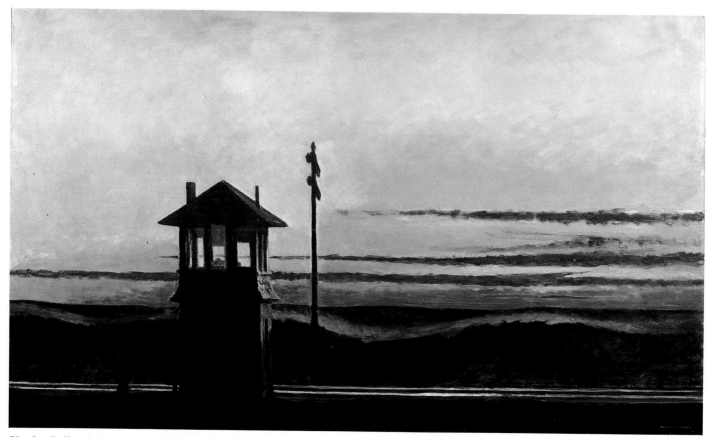

Pl. 382. *Railroad Sunset*, 1929. Oil on canvas, 28½ × 47¾ inches. Whitney Museum of American Art, New York; Bequest of Josephine N. Hopper. 70.1170

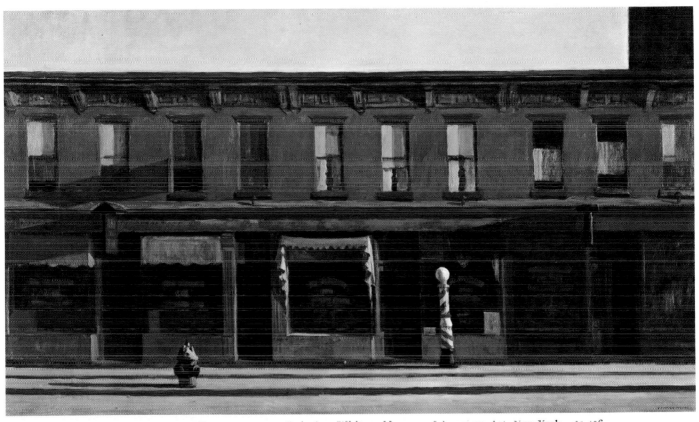

Pl. 383. *Early Sunday Morning*, 1930. Oil on canvas, 35 × 60 inches. Whitney Museum of American Art, New York. 31.426

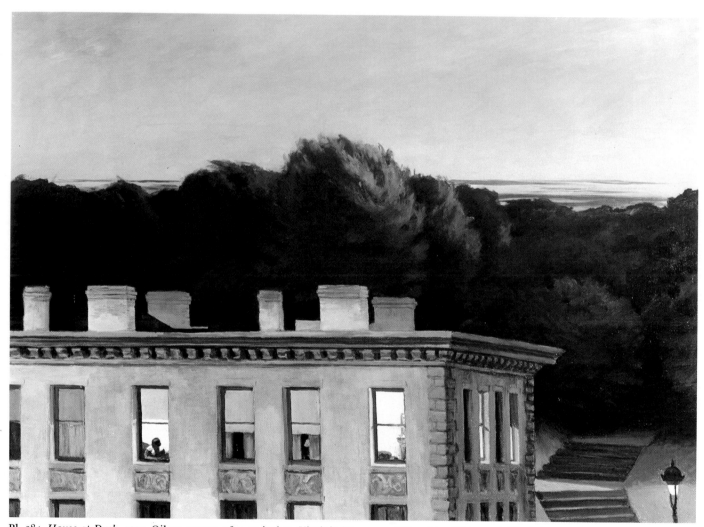

Pl. 384. *House at Dusk,* 1935. Oil on canvas, 36 × 50 inches. Virginia Museum of Fine Arts, Richmond, Virginia.

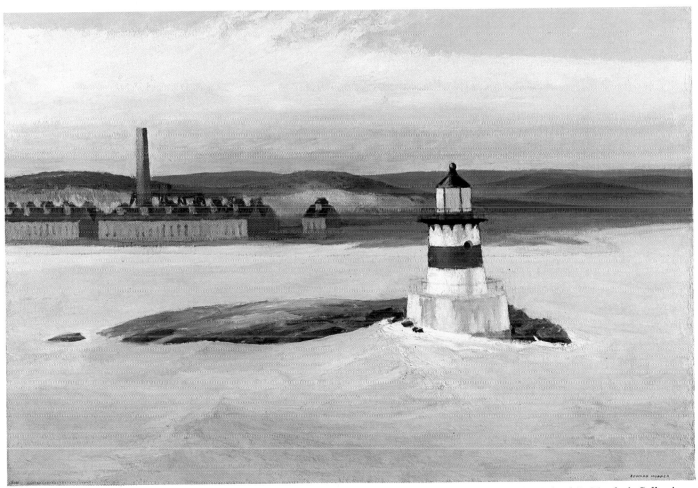

Pl. 385. *Five A.M.*, c. 1937. Oil on canvas, 25 × 36 inches. Courtesy of the Wichita Art Museum, Kansas; The Roland P. Murdock Collection.

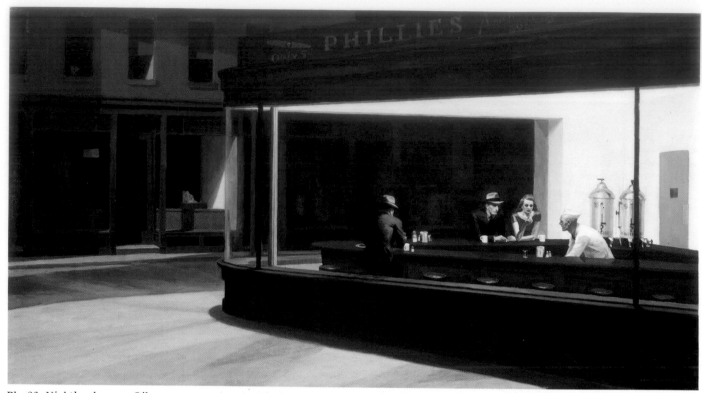

Pl. 386. *Nighthawks,* 1942. Oil on canvas, 33¼ × 60⅛ inches. The Art Institute of Chicago; Friends of American Art.

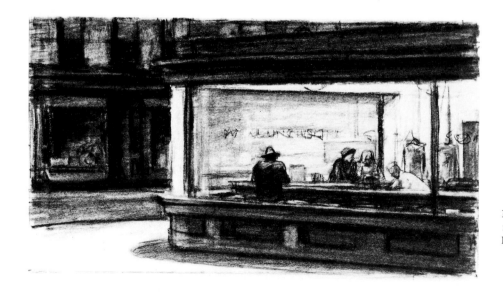

Pl. 387. Drawing for painting, *Nighthawks,* 1942. Conté on paper, 7¾ × 14 inches. Collection of Mr. and Mrs. Peter R. Blum.

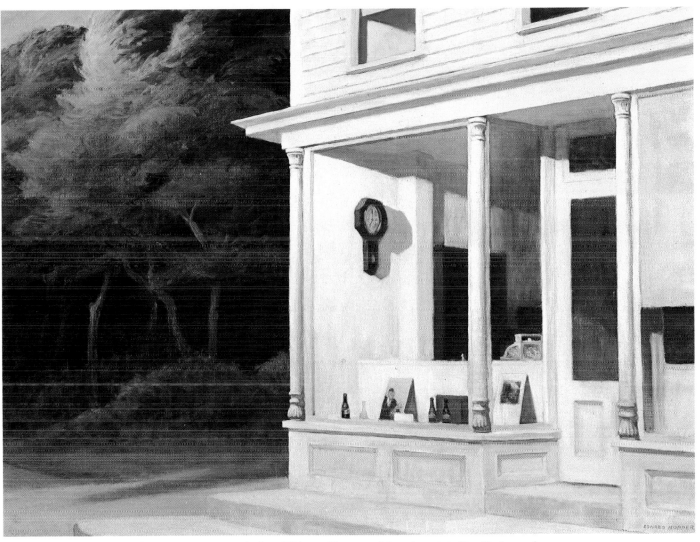

Pl. 388. *Seven A.M.*, 1948. Oil on canvas, 30 × 40 inches. Whitney Museum of American Art, New York. 50.8

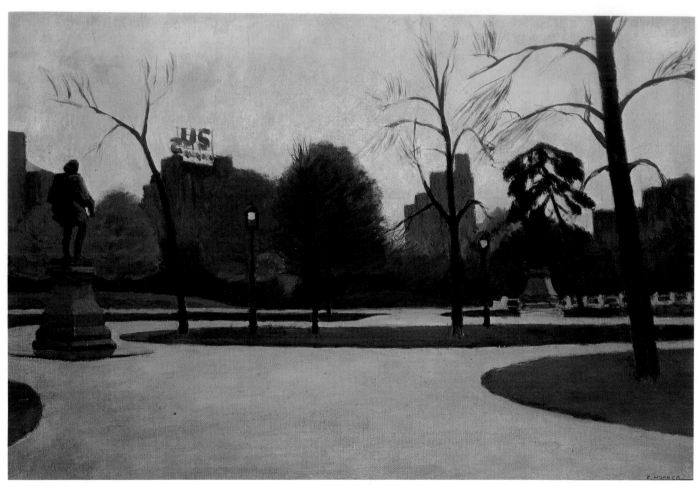

Pl. 389. *Shakespéare at Dusk,* 1935. Oil on canvas, 17 × 25 inches. Collection of John Astor.

Pl. 391. Drawing for painting, *Shakespeare at Dusk*, 1935. Pencil on paper, 4½ × 7¼ inches. Whitney Museum of American Art, New York; Bequest of Josephine N. Hopper. 70.127

Pl. 390. Drawing for painting, *Shakespeare at Dusk*, 1935. Conté on paper, 8⅞ × 11⅞ inches. Whitney Museum of American Art, New York; Bequest of Josephine N. Hopper. 70.281

Pl. 392. Drawing for painting, *Shakespeare at Dusk*, 1935. Pencil on paper, 8⅞ × 23⁷⁄₁₆ inches. Whitney Museum of American Art, New York; Bequest of Josephine N. Hopper. 70.453

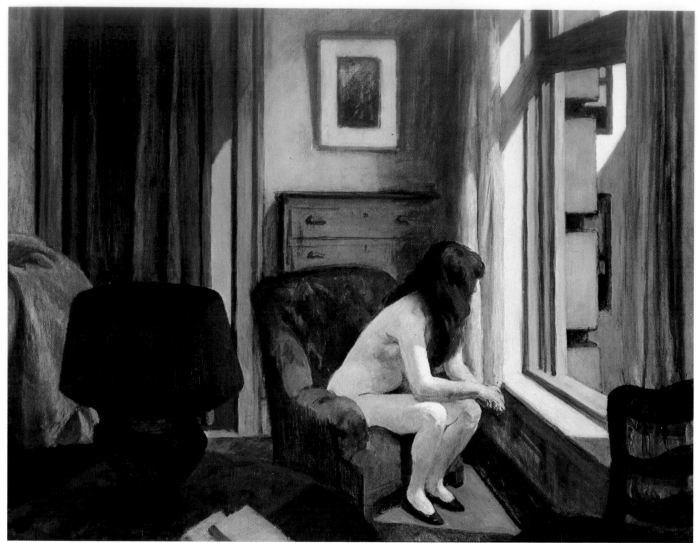

Pl. 393. *Eleven A.M.*, 1926. Oil on canvas, 28 × 36 inches. Hirshhorn Museum and Sculpture Garden, Smithsonian Institution, Washington, D.C.

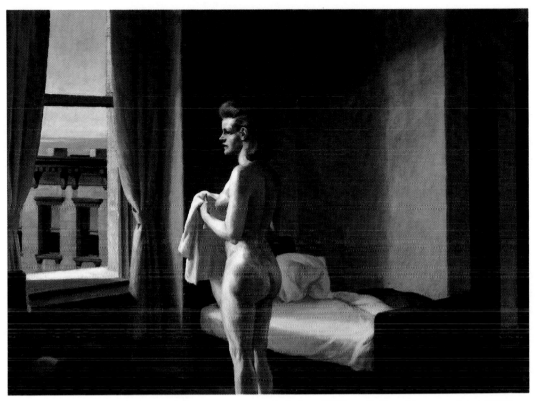

Pl. 394. *Morning in a City*, 1944. Oil on canvas, 44 × 60 inches. Williams College Museum of Art, Williamstown, Massachusetts.

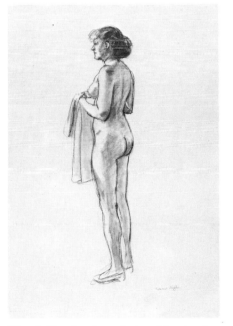

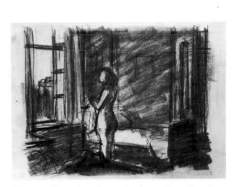

Pl. 395. Drawing for painting, *Morning in a City*, 1944. Conté and pencil on paper, 8½ × 11 inches. Whitney Museum of American Art, New York; Bequest of Josephine N. Hopper. 70.207

Pl. 396. Drawing for painting, *Morning in a City*, 1944. Conté on paper, 22⅛ × 15 inches. Whitney Museum of American Art, New York; Bequest of Josephine N. Hopper. 70.294

Pl. 397. Drawing for painting, *Morning in a City*, 1944. Conté on paper, 8⅞ × 11⅞ inches. Whitney Museum of American Art, New York; Bequest of Josephine N. Hopper. 70.208

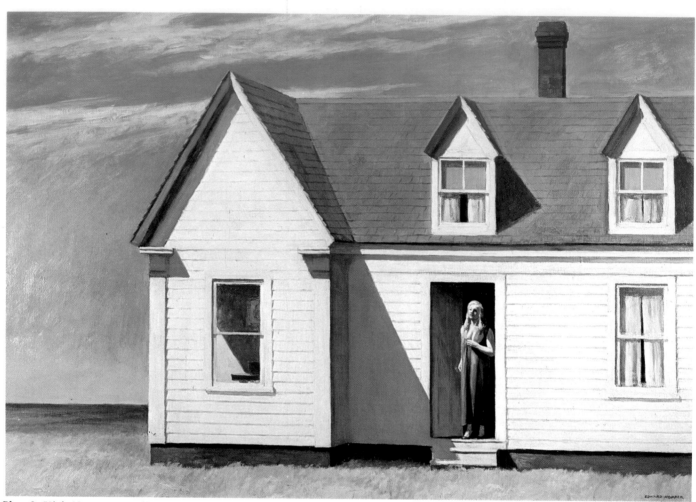

Pl. 398. *High Noon*, 1949. Oil on canvas, 28 × 40 inches. The Dayton Art Institute, Ohio.

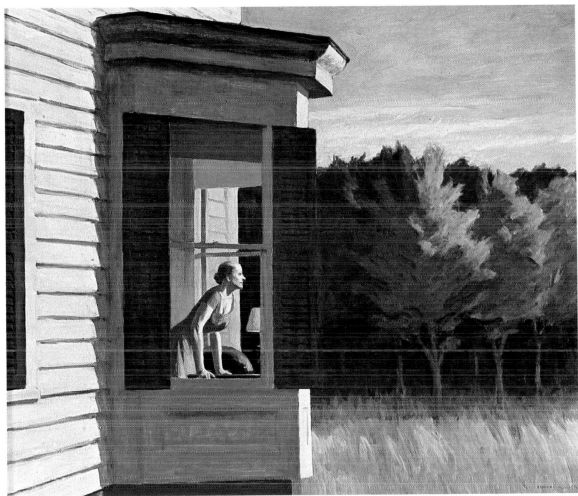

Pl. 399. *Cape Cod Morning*, 1950. Oil on canvas, 34 × 40 inches. The Sara Roby Foundation, New York.

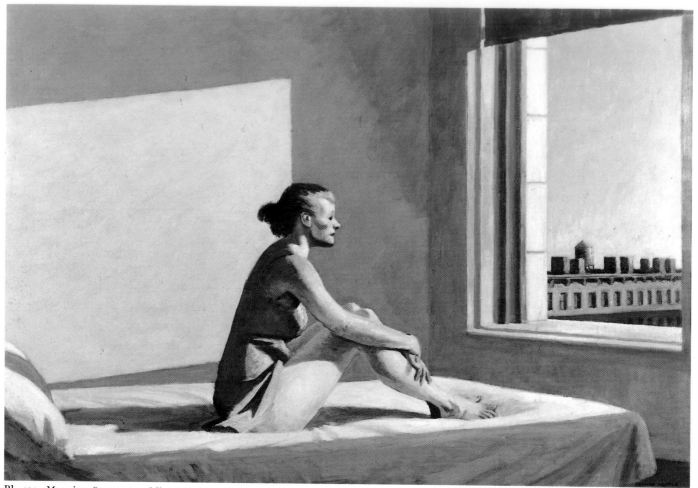

Pl. 400. *Morning Sun,* 1952. Oil on canvas, 28⅛ × 40⅛ inches. Columbus Museum of Art, Ohio; Howald Fund Purchase.

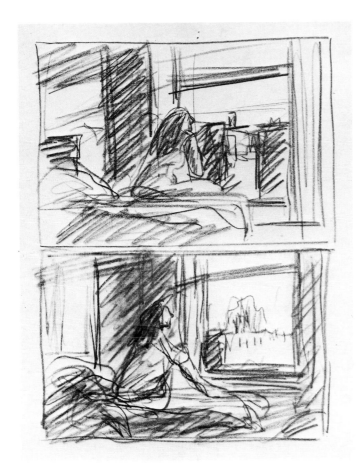

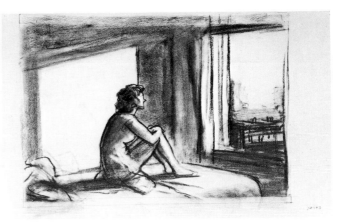

Pl. 402. Drawing for painting, *Morning Sun*, 1952. Conté on paper, 12 × 19 inches. Whitney Museum of American Art, New York; Bequest of Josephine N. Hopper. 70.244

Pl. 401. Drawings for painting, *Morning Sun*, 1952. Conté on paper, 11 × 8½ inches. Whitney Museum of American Art, New York; Bequest of Josephine N. Hopper. 70.243

Pl. 403. Drawing for painting, *Morning Sun*, 1952. Conté and pencil on paper, 12 × 18¹⁵⁄₁₆ inches. Whitney Museum of American Art, New York; Bequest of Josephine N. Hopper. 70.291

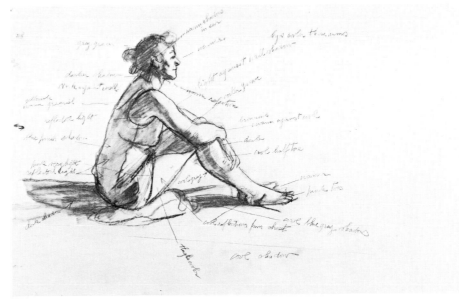

The Hoppers spent their first summer in South Truro, Massachusetts, on Cape Cod in 1930. After renting A. B. Cobb's house for four summers, in 1934 they built their own house on the Cape. In his paintings from these summers, Hopper depicted the surrounding houses, trees, and vistas.

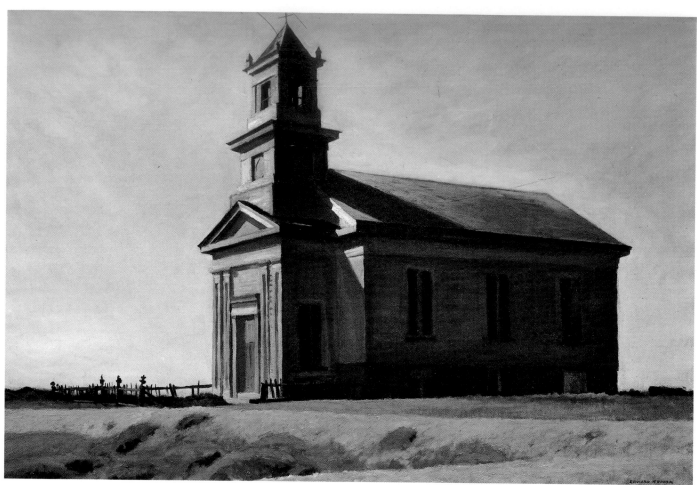

Pl. 404. *South Truro Church*, 1930. Oil on canvas, 29 × 43 inches. Private collection.

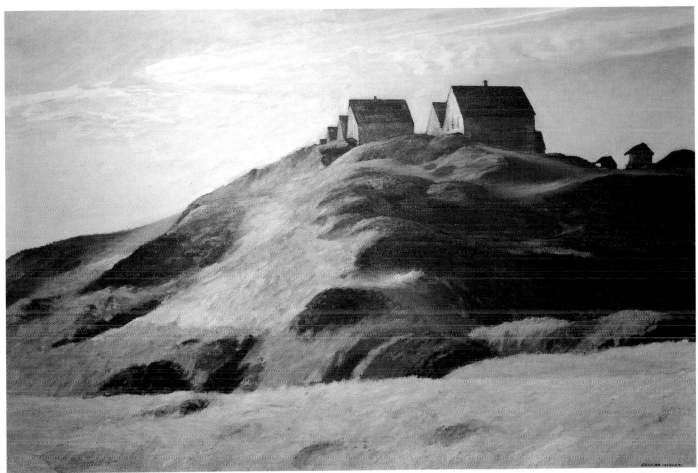

Pl. 405. *Corn Hill,* 1930. Oil on canvas, 29 × 43 inches. Marion Koogler McNay Art Institute, San Antonio, Texas; Sylvan and Mary Long Collection.

Pl. 406. *The Coal Box,* 1930. Watercolor on paper, 14 × 20 inches. Wadsworth Atheneum, Hartford, Connecticut; The Ella Gallup Sumner and Mary Catlin Sumner Collection.

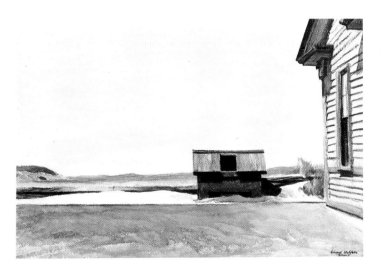

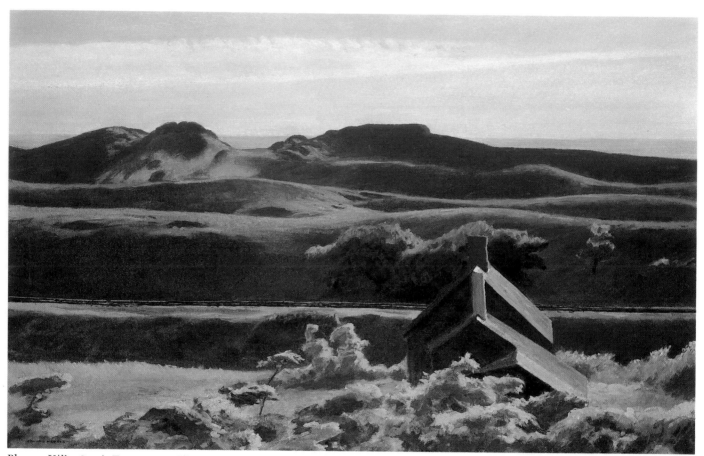

Pl. 407. *Hills, South Truro,* 1930. Oil on canvas, 27⅜ × 43⅛ inches. The Cleveland Museum of Art; Hinman B. Hurlbut Collection.

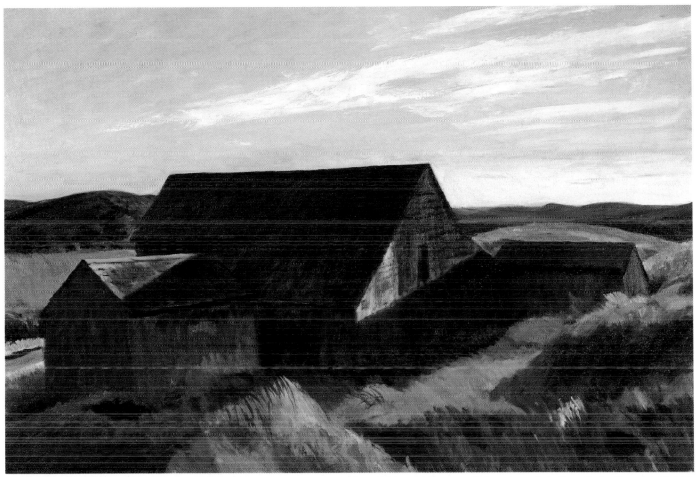

Pl. 408. [*Cobb's Barns, South Truro*], c. 1931. Oil on canvas, 34 × 50 inches. Whitney Museum of American Art, New York; Bequest of Josephine N. Hopper. 70.1207

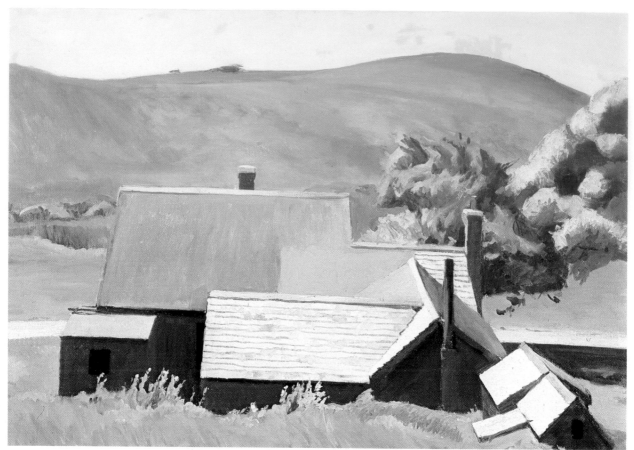

Pl. 409. [*Burly Cobb's House, South Truro*], c. 1930. Oil on canvas, 24¾ × 36 inches. Whitney Museum of American Art, New York; Bequest of Josephine N. Hopper. 70.1210

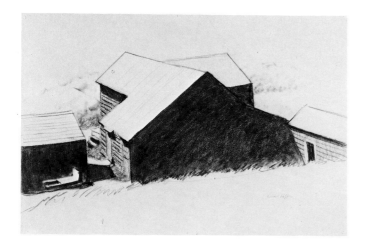

Pl. 410. [*Cobb's Barns, South Truro*], c. 1931. Conté and red crayon on paper, 15 × 22⅛ inches. Whitney Museum of American Art, New York; Bequest of Josephine N. Hopper. 70.684

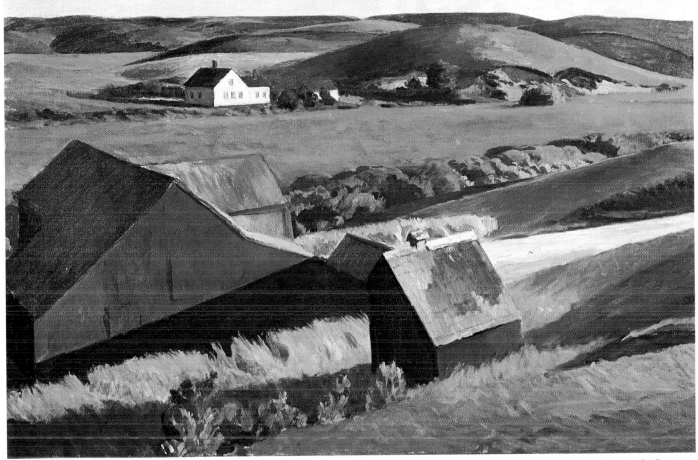

Pl. 411. [*Cobb's Barns and Distant Houses*], c. 1931. Oil on canvas, 28½ × 42 inches. Whitney Museum of American Art, New York; Bequest of Josephine N. Hopper. 70.1206

Pl. 412. [*Cobb's Barns and Distant Houses*], c. 1931. Watercolor on paper, 21⅞ × 29¾ inches. Whitney Museum of American Art, New York; Bequest of Josephine N. Hopper. 70.1081

Pl. 413. *The Camel's Hump,* 1931. Oil on canvas, 32¼ × 50⅛ inches. Munson-Williams-Proctor Institute, Museum of Art, Utica, New York; Edward W. Root Bequest.

Pl. 414. *House of the Fog Horn, No. 3*, 1929. Watercolor on paper, 13⅝ × 19½ inches. Yale University Art Gallery, New Haven, Connecticut; Gift of Mr. and Mrs. George Hopper Fitch, B.A. 1932.

Pl. 415. *Dauphinée House,* 1932. Oil on canvas, 34 × 50¼ inches. Private collection.

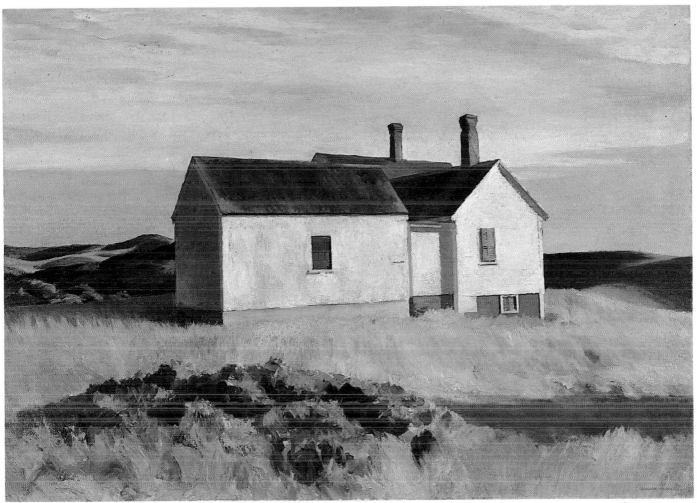

Pl. 416. *Ryder's House,* 1933. Oil on canvas, 36 × 50 inches. Museum of Fine Arts, Boston; Gift of the National Academy of Design, Henry Ranger Fund.

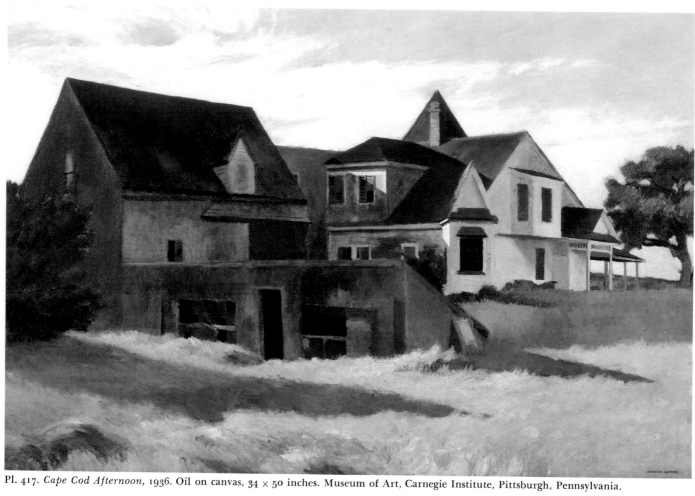

Pl. 417. *Cape Cod Afternoon*, 1936. Oil on canvas, 34 × 50 inches. Museum of Art, Carnegie Institute, Pittsburgh, Pennsylvania.

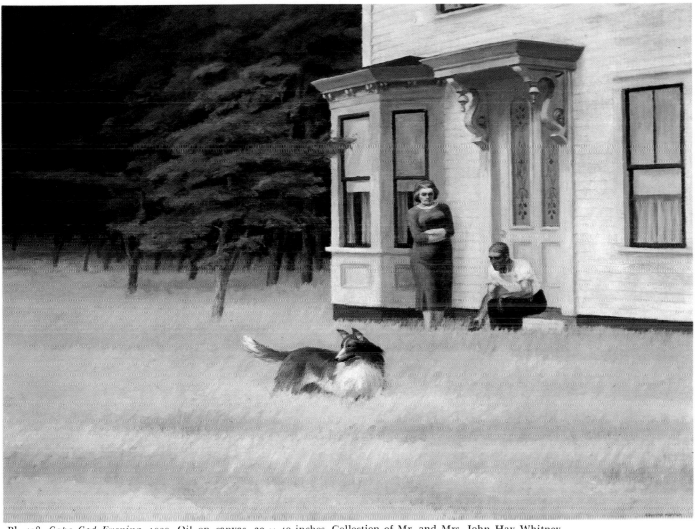

Pl. 418. *Cape Cod Evening,* 1939. Oil on canvas, 30 × 40 inches. Collection of Mr. and Mrs. John Hay Whitney.

Pl. 419. Drawing for painting, *Cape Cod Evening,* 1939. Conté on paper, 8½ × 11 inches. Whitney Museum of American Art, New York; Bequest of Josephine N. Hopper. 70.183

Pl. 420. *October on Cape Cod*, 1946. Oil on canvas, 26 × 42 inches. Collection of Loretta and Robert K. Lifton.

Pl. 421. *Portrait of Orleans,* 1950. Oil on canvas, 26 × 40 inches. Private collection.

Speaking of his distaste for illustration, Hopper once insisted: "What I wanted to do was to paint sunlight on the side of a house." Recording the drama of sunlight was a lifelong interest.

Pl. 423. *Trees in Sunlight, Parc du Saint Cloud,* 1907. Oil on canvas, 23⅝ × 28¾ inches. Whitney Museum of American Art, New York; Bequest of Josephine N. Hopper. 70.1248

Pl. 422. *Mass of Trees at Eastham,* July–August 1962. Watercolor on paper, 21 × 28¾ inches. Whitney Museum of American Art, New York; Bequest of Josephine N. Hopper. 70.1164

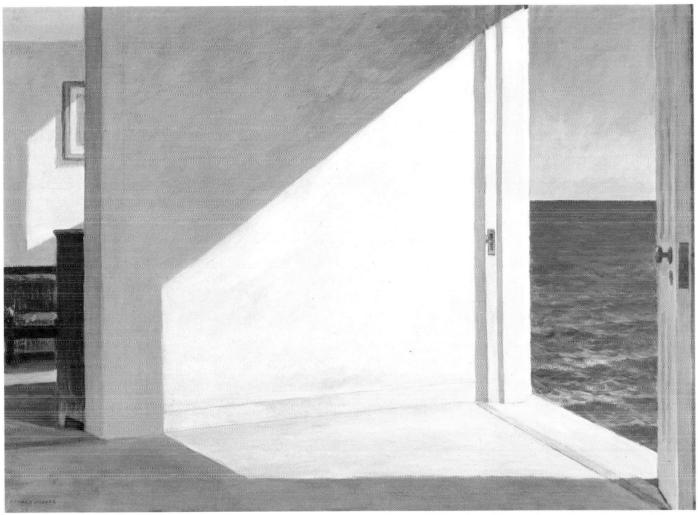

Pl. 424. *Rooms by the Sea,* 1951. Oil on canvas, 29 × 40 inches. Yale University Art Gallery, New Haven, Connecticut; Bequest of Stephen Carlton Clark, B.A. 1903.

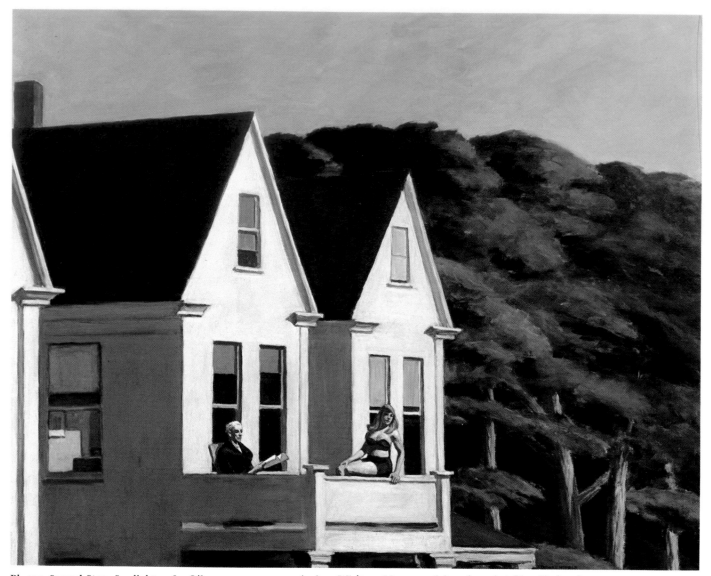

Pl. 425. *Second Story Sunlight,* 1960. Oil on canvas, 40 × 50 inches. Whitney Museum of American Art, New York. 60.54

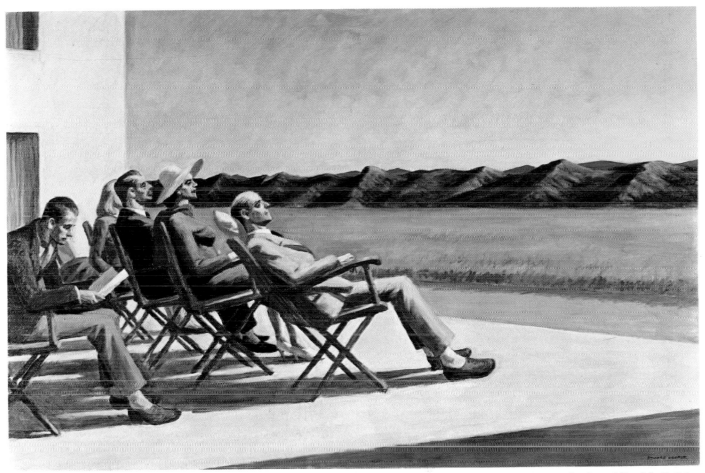

Pl. 426. *People in the Sun,* 1960. Oil on canvas, 40 × 60 inches. National Collection of Fine Arts, Smithsonian Institution; Gift of S. C. Johnson and Son, Inc.

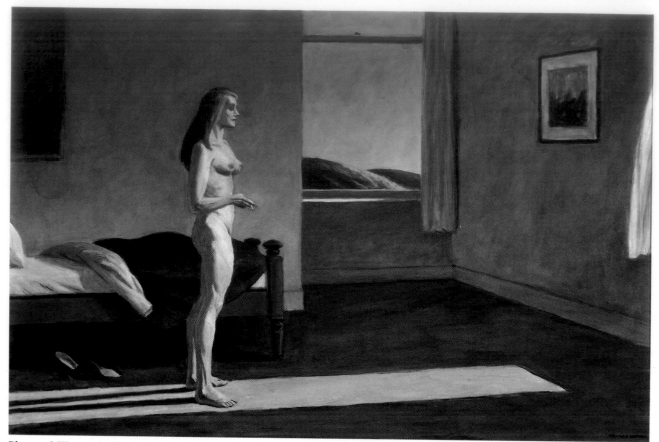

Pl. 427. *A Woman in the Sun,* 1961. Oil on canvas, 40 × 60 inches. Whitney Museum of American Art, New York; Promised and Partial 50th Anniversary Gift of Mr. and Mrs. Albert Hackett in honor of Edith and Lloyd Goodrich. P. 18.80

Pl. 428. Drawing for painting, *A Woman in the Sun,* c. 1961. Conté on paper, 18½ × 11¼ inches. Private collection.

Pl. 429. *Sun in an Empty Room*, 1963. Oil on canvas, 28¾ × 39½ inches. Private collection

CHRONOLOGY

The information in this chronology has been compiled from the artist's ledgers and letters, various museum archives, exhibition catalogues, and published reviews. A complete chronology will follow in the catalogue raisonné. The titles of Hopper's works may be given in French or English, according to the listing in individual exhibition catalogues.

1882 July 22, Edward Hopper born in Nyack, New York, son of Garrett Henry Hopper and Elizabeth Griffiths Smith Hopper.

1888– Attended local private school, graduated from Nyack
1899 High School. As a teenager, built himself a catboat with wood provided by his father.

1899– Winter, studied illustration at the Correspondence
1900 School of Illustrating, a commercial art school in New York City at 114 West Thirty-fourth Street.

1900– New York School of Art, studied illustration with Arthur
1906 Keller and Frank Vincent DuMond, then painting under Robert Henri, William Merritt Chase, and Kenneth Hayes Miller. In class with Gifford Beal, George Bellows, Homer Boss, Patrick Henry Bruce, Arthur Cederquist, Clarence K. Chatterton, Glenn O. Coleman, Guy Pène du Bois, Arnold Friedman, Julius Golz, Jr., Rockwell Kent, Vachel Lindsay, Walter Pach, Eugene Speicher, Carl Sprinchorn, Walter Tittle, and Clifton Webb. Along with Douglas John Connah and W. T. Benda, taught the Saturday class in drawing from life, painting, sketching, and composition at the New York School of Art.

1906 Employed as an illustrator by C. C. Phillips & Company, 24 East Twenty-second Street, New York.

October, to Paris, lived at 48, rue de Lille in the building of the Eglise Evangélique Baptiste. Continued friendship with Patrick Henry Bruce in Paris.

1907 June 27, left Paris to travel to London where he visited the National Gallery, the Wallace Collection, and Westminster Abbey.

July 19, left London for Holland. Visited Amsterdam and Haarlem where Robert Henri was conducting a summer school for American students. July 26, arrived in Berlin.

August 1, arrived in Brussels for two days before returning to Paris.

August 21, sailed for New York.

Worked as a commercial artist in New York.

1908 March 9–31, included in "Exhibition of Paintings and Drawings by Contemporary American Artists" at the old Harmonie Club building, 43–45 West Forty-second Street, New York; exhibited for the first time with several other Henri students; exhibited three oils, *The*

Louvre and Seine, The Bridge of the Arts, and *The Park at Saint Cloud,* and one drawing, *Une Demimondaine.* The exhibition was organized by Arnold Friedman, Julius Golz, Jr., and Glenn O. Coleman. Also included were paintings by George Bellows, Guy Pène du Bois, Lawrence T. Dresser, Edward R. Keefe, Rockwell Kent, George McKay, Howard McLean, Carl Sprinchorn, and G. Leroy Williams.

1909 March 18, arrived in Paris via Cherbourg.

May, painted out-of-doors along the Seine frequently. Visited Fontainebleau.

June, visited St.-Germain-en-Laye.

July 31, sailed on Holland-America Line to New York, arriving on August 9.

1910 April 1–27, included in "Exhibition of Independent Artists," organized by John Sloan, Robert Henri, and Arthur B. Davies, at 29–31 West Thirty-fifth Street, New York; exhibited one oil, *The Louvre.*

Mid-May, returned to Paris. May 26, left Paris for Madrid. While in Spain, visited Toledo and attended a bullfight. Returned to Paris on June 11.

July 1, sailed for New York.

After returning to New York, began to earn his living by commercial art and illustration; painted in free time and in the summers.

1912 February 22–March 5, included in "Exhibition of Paintings," The MacDowell Club of New York, at 108 West Fifty-fifth Street; exhibited five oils: *River Boat, Valley of the Seine, The Wine Shop, Sailing,* and *British Steamer.* Also included were paintings by George Bellows, Randall Davey, and Guy Pène du Bois.

Summer in Gloucester, Massachusetts, where he painted with Leon Kroll.

1913 January 9–21, included in "Exhibition of Paintings," The MacDowell Club of New York; exhibited two oils: *La Berge* and *Squam Light.*

February 15–March 15, included in the Armory Show (International Exhibition of Modern Art); exhibited one oil, *Sailing,* which sold for $250.

Moved to 3 Washington Square North, New York, where he lived until his death.

1914 January 22–February 1, included in "Exhibition of Paintings," The MacDowell Club of New York; exhibited two oils: *Gloucester Harbor* and *The Bridge.*

April 30–May 17, included in "Exhibition of Water Colors, Pastels, and Drawings by Four Groups of Artists," The MacDowell Club of New York; exhibited *On the Quai, Land of Fog, The Railroad, The Port,* and *Street in Paris.*

Summer in Ogunquit, Maine.

October 10–31, included in "Opening Exhibition, Season 1914–1915," at the Montross Gallery, 550 Fifth Avenue, New York; exhibited one oil, *Road in Maine.*

1915 Took up etching.

February 11–21, included in "Exhibition of Paintings," The MacDowell Club of New York; exhibited two oils: *Soir Bleu* and *New York Corner (Corner Saloon).* Exhibition also included the paintings of George Bellows, John Sloan, Randall Davey, Eugene Speicher, and others.

Second summer in Ogunquit, Maine.

November 18–28, included in "Exhibition of Paintings," The MacDowell Club of New York; exhibited three oils: *American Village, Rocks and Houses,* and *The Dories.*

1916 February, eight of his Paris watercolor caricatures reproduced in *Arts and Decoration.*

Summer on Monhegan Island, Maine.

1917 February 15–25, included in "Exhibition of Paintings and Sculpture by Mary L. Alexander, George Bellows, A. Stirling Calder, Clarence K. Chatterton, Andrew Dasburg, Randall Davey, Robert Henri, Edward Hopper, Leon Kroll, Thalia W. Millett, Frank Osborn, John Sloan," The MacDowell Club of New York; exhibited three oils: *Portrait of Mrs Sullivan, Rocks and Sand,* and *Summer Street.*

April 10–May 6, included in the "First Annual Exhibition," American Society of Independent Artists; exhibited two oils: *American Village* and *Sea at Ogunquit.*

Summer on Monhegan Island, Maine.

1918 March 25–May 1, included in "An Exhibition of Etchings," Chicago Society of Etchers; exhibited *Somewhere in France.*

April 27–May 12, included in "Exhibition of Water Colors, Pastels, and Drawings by Four Groups of Artists," The MacDowell Club of New York, along with Louis Burt, Clara M. Davey, Randall Davey, Benjamin Greenstein, Bernard Gussow, Robert Henri, Amy Londoner, Marjorie Organ, Louise de G. Rogers, John Sloan, Ruth Townsend, and others; exhibited eight etchings.

Summer on Monhegan Island, Maine.

October, Hopper's poster *Smash the Hun,* which won the first prize in the "citizens" class nationwide competition of the National Service Section of the United States Shipping Board Emergency Fleet Corporation, was exhibited with those of nineteen other contestants in the window of Gimbel's department store on Broadway.

1919 Summer on Monhegan Island, Maine.

1920 January 14–28, Hopper's first one-man exhibition. Whitney Studio Club, 147 West Fourth Street, New York; showed sixteen oils painted in Paris and in Monhegan, Maine: *Le Bistro, Le Pont des Arts, Le Pont-Neuf,*

Notre Dame de Paris, Juin, Après-midi de Printemps, Le Parc de St. Cloud, Le Quai des Grands Augustins, Le Louvre et la Seine, Les Lavoirs, Black Head, Monhegan, The Little Cove, Monhegan, Rocks and Houses, Squam Light, La Cité, and *Road in Maine.*

1921 March 20–April 20, included in "Annual Exhibition of Paintings and Sculpture by Members of the Club," Whitney Studio Club; exhibited one oil, *The Park Entrance.*

1922 March 25–April 23, included in "Annual Exhibition of Paintings and Sculpture by Members of the Club," Whitney Studio Club; exhibited three etchings, and one oil, *New York Interior.*

October, exhibition of ten Paris watercolor caricatures at the Whitney Studio Club.

1923 Attended the Whitney Studio Club evening sketch class and made numerous lifedrawings.

February 1–March 11, included in "Exhibition of Etchings," Chicago Society of Etchers, The Art Institute of Chicago; exhibited two etchings: *East Side Interior* and *Evening Wind.* Hopper was awarded the Logan Prize of twenty-five dollars for the etching *East Side Interior.*

February 4–March 25, included in "118th Exhibition of Pennsylvania Academy of the Fine Arts," Philadelphia; exhibited one oil, *New York Restaurant.*

February, included in "National Arts Club, Humorist's Exhibition"; exhibited two Paris watercolor caricatures: *Le Militaire* and *Sargent de Ville.*

Made the last of his etchings. Summer in Gloucester, Massachusetts. Began to paint watercolors regularly.

November 19–December 20, included in "A Group Exhibition of Watercolor Paintings, Pastels, Drawings, and Sculpture by American and European Artists," at the Brooklyn Museum; exhibited six watercolors: *Deck of a Beam Trawler, House with a Bay Window, The Mansard Roof, Beam Trawler Seal, Shacks at Lanesville,* and *Italian Quarter, Gloucester.*

December 7, 1923, the Brooklyn Museum purchased *The Mansard Roof* for $100.

1924 February 3–March 23, included in "119th Annual Exhibition," Pennsylvania Academy of the Fine Arts, Philadelphia; exhibited one oil, *New York Interior.*

March 20–April 22, exhibited in "Fourth International Water Color Exhibition," The Art Institute of Chicago; included four watercolors: *Deck of a Beam Trawler, Houses of Squam Light, Beam Trawler Seal,* and *Italian Quarter, Gloucester.*

May 1–25, included in "Annual Members Exhibition," Whitney Studio Club; exhibited one oil, *New York Restaurant.*

Married Josephine Verstille Nivison on July 9, 1924, at the Eglise Evangélique on West Sixteenth Street, New York. Guy Pène du Bois was Hopper's best man.

Summer in Gloucester, Massachusetts.

October–November, Frank K. M. Rehn Gallery, New York, exhibition of recent watercolors. All eleven shown and five additional ones were sold. The exhibition was a success, enabling Hopper to give up commercial work and illustration. (His illustrations were published in *Scribner's* through 1927.)

1925 May 18–May 30, included in "Tenth Annual Exhibition," Whitney Studio Club at the Anderson Galleries; exhibited two oils: *Yonkers* and *New York Corner.*

June through late September, visited James Mountain, Colorado, and Santa Fe, New Mexico, where he painted seven watercolors.

1926 February 17–March 6, included in an exhibition at the Boston Art Club; exhibited five oils: *The Louvre, Le Pont des Arts, Le Quai des Grands Augustins, Ecluse de la Monnaie,* and *Notre Dame de Paris.*

February, included in "Today in American Art," Frank K. M. Rehn Gallery; exhibited one oil, *Sunday.*

April 13–May 1, "Exhibition of Water Colors and Etchings by Edward Hopper," St. Botolph Club, Boston; exhibited twenty-one prints and nineteen watercolors.

Took train trip to Eastport, Maine, for several days, then to Bangor.

Traveled by boat to Rockland, Maine, for seven weeks, then on to Gloucester, Massachusetts.

1927 Purchase of automobile.

Summer at Two Lights, Cape Elizabeth, Maine. Visited Mrs. Summer at Two Lights. Visited Mrs. Catherine Budd in Charlestown, New Hampshire, on return trip. Made an excursion across the Connecticut River into Vermont.

1928 January 20, made his last print, a drypoint, *Portrait of Jo.*

Summer in Gloucester, Massachusetts. Trip to Ogunquit, Maine, to visit Clarence K. and Annette Chatterton of Vassar. Traveled through New Hampshire and Vermont before returning to New York.

1929 January 21–February 2, one-artist exhibition at Frank K. M. Rehn Gallery of twelve oils, ten watercolors, and a group of drawings.

April 1–May 11, trip to Charleston, South Carolina.

Summer, visit to Topsfield, Massachusetts, home of Mr. and Mrs. Samuel A. Tucker. Second stay at Two Lights, Cape Elizabeth, Maine. Trips to Essex and Pemaquid Point.

1930 Visited with Edward and Grace Root at Hampton College, Clinton, New York, before going to South Truro, Massachusetts, on Cape Cod. Rented A. B. Cobb's house, "Bird Cage Cottage," on a hill.

1931 Honorable Mention and cash award, First Baltimore Pan-American Exhibition.

1931–
1932 Summers in "Bird Cage Cottage" in South Truro, Massachusetts.

1932 March, elected an associate member of the National Academy of Design, which he declined as they had rejected his paintings in years past. Took additional studio space at 3 Washington Square North, New York.

November–January 5, 1933, included in the first Whitney Museum of American Art Biennial (and in almost every later Whitney Biennial and Annual).

1933 Trip to Murray Bay, Quebec Province, Canada, then visited Ogunquit and Two Lights, Maine, and Boston. Returned to South Truro, Massachusetts, to "Bird Cage Cottage."

October 1, purchased land in South Truro and returned to New York later that month.

November 1–December 7, retrospective exhibition at the Museum of Modern Art, New York; exhibited twenty-five oils, thirty-seven watercolors, and eleven prints.

1934 January 2–16, retrospective at the Arts Club of Chicago.

Early May, went to South Truro, Massachusetts. While building studio house at South Truro (in which they spent every successive summer except where noted), the Hoppers stayed at the Jenness' house. The house was completed on July 9, and they remained through late November.

1935 Awarded Temple Gold Medal, Pennsylvania Academy of the Fine Arts, and First Purchase Prize in watercolor, Worcester Art Museum.

Trip from South Truro to East Montpelier, Vermont.

1936 Visited Plainsfield, Vermont.

1937 Awarded First W. A. Clark Prize and Corcoran Gold Medal, Corcoran Gallery of Art.

September, visited South Royalton (White River Valley), Vermont.

1938 September, visit to South Royalton during hurricane. Stayed in South Truro, Massachusetts, through late November.

Acquired rear studio at 3 Washington Square North for Jo Hopper.

1939 Returned to New York early from summer at South Truro in order to travel to Pittsburgh, Pennsylvania, to be on the jury of the Carnegie Institute. Painted no watercolors this year or next, but painted oils in South Truro studio.

1940 Traveled from South Truro to New York to register to vote. Returned to New York early from the Cape in order to vote for Wendell Willkie against Franklin Roosevelt.

1941 Spring, trip to Albany to jury exhibition.

Summer (May through July), traveled to the West Coast by car. Visited Colorado and Utah. Drove through Nevada desert to Pacific Coast and north through California to Oregon Coast. Returned via Wyoming and Yellowstone Park. Returned to house at South Truro late in August.

1942 Awarded Ada S. Garrett Prize, The Art Institute of Chicago.

1943 March, traveled to Washington to be on the Corcoran jury.

Summer, having no gas to travel to Cape Cod, made first trip to Mexico by train. Visited Mexico City, Saltillo, and Monterey, returning in early October. Painted four watercolors from roof of Guarhado House, Saltillo, and two from window of Monterey Hotel.

1944 South Truro. Trips to Boston and Hyannis for automobile repairs.

1945 Awarded Logan Art Institute Medal and Honorarium, The Art Institute of Chicago.

May, elected member of the National Institute of Arts and Letters.

1946 Awarded Honorable Mention, The Art Institute of Chicago.

May, drove to Saltillo, Mexico. Painted four watercolors. July in Grand Tetons; August through November in South Truro.

1947 November, trip to Indianapolis to serve on jury of Indiana artists exhibition.

1950 February 11–March 26, retrospective exhibition at the Whitney Museum of American Art; exhibition shown at the Museum of Fine Arts, Boston, in April, and the Detroit Institute of Arts in June. Awarded honorary degree, Doctor of Fine Arts, by the Art Institute of Chicago. Hopper attended the openings in Boston and Detroit and received his degree in Chicago.

1951 May 28, left by car for third trip to Mexico via Chattanooga, Tennessee. In Saltillo for a month. Visited Santa Fe, New Mexico, briefly on returning. Stayed in South Truro until November.

1952 Hopper was one of the four artists chosen by the American Federation of Arts to represent the United States in the Venice Biennale.

Summer in South Truro.

December, left for Mexico. Stayed eight days in El Paso, Texas. Visited Posada de la Presa Guanajuato, and spent one month at Mitla, Oaxaca. Visited Puebla and returned via Laredo.

1953 March 1, returned to New York from Mexico, where he painted two watercolors.

Joined Raphael Soyer and other representational painters in publishing *Reality* (on editorial committee).

June, honorary degree, Doctor of Letters, Rutgers University.

July, South Truro. September 15, to Gloucester and on to Charlestown, New Hampshire, to visit Mrs. William Proctor.

1954 Awarded First Prize for Watercolor, Butler Art Institute, Youngstown, Ohio.

1955 March 31, left for Mexico through May 1. Summer and fall in South Truro.

Gold Medal for Painting presented by the National Institute of Arts and Letters in the name of the American Academy of Arts and Letters.

1956 Awarded Huntington Hartford Foundation fellowship.

December 9, arrived at Huntington Hartford Foundation, Pacific Palisades, California.

1957 June 6, left Huntington Hartford Foundation.

July 22 through late October in South Truro.

Received New York Board of Trade's Salute to the Arts Award, and First Prize, Fouth International Hallmark Art Award.

1959 July 15, to South Truro for summer.

October trip to Manchester, New Hampshire, for November one-artist exhibition at Currier Gallery of Art.

December, this exhibition shown at Rhode Island School of Design. Visited Providence, Rhode Island, as the guests of Mr. and Mrs. Malcolm Chace.

1960 January, exhibition at Wadsworth Atheneum, Hartford, Connecticut.

Received Art in America Annual Award.

Spring, met with the artists' group who had published *Reality* at home of John Koch to protest the predominance of the "gobbledegook influences" of abstract art at the Whitney Museum and the Museum of Modern Art.

1962 October–November, "The Complete Graphic Work of Edward Hopper," Philadelphia Museum of Art; included fifty-two prints; publication of a catalogue raisonné; show later went to Worcester Art Museum.

1963 Received award from the St. Botolph Club, Boston. Retrospective exhibition at the Arizona Art Gallery. July 4 through late November, in South Truro.

1964 May, illness kept Hopper from painting.

Awarded M. V. Khonstamn Prize for Painting, The Art Institute of Chicago.

September 29–November 29, major retrospective exhibition at the Whitney Museum of American Art; shown from December (through January 1965) at the Art Institute of Chicago.

1965 February 18–March 21, retrospective shown at the Detroit Institute of Arts and, April 7–May 9, at the City Art Museum of St. Louis.

Awarded honorary degree, Doctor of Fine Arts, Philadelphia College of Art.

July 16, death of Hopper's sister Marion in Nyack, New York.

Last painting, *Two Comedians*.

1966 Awarded Edward MacDowell Medal.

1967 May 15, Edward Hopper died in his studio at 3 Washington Square North.

September 22–January 8, 1968, Hopper's work was featured in the United States Exhibition at the Bienal de São Paulo 9.

Henry Varnum Poor presenting the Gold Medal for Painting to Edward Hopper for the American Academy of Arts and Letters, May 25, 1955.